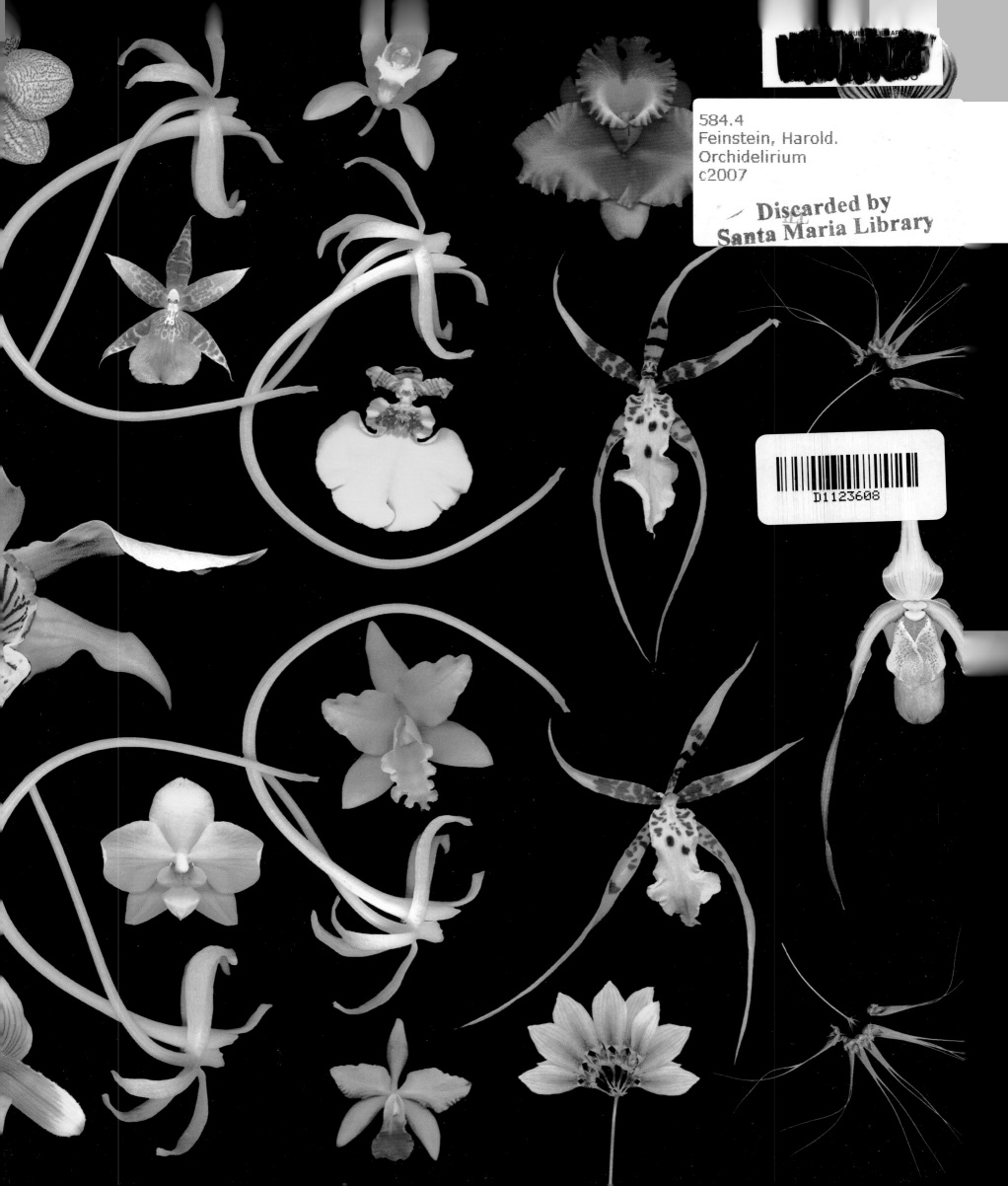

ORCHIDELIRIUM

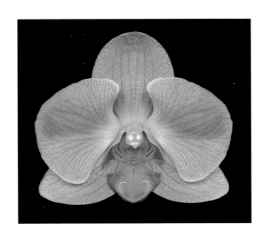

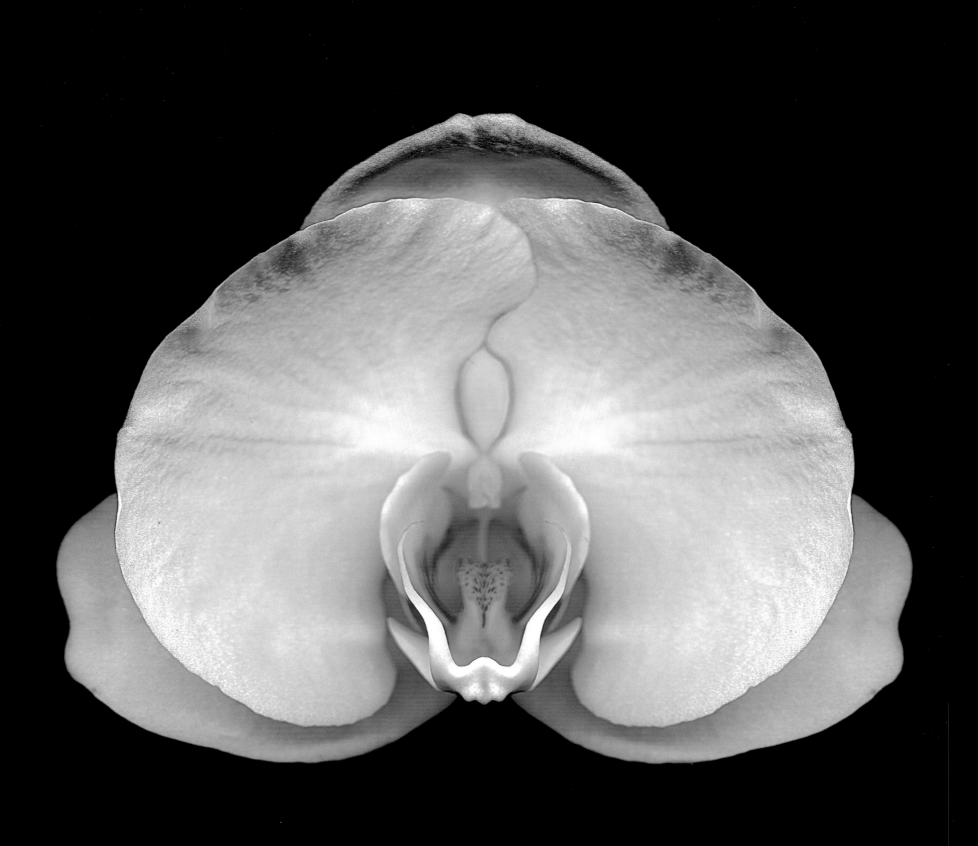

ORCHIDELIRIUM

HAROLD FEINSTEIN

INTRODUCTION BY ROBERT H. HESSE

Bulfinch Press

NEW YORK · BOSTON · LONDON

To the most flamboyant orchids I know—the sisters Ruth,
Beth, and Judith, and their illustrious father, Lamont

FRONTISPIECE: PHALAENOPSIS HYBRID

BULFINCH PRESS
Hachette Book Group USA
1271 Avenue of the Americas, New York, NY 10020
Visit our Web site at www.bulfinchpress.com

First Edition: February 2007

Library of Congress Cataloging-in-Publication Data
Orchidelirium / Harold Feinstein ; introduction by
Robert H. Hesse.
 p. cm.
ISBN—10: 0-8212-6205-X (hardcover)
ISBN—13: 978-0-8212-6205-4 (hardcover)
1. Orchids—Pictorial works. 2. Orchids. 3. Photography of
plants. I. Title.

QK495.O64F35 2006
584'.4—dc22

2006004119

Book and jacket design by Lance Hidy

PRINTED IN SPAIN

FOREWORD

Harold Feinstein

I **HARDLY** know how to refer to these wonders called orchids.

Are they creatures? They do eat insects.

Are they flowers? They adorn celebrations in life, such as weddings and graduations.

They all beckon you to come closer to see their beauty. Some have a majesty with which they soar.

Colors, both blatant and subtle, form an array that leaves one in awe, as though they were choreographed dancers or inspired examples of calligraphy.

In completing this book, part of me wishes I could begin anew.

What follows is a pathway of my journey among these wonders.

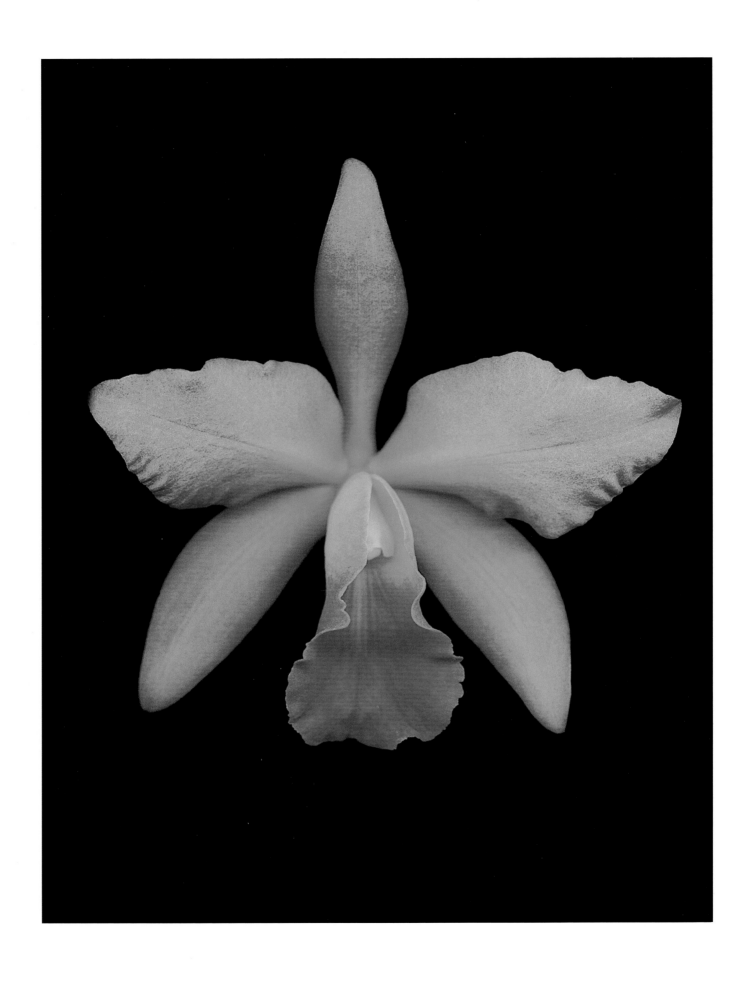

SOPHROLAELIOCATTLEYA HYBRID

INTRODUCTION

Robert H. Hesse

THIS may be a dangerous book. Volumes of orchid illustrations have appeared since the lavish efforts of the mid-nineteenth century, but the renditions of orchid flowers have generally been objective, nearly clinical, with an emphasis on accurate identification and scientific precision. Imagine the poverty of a world in which images of the human form came only from anatomy texts. This book is not a catalog or botanical text; the images aren't meant to teach the mind but rather to capture the heart, and capture they do, for Harold Feinstein's photographs evoke the subjective magic, the wonder, passion, and lust engendered in the susceptible by these most captivating flowers.

Follow Feinstein's explorations of sinuous, richly draped curves as they seductively emerge from Caravaggio lighting. Be dazzled by exotic blooms glowing and virtually illuminating the page. Experience an insect's intoxicating view into the mysterious depths revealed in Feinstein's close-ups. But be warned, after savoring the enchanting images you hold in this book, you too may succumb to an irresistible passion for the orchid!

The very name *orchid* echoes with passion, coming as it does from the Greek *orchis,* meaning "testis." No other flower has so inflamed the passions and exerted such a grasp on the lives of its devotees. In the West, interest in orchids was for centuries dominated by the seminal imagery of the gonadlike tubers possessed by many of the local genera. In Turkey, a highly regarded ice cream is still made from an extract of orchid tubers

termed *salep,* literally "fox testicle." Because of early medicine's "doctrine of signatures," orchid parts were extolled for centuries throughout Europe as remedies for maladies involving deficiencies (or excesses!) of fertility, performance, or desire. Thus, the ardent hopes of courtiers presenting orchids to courtesans (or of young men giving them to prom dates) is well-rooted in history. At least two orchids appear in Ophelia's sodden garland, a curious bridging of past and present.

In the East, orchids are known from the earliest written and painted records in both China (where they are called *lan*) and in Japan (*ran*). The orchid is one of the "Five Gentlemen" that must be mastered by aspirants to the art of *sumi-e* painting. The image of *Neofinetia falcata* (see pages 74, 128), an orchid supposedly carried about by samurai warriors, eloquently illustrates the attraction a subject like this must have held for cultures in which painting and calligraphy are entwined.

Orchids remained contentedly in the medicine cabinets of the West and in the studios of Eastern artists and connoisseurs of refined sensibility until the nineteenth century, when the introduction into England of several spectacular tropical orchid species touched off a mania for orchids unmatched by that for any other plant. It is a mania that continues, unabated, to this day. The spark that ignited this blaze may have been the first flowering in 1818 of *Cattleya labiata*. By an astonishing gift of good fortune, this rare species, the spectacular ancestor of our present-day corsage orchids (see pages 79, 122 bottom), was salvaged and grown on by Mr. William Cattley from discarded bulbs included among the worthless vegetation used as packing material for a shipment of rather mundane tropical plants.

The blaze was fueled by the Victorian obsession with the exotic, the new, and the extravagant, and the vital breath of oxygen was provided by the development of rational and splendidly successful methods of orchid

culture by William Paxton, gardener to the Duke of Devonshire and designer of the famed Crystal Palace. (Prior to Paxton, English gentlemen—led astray by lurid tales and grotesque misrepresentations of the tropics—cultivated orchids under conditions more conducive to compost than to blossoms, and England was referred to as "the graveyard of tropical orchids.") Following Paxton, there was no looking back. The introduction of one astonishing flower after another (a notable example being the inconceivably exotic "butterfly orchid," *Oncidium papillio,* in 1833; see page 35) added to the conflagration. Excess was the mode of the day. A prince of commerce or of the realm could travel by private railway car, have it shunted off into the establishment of Frederick Sander (the "Orchid King") in St. Albans, and alight among the wonders in the main orchid display house without ever setting foot on common soil.

Orchids changed hands for tens, hundreds, even thousands of pounds. More than the salary of a manservant, more than works of art, fine furniture, or country houses. Hundreds of collectors were dispatched by large orchid firms to seek plants in some of the least hospitable areas of the globe. Goaded by a sense of adventure and a passion for these magnificent vegetables (and perhaps a lust for exotic garb), these deranged and fearless men braved hostile tribesmen, disease, revolution, natural disasters, and the chicanery of their fellow collectors. No band of brothers these: deception, threats, and the occasional invitation to weapons characterized the encounters of these solitary competitors for the same prize. Some died or were killed abroad, some simply disappeared. A few survived remarkable challenges—earthquake, revolution, shipwreck, fire, and headhunters, among other perils—returning to the jungles and mountains again and again in quest of these enthralling plants. The record of their ordeals is sparse, and while there is a statue in Prague commemorating the collector

Benedict Roezl, most of these dedicated disciples of the orchid have been commemorated, if at all, solely in the names of species they discovered.

Until the late twentieth century, the great difficulty in propagating orchids perpetuated outrageous prices for the plants (fine forms of natural species and new hybrids in particular). The discovery of a reliable method for germinating orchid seed by Lewis Knudson in the 1920s, and the mass multiplication of exact copies of many fine orchids through tissue culture pioneered by Georges Morel in the 1960s, have radically changed this. Many orchids, even fine forms and new hybrids, are now accessible to the ordinary gardener. Orchids that years ago would have commanded the price of a small car can now be had at the local supermarket, and today orchids are the second-largest-selling category of houseplant. Yet, in sharp contrast to the normal devaluation of aesthetic objects upon proliferation, orchids have not (nor will they ever) become commonplace. Some of the orchids depicted in this book came from supermarkets, others are rare, prized blooms inveigled from connoisseurs. I challenge you to puzzle out which is which, to decide which is more beautiful, more dramatic, or more enticing. Orchids are, indeed, like a drug: availability merely fans desire.

The mad quest for orchids continues. One of my fellow orchid-judging students was rendered quadriplegic in a fall suffered while attempting to collect "ordinary" orchids in South America. A Harvard botanist recently had to choose between facing hundreds of venomous, stinging bees and a plunge into a river liberally stocked with piranha. A noted taxonomist nearly succumbed to altitude sickness in Peru. A number of the more spectacular, newly discovered orchid species were collected questionably in spite of sanctions up to (and including) the death penalty. A grand jury indictment was brought against an orchidist involved with the collection, description, and naming of a stunning new slipper orchid.

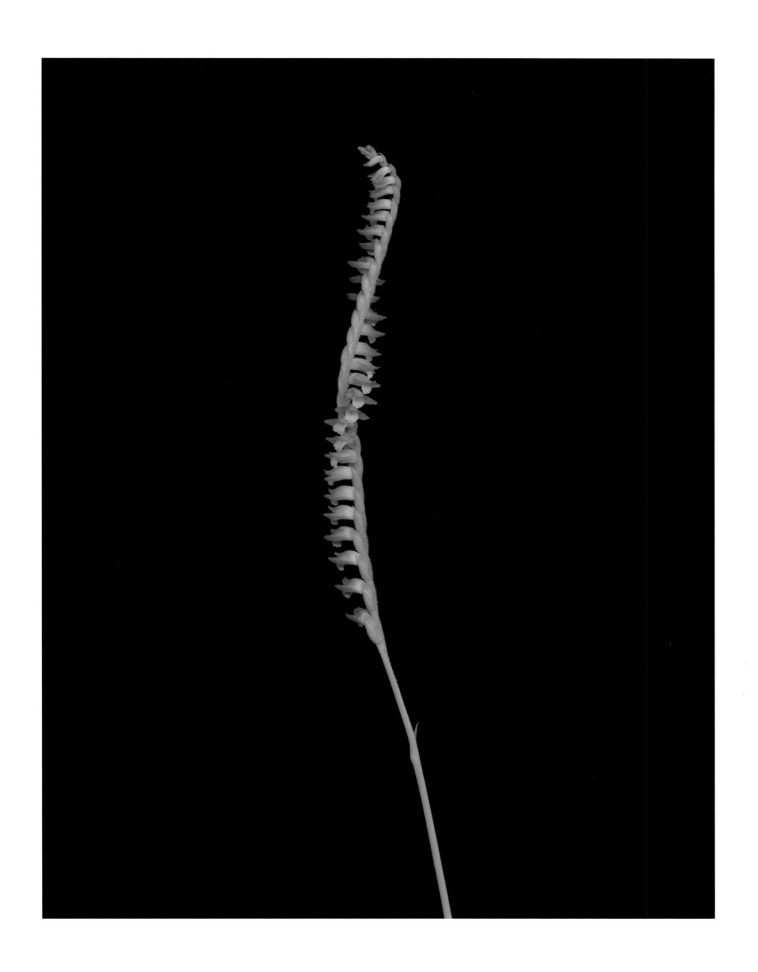

The objects of these passionate quests are members of the family Orchidacea, generally considered the largest family of flowering plants. There are more than thirty thousand known species of orchid and an even greater number of man-made hybrids. Recent studies of orchid DNA have led Dr. Ken Cameron of the New York Botanical Garden to suggest that orchids, for all their exotic appeal, are most closely related to asparagus and are cousins to onions and garlic! Belying this humble lineage, the couplings of these regal vegetables have been recorded with as much diligence as might be found in Debrett's Peerage. The lineage and naming of orchid hybrids have been recorded in *Sander's List of Orchid Hybrids* (first published by Frederick Sander and then by the Royal Horticultural Society) since the flowering in 1856 of the first man-made hybrid, *Calanthe dominii,* an event greeted with the words, "Man, you will drive the botanists mad!"

Fascinating as all this may be to a specialist, it does little to reveal what it is that has blinded men to reason and self-preservation and fostered nearly inconceivable excesses in the quest for these flowers. Sheer numbers provide little justification for "orchidelirium." The family Compositae (asters, daisies, and sunflowers) encompasses essentially as many species, yet who has heard of the "aster thief" or "daisy mania"? We require a different guide. Take a moment to savor the endpapers of this book. Explore the extraordinary forms—some beautiful, others bizarre, but all complex, exotic. Imagine hundreds of these pages, no two alike. You will have a hint of the astonishing diversity of orchids that have evolved to produce the most varied, extravagant, complex, ornate, lurid, and beguiling floral displays to be found in the plant kingdom.

Add to this that orchids can be induced to make strange matches. Differing species, even differing genera of orchids can be mated, producing offspring with dozens of species and, on occasion, five or more genera

as ancestors. Such pairings sometimes lead to remarkable new flower forms, the orchidaceous equivalents of griffins, centaurs, cockatrices, and perhaps unicorns. (See pages 39, 101, 125.) Turn the pages of this book, which, like Roger Vadim's depictions of Brigitte Bardot, unabashedly celebrates and shares the seductive details, the play of light upon voluptuous forms and lush, complex colors, all rendered with the eye of a generous lover, and you will begin to appreciate the allure and passionate attraction exerted by orchids.

While the evolutionary divergence of orchids as a family appears to have occurred much earlier than previously thought, perhaps as early as the appearance of the first palms, according to Dr. Cameron's DNA analysis, the exotic and captivating diversity portrayed in these pages seems to have occurred much more recently, following the abandonment of terra firma and the ascent of orchids into the trees. We have now come nearly full circle in our search for the source of the lure of orchids, as there is no doubt that the force behind the diversity and extravagance of form orchids display is sex. Orchids exhibit a predilection for sexual reproduction that seems extreme even by the standards of modern advertising or daytime television, a predilection vastly complicated by the unique nature of these flowers and their mode of reproduction, which imposes severe constraints upon their mating.

First, orchids, alone among flowering plants, produce seed that is no more than a naked embryo. While these minute successors are buoyant and wonderfully suited to vast dispersal, the absence of stored nutrients to sustain growth and development demands that the germinating orchid seed must, like Romulus and Remus, either experience a nurturing encounter with an alien but beneficent species or perish of starvation. In the case of the orchid, this nurture is provided by association with a fungus that

digests plant material, producing simple sugars that can be assimilated by the developing orchid infant. As fungi are among the greatest enemies of other plants, such nurturing encounters are scarcely more common than the suckling of human infants by wolves. Therefore, the reproduction and survival of orchids depend on the production of many thousands, even millions, of these tiny, fragile hostages. Because each seed (a fertilized ovum) requires an individual grain of pollen, the pollen, in turn, becomes much too precious to entrust to capricious breezes or the sort of casual encounters with insects that suffice for ordinary plants. To survive, orchids must ensure the efficient transport of large packets of pollen, intact, to a distant mate.

Such transport is facilitated structurally by the fusion of the male and female sexual parts, the stamen and pistil(s), which are distinct and separate in other flowering plants, into a single organ, the column, which is unique to and a defining characteristic of orchids. It is further assisted by the aggregation of orchid pollen itself into well-bundled packets termed pollinia. These structural elements, combined with bilateral symmetry, add to the beguiling (and occasionally the erotic) aspects of orchid flowers, suggesting faces, noses, the necks of swans, or other creatures (see pages 23, 24, 25, 40, 46). But it has been the need to attract and provide vehicles for transporting the pollinia that has driven orchid flowers to produce the astonishing structures that madden their admirers.

Orchids employ the same strategies, scents, and displays typically invested by animals in mating to the attraction, enticement, and (sometimes literally) seduction of pollinators. The fact that orchids expend these resources to entice and preempt the activity of individuals from another kingdom imbues these encounters with profound elements of subterfuge and deception. Orchid flowers have been shaped to attract, trap, buffet, in-

toxicate, mislead, and otherwise bend other creatures to the orchid's bidding. A number of orchids resemble and are scented like female insects to entice males to attempt mating. Others counterfeit male insects and provoke territorial attacks from other males (see pages 35, 71). Some lure flies with the false promise of ripe carrion, using lurid color, mobile elements, and, often, fetid scents (see pages 27, 57). (Some of these masquerades are apparent to us, but others depend on the ability of an insect's eye to perceive UV light, invisible to humans.)

Some orchids lure pollinators into pits or labyrinths. Some pose as hapless victims inviting a predator's attack. A number of Old World orchids have coevolved with moths, the orchid possessing a long, spurlike nectary and the moth a correspondingly long proboscis that can barely reach the few drops of intoxicating nectar present at the bottom of the spur (see page 38). The moth and the orchid must correspond precisely in dimension—too long a spur and the moth cannot obtain nectar and will not visit the next flower, too short and the pollinia will not become attached to the moth. These few examples provide a mere taste. The extraordinary means by which orchids ensure sexual reproduction would fill books, and at least two have been written—one by Charles Darwin and the other by Dodson and Vander Pil.

Until recently I was of the opinion that the single theme running among these encounters was that the pollinator was always deceived, never receiving anything of true value from the orchid. I now question that assessment. There is a large group of exotically scented, stunningly complex orchid flowers that are extremely abusive to their pollinators: sending them down chutes, nearly drowning them, bombarding them with pollinia fired off as projectiles, literally knocking them from the flower. In spite of this savage abuse, the codependent male bees visit these flowers again and again, ap-

parently drawn on by scents that are intoxicating and irresistible. Evidence is accumulating that suggests these scented chemicals may actually be collected by the bees and employed as vital ingredients from which to concoct the pheromones necessary to attract mates. Here at last, after all the false advertising and deception, we may yet find a redeeming fulfillment of promised romantic bliss.

The most dramatic and tangible evidence that orchids can, indeed, bestow real and valuable rewards comes from my involvement with Harold Feinstein and this book. Harold has devoted his life to seeking beauty and perfecting the means to share it. He has seen many of the most spectacular products of nature, seen them with a lover's lingering eye, yet even he was galvanized by the orchids as he acquired new subjects for this book. "My God! Incredible! How beautiful! How wonderful!" And I, after years of seeking, studying, growing, lecturing on, and judging orchids, fell in love all over again. For all my study and passionate involvement I have never really experienced the magic of the orchid as captured in these pages. The images here are, perhaps, the ultimate distillation of the beauty and allure of the orchid, the irresistible attraction of these marvels.

ORCHIDELIRIUM

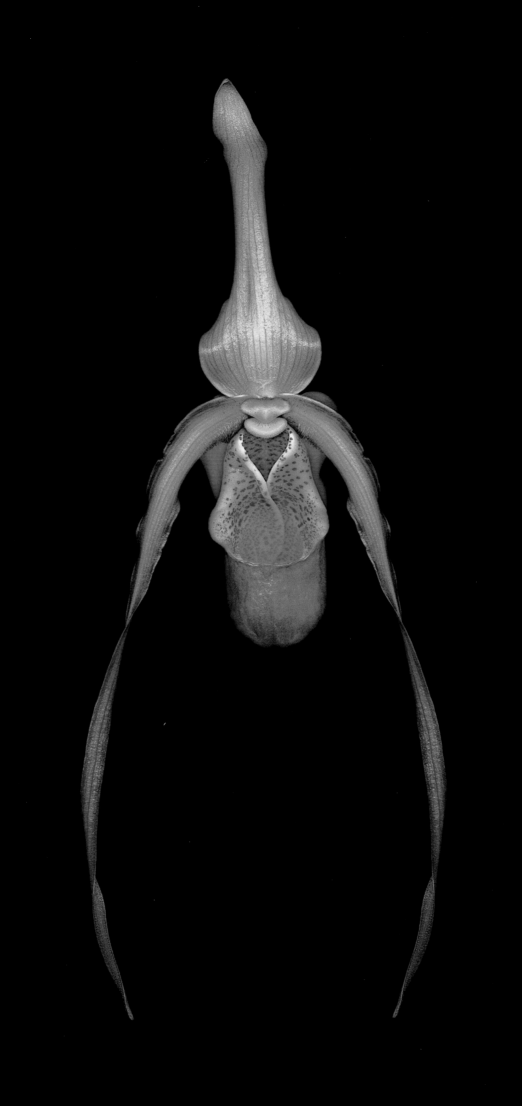

PHRAGMIPEDIUM HYBRID

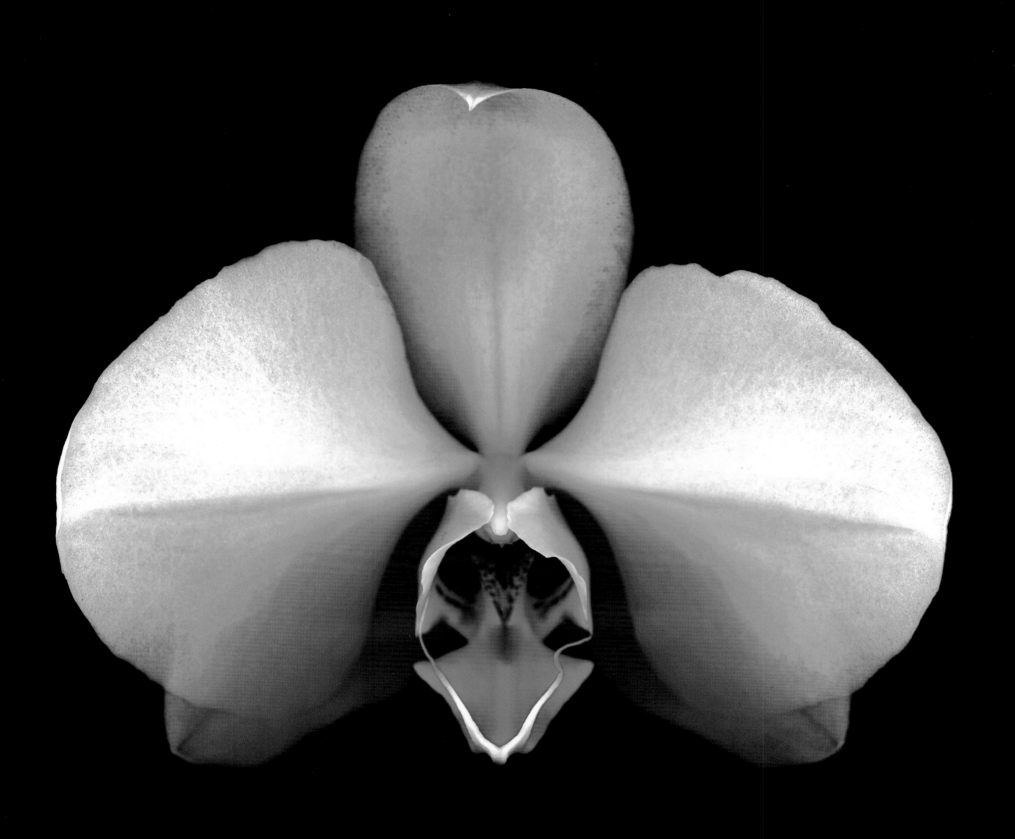

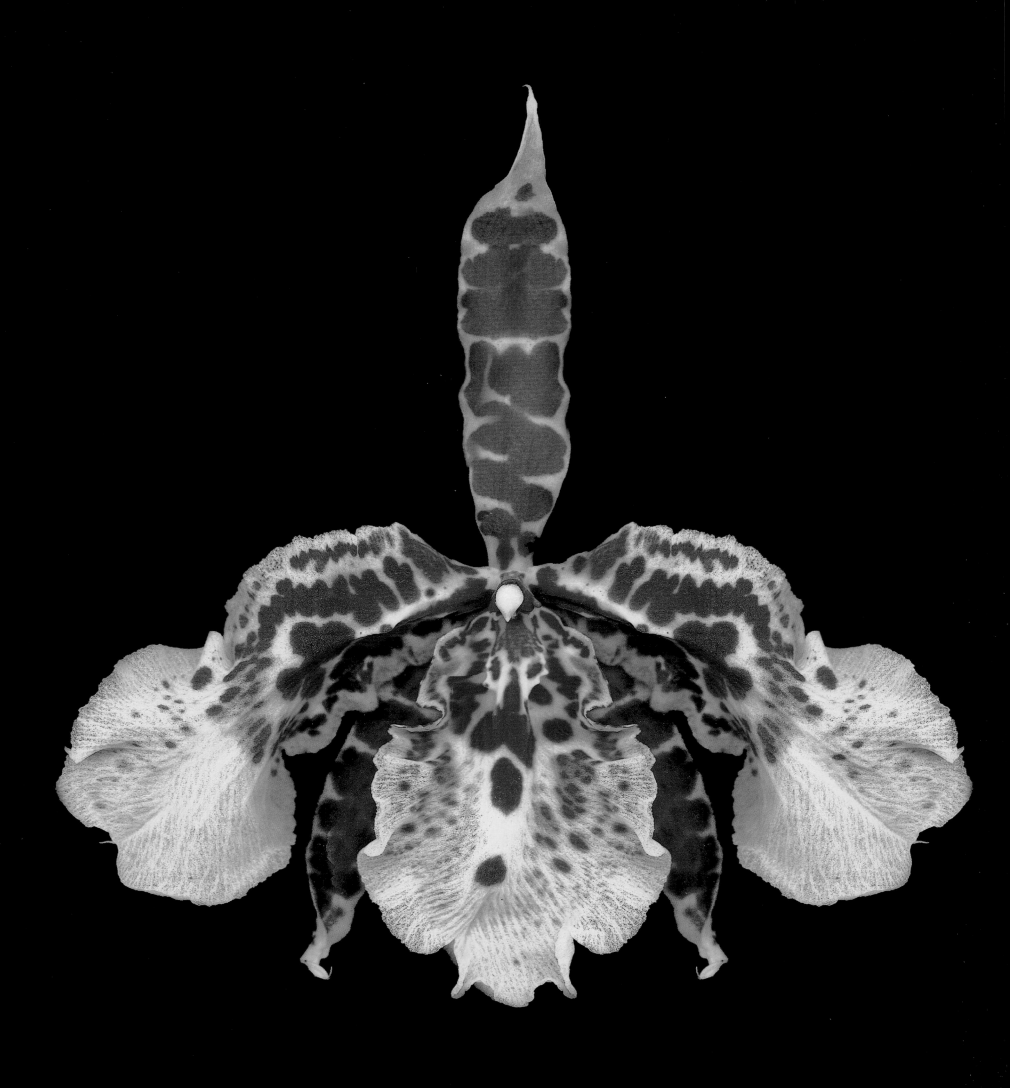

ROSSIOGLOSSUM (SYN. ODONTOGLOSSUM) HYBRID

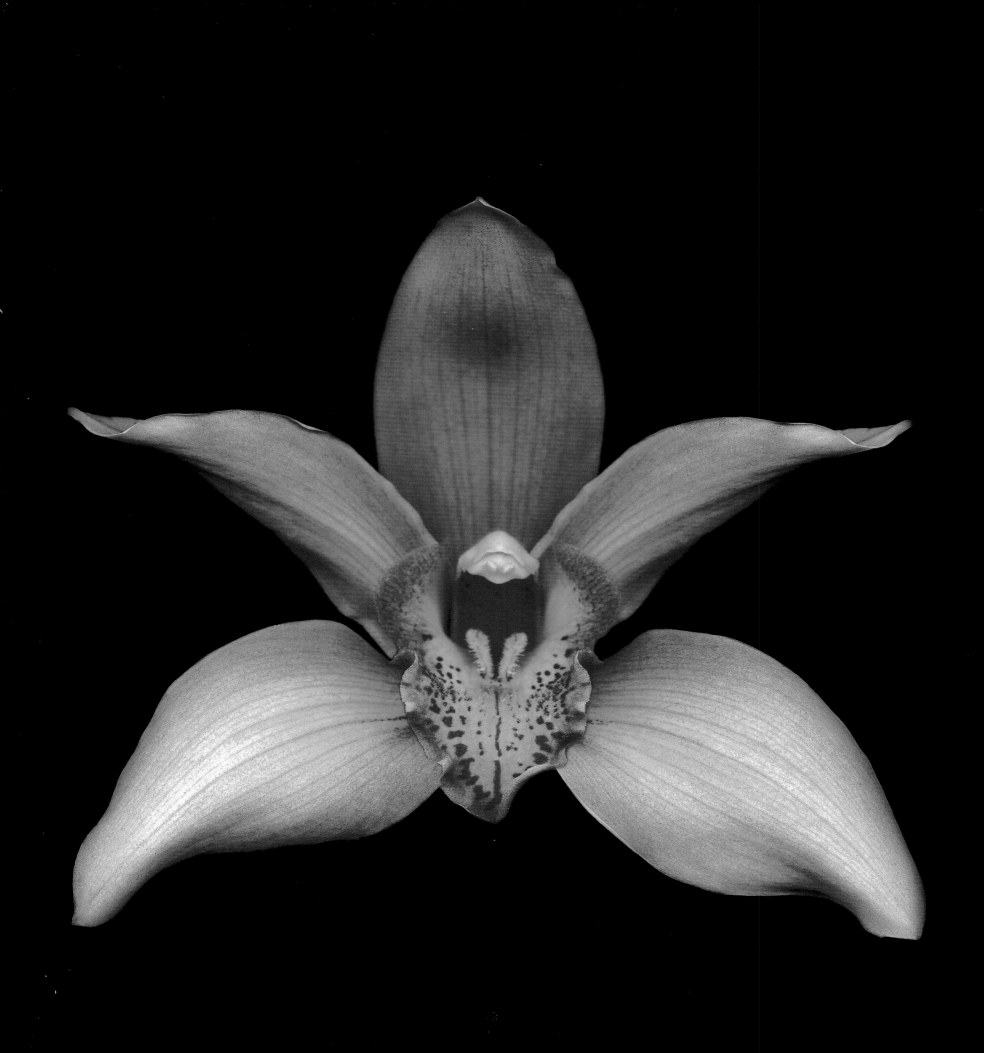

CYMBIDIUM HYBRID

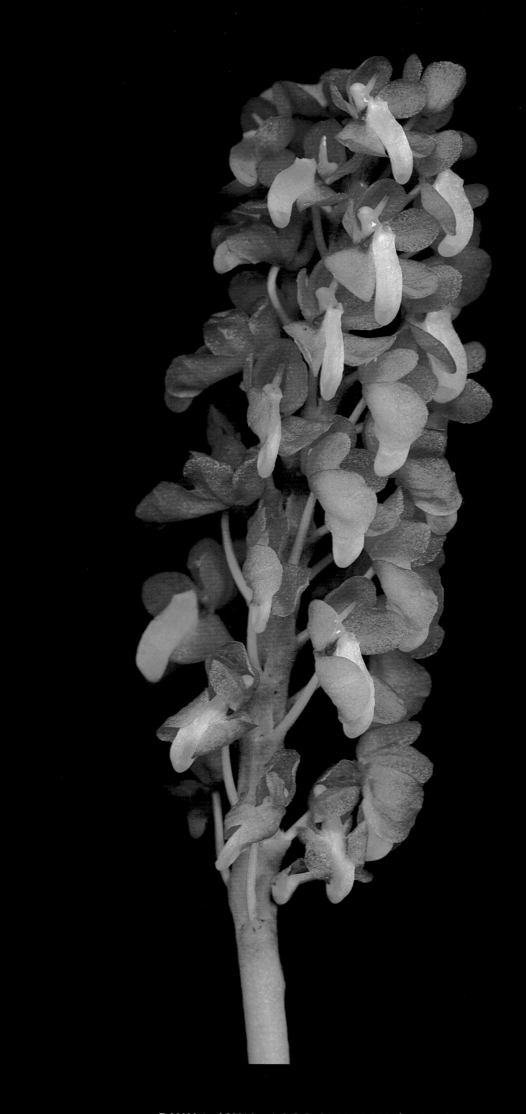

DYKIA (SYN. ASCOCENTRUM) SPECIES

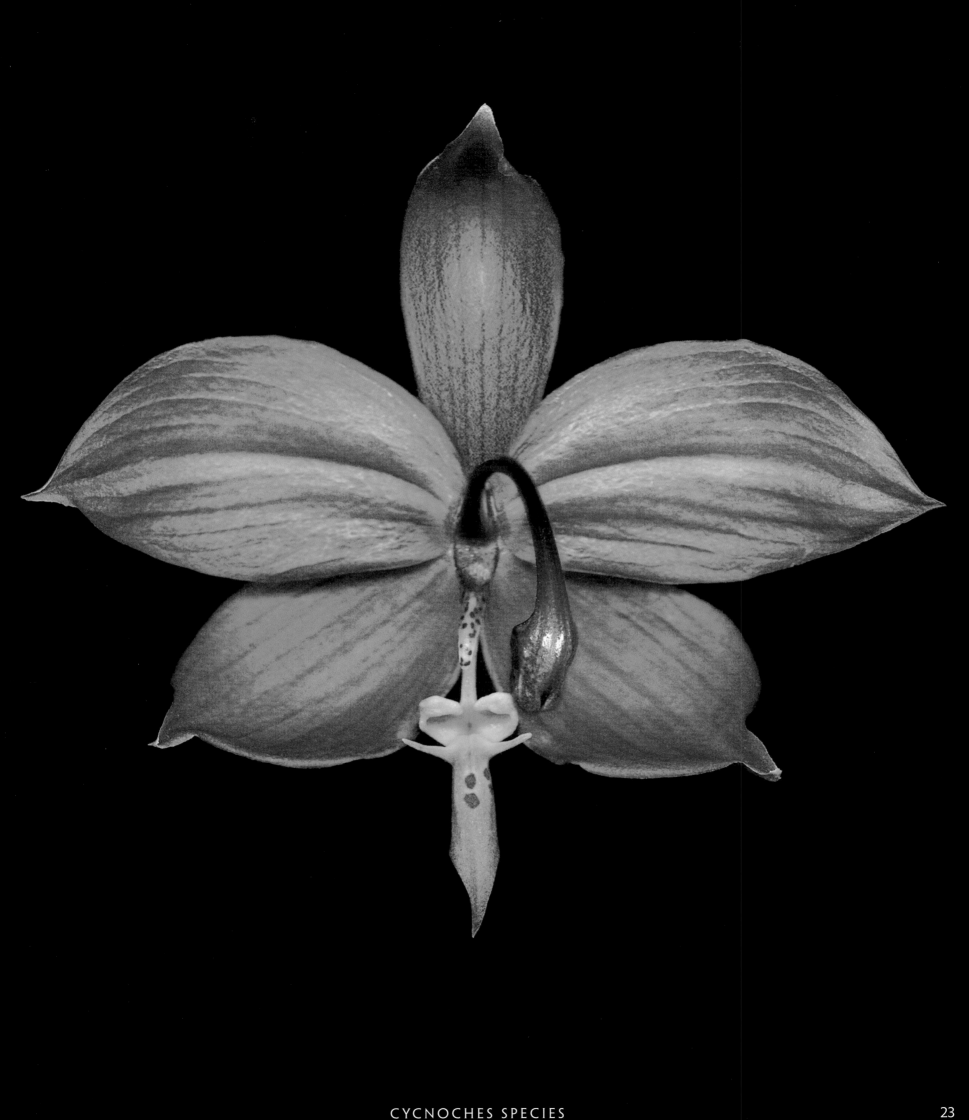

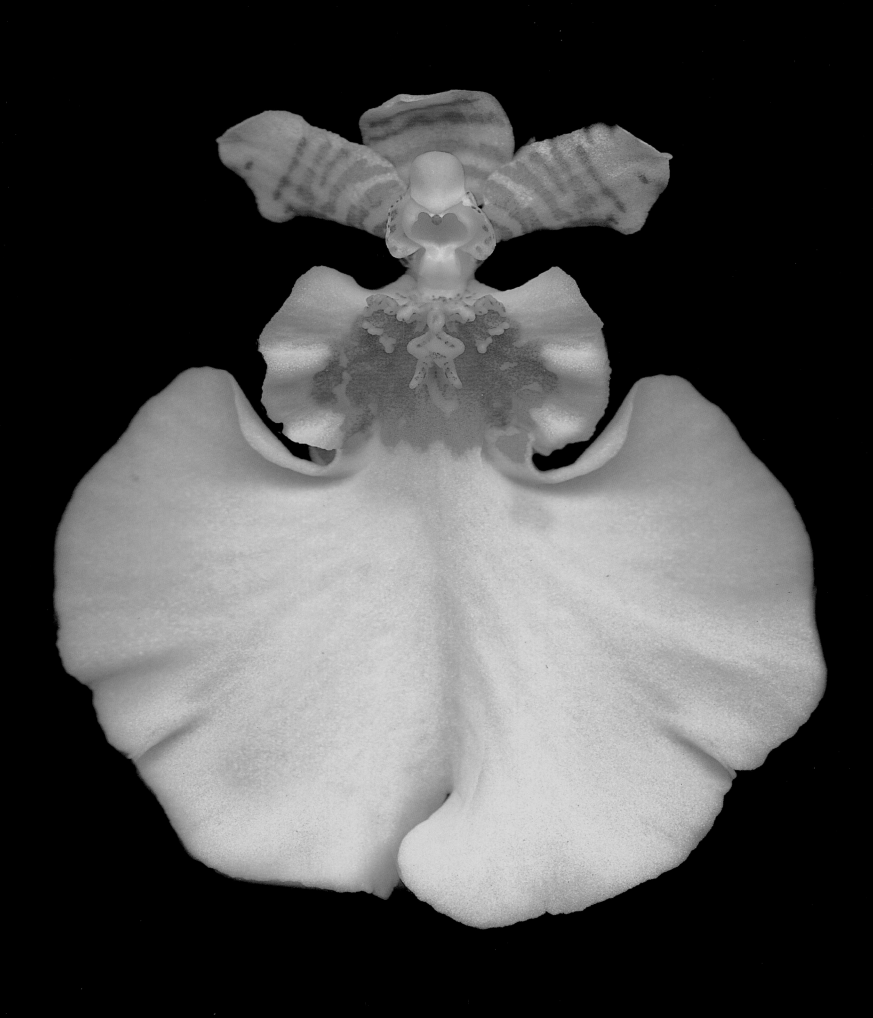

ONCIDIUM HYBRID

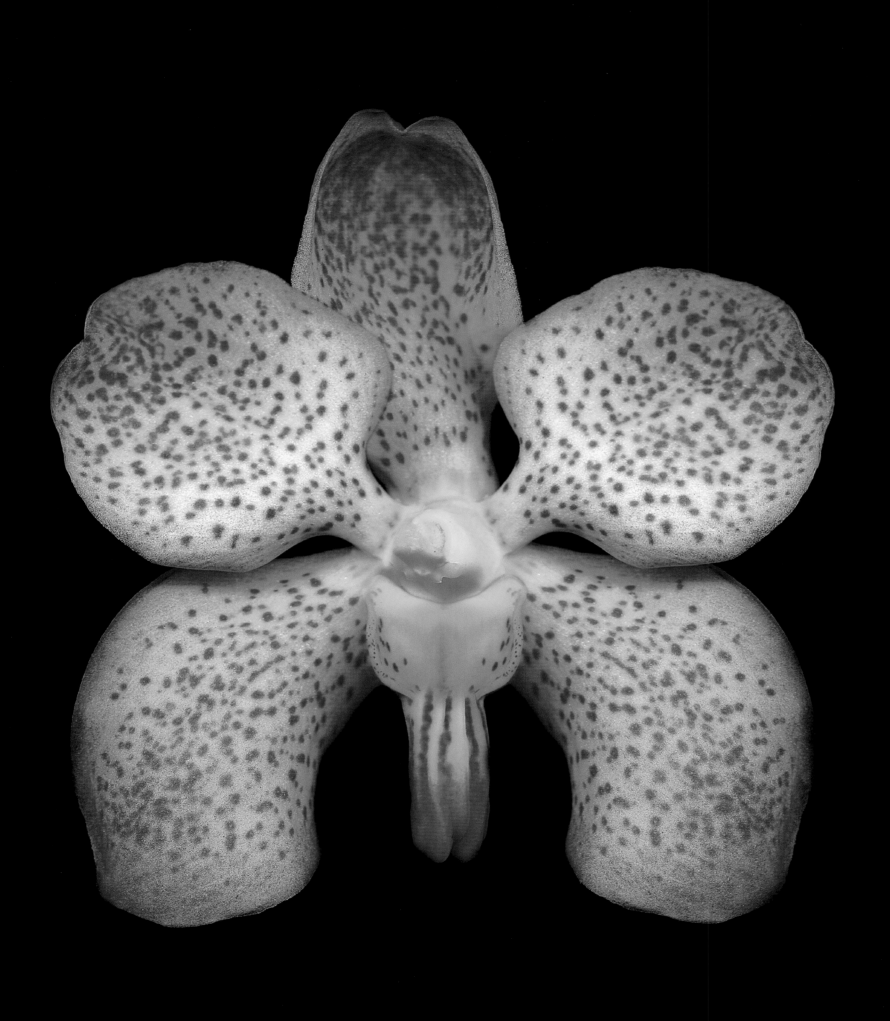

AERIDOVANDA HYBRID

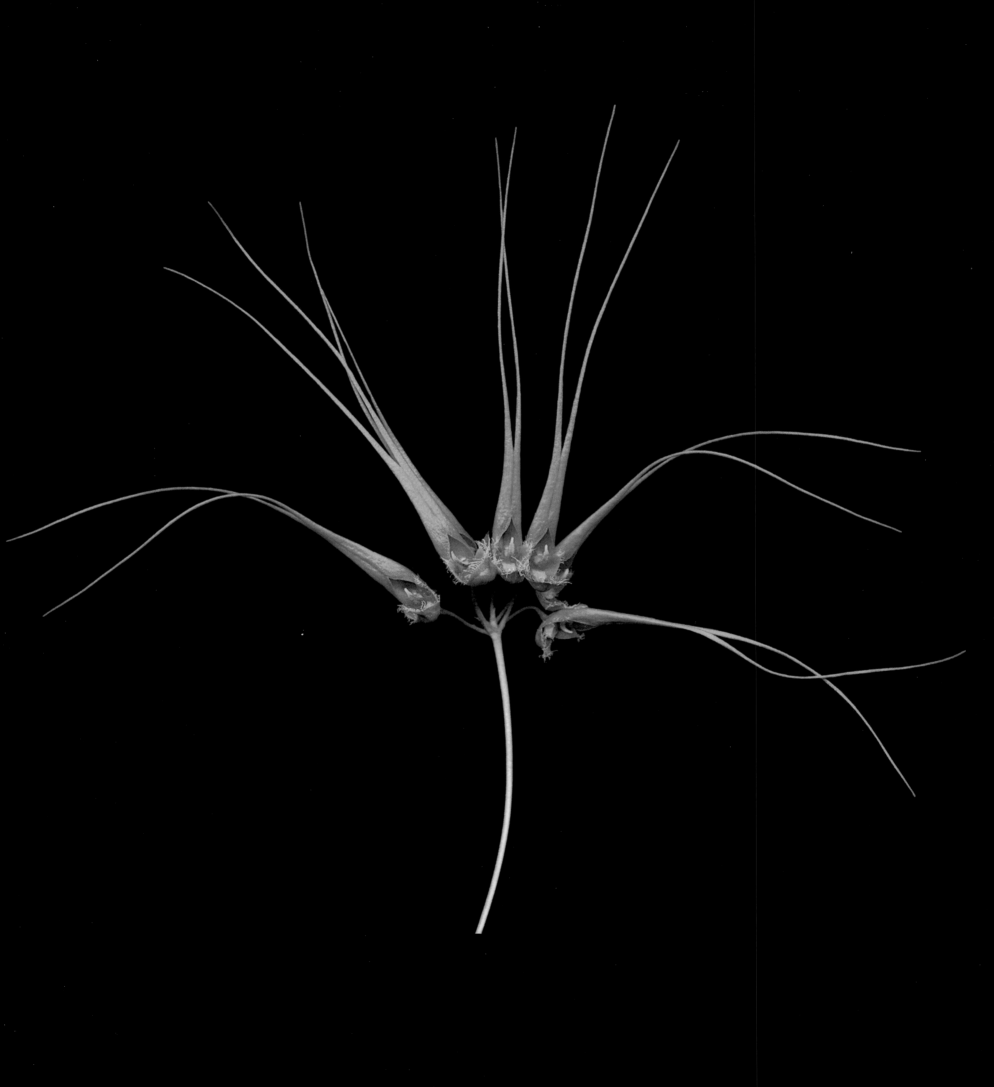

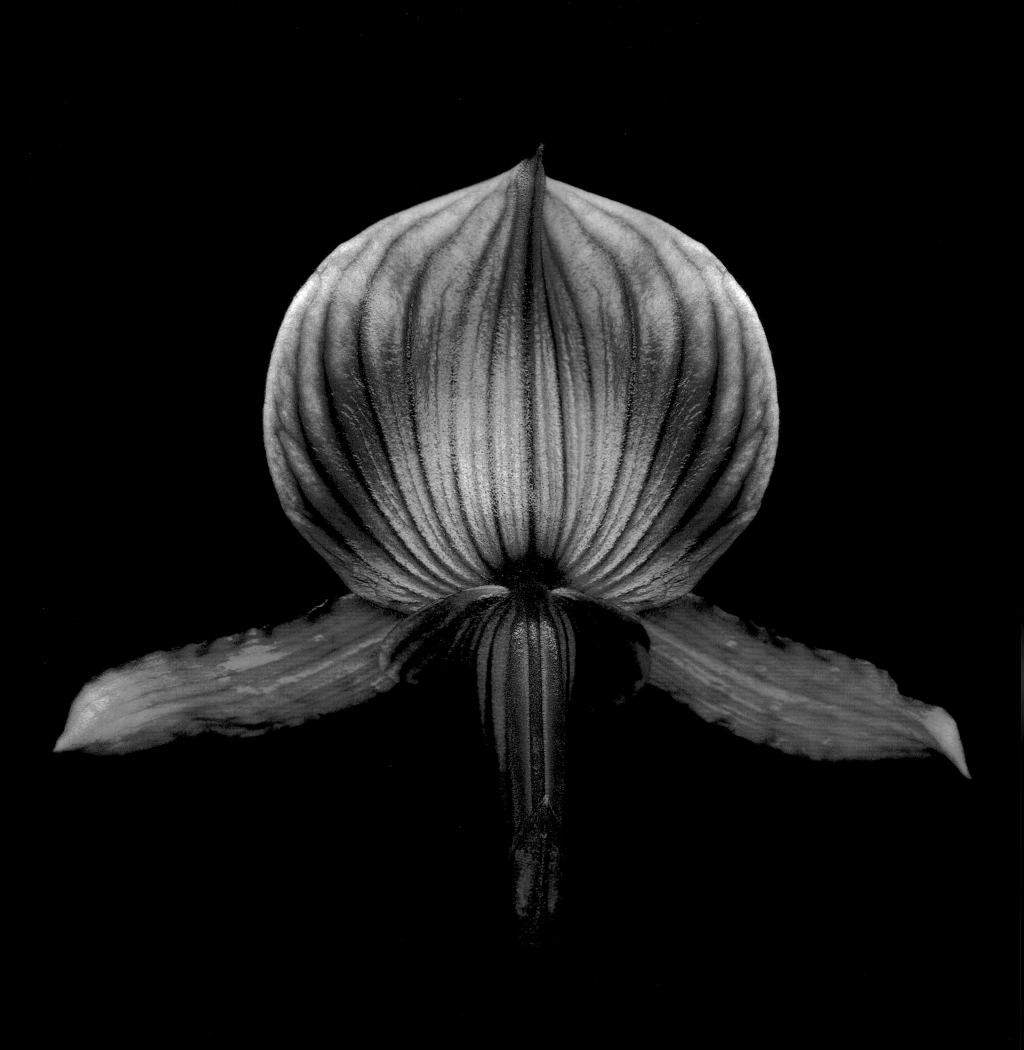

PAPHIOPEDILUM HYBRID

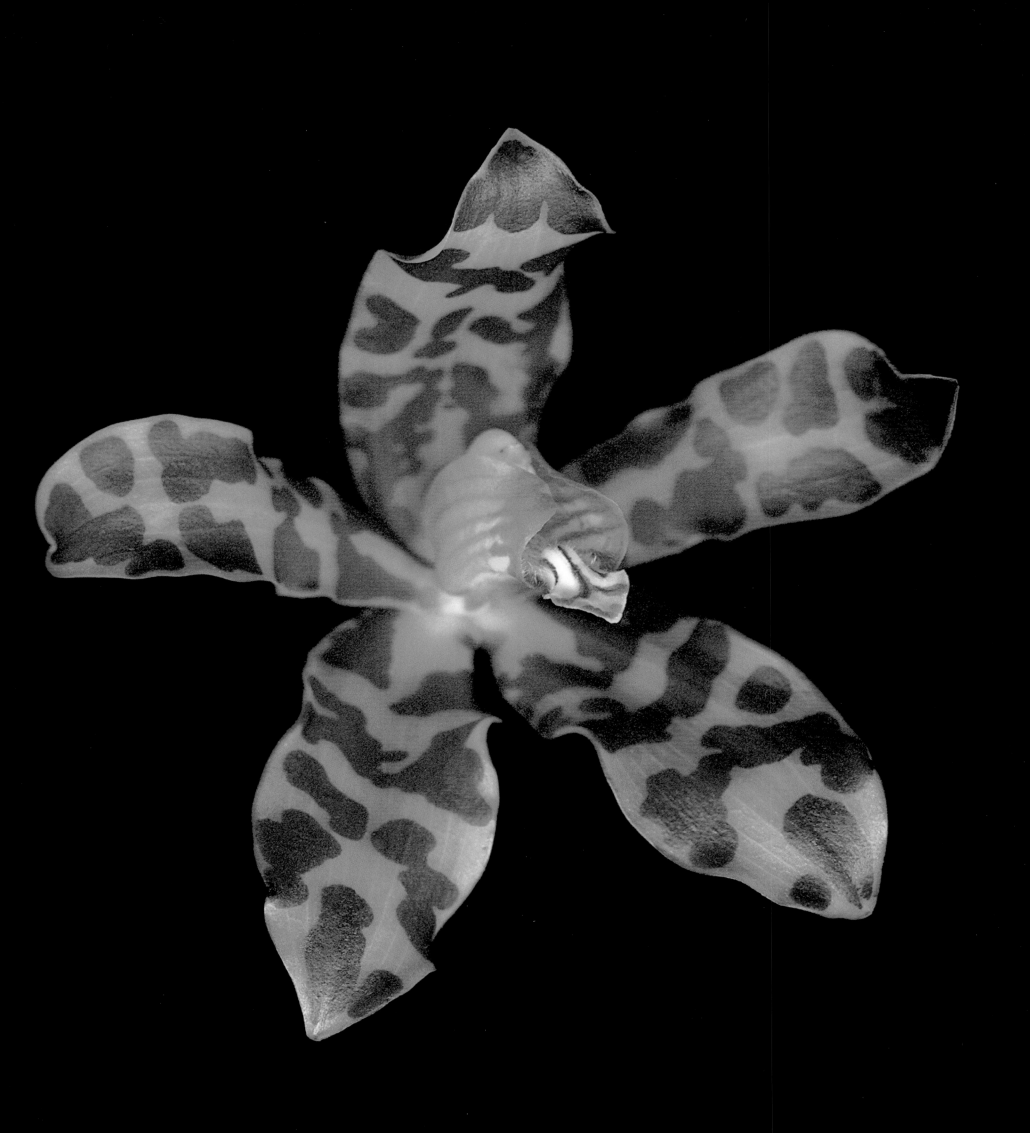

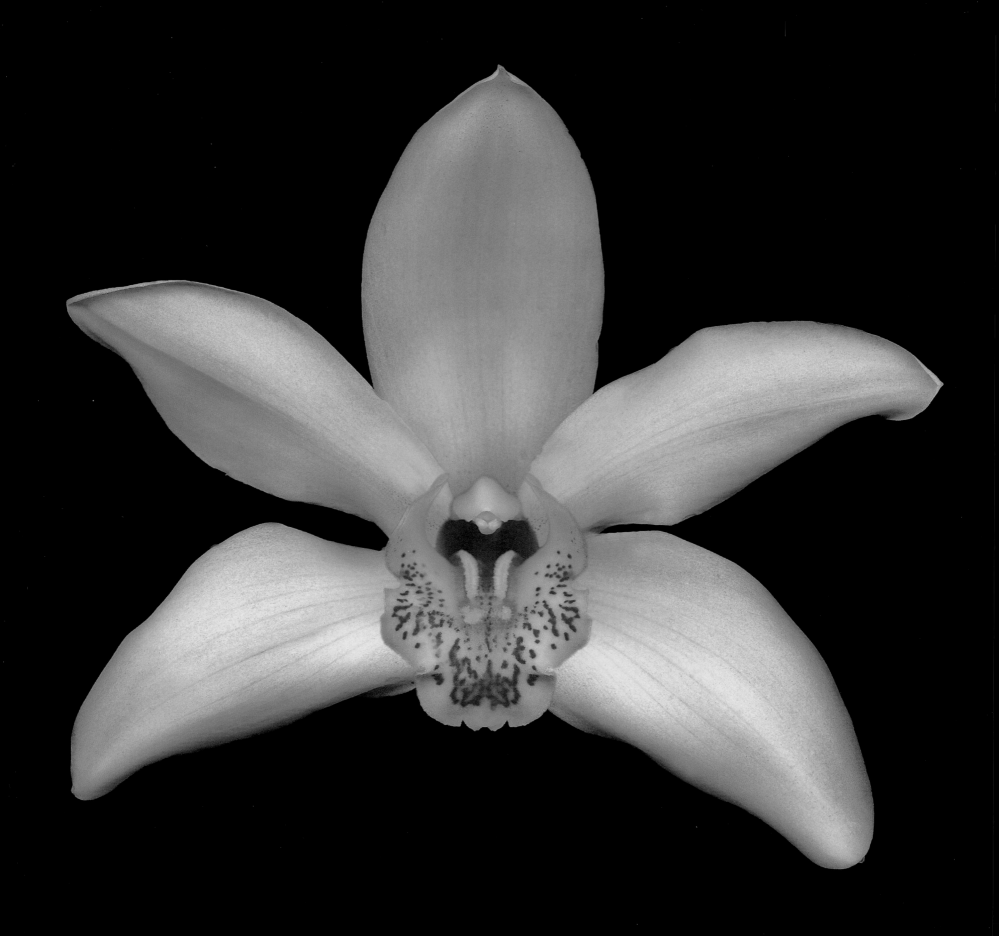

CYMBIDIUM HYBRID

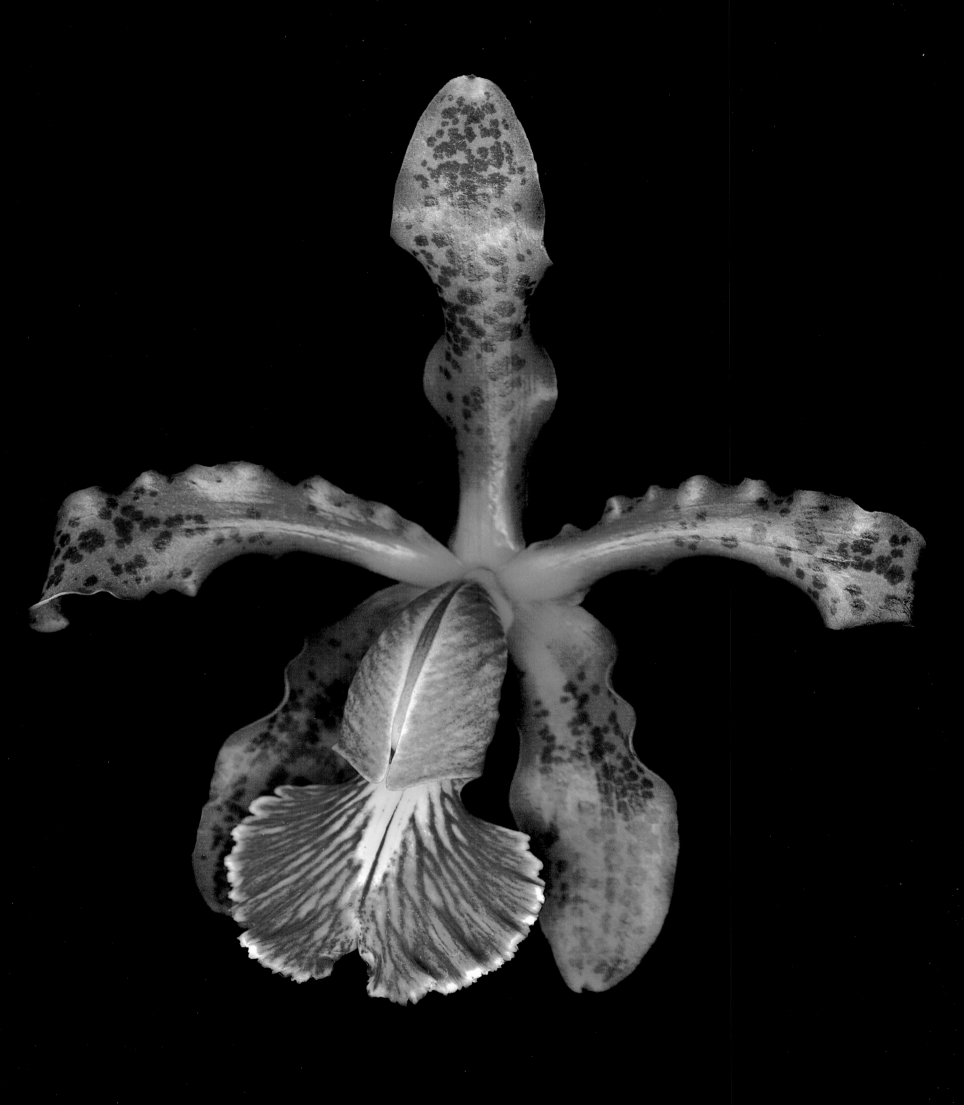

CATTLEYA HYBRID

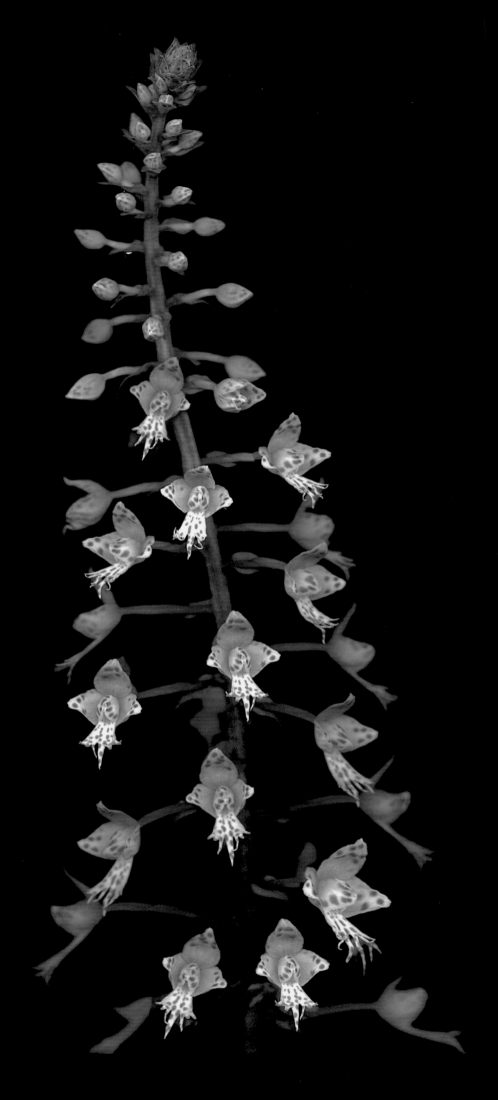

STENOGLOTTIS SPECIES

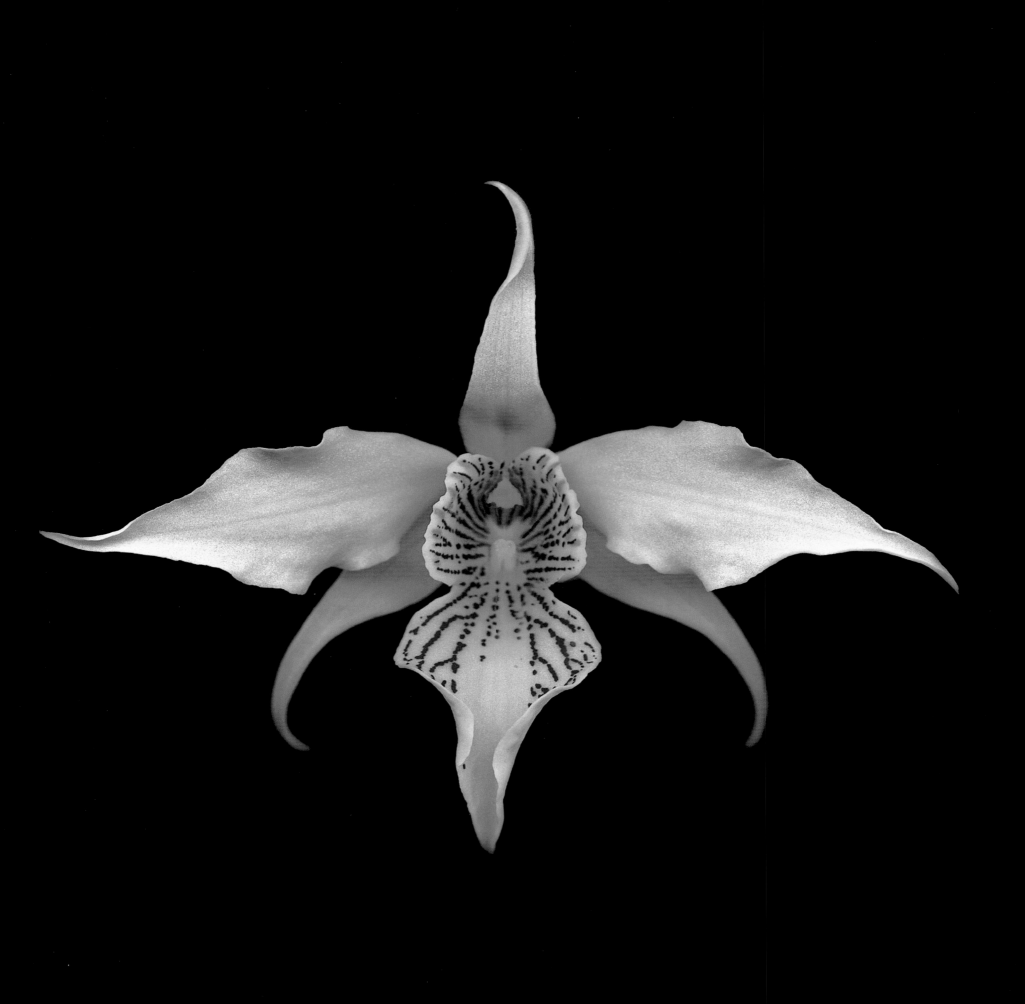

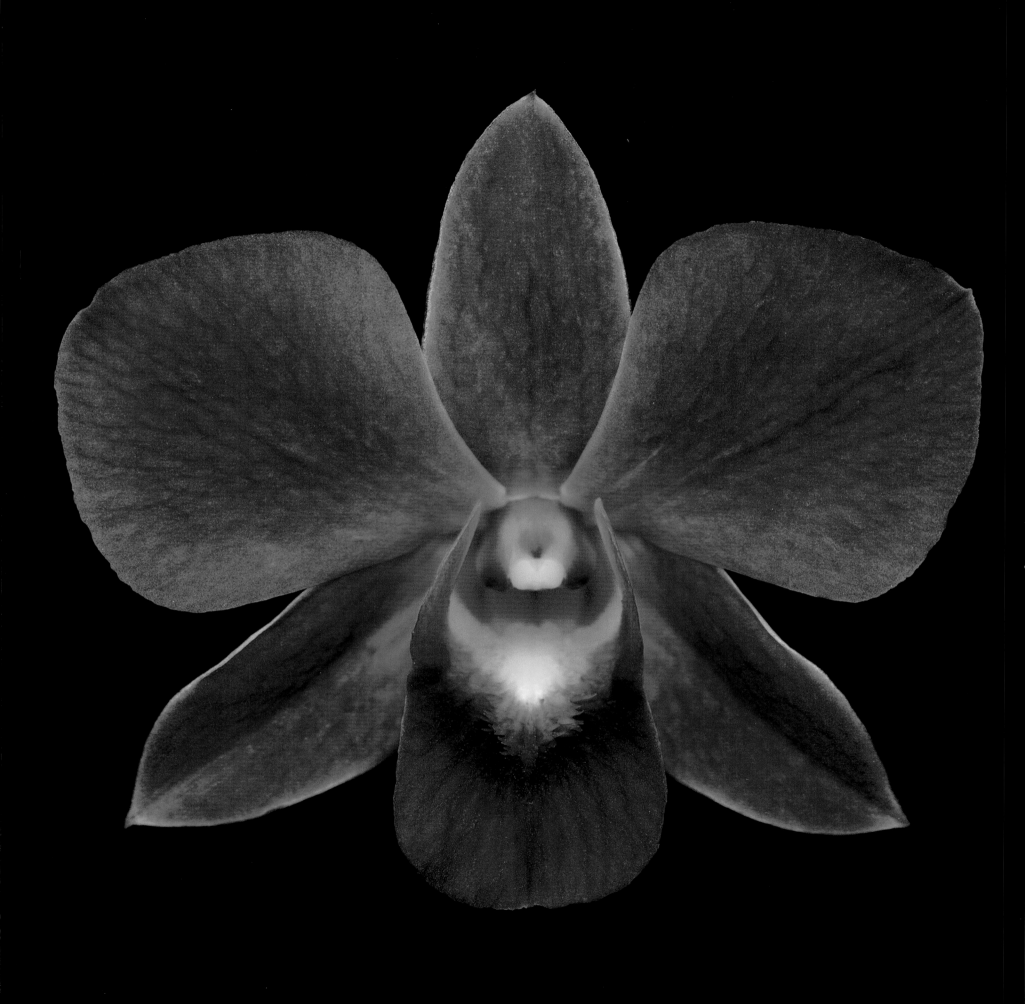

DENDROBIUM HYBRID

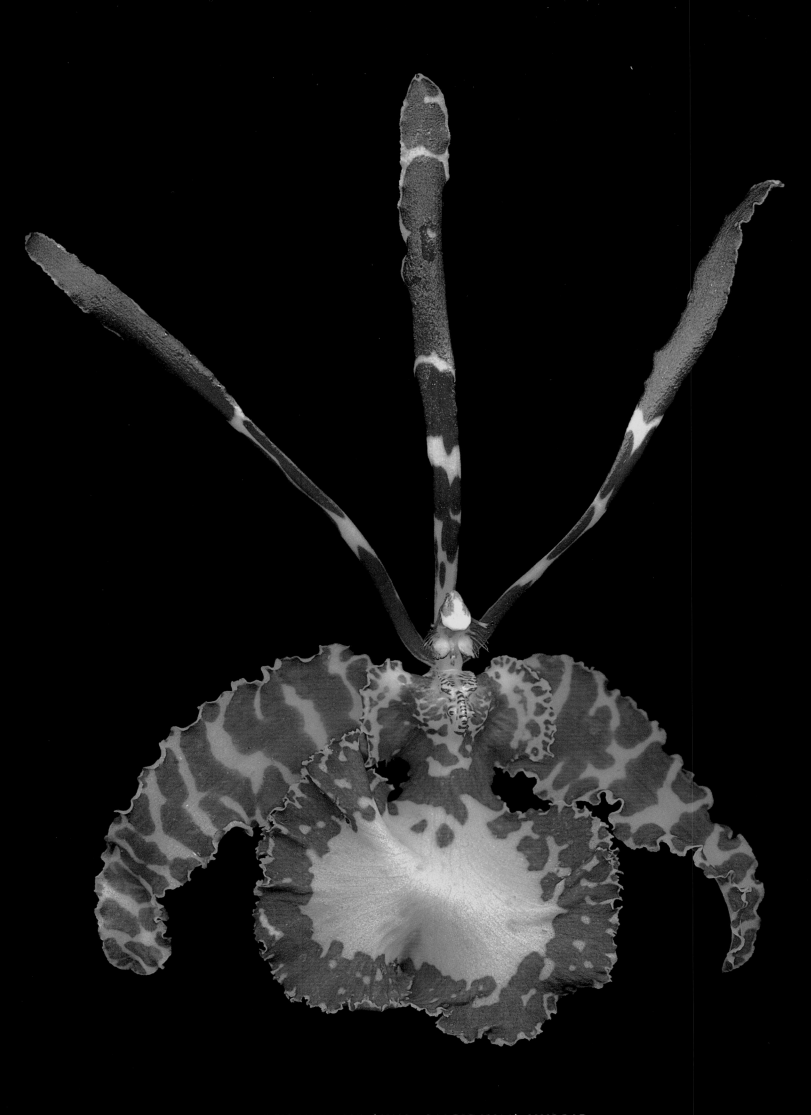

PSYCHOPSIS (SYN. ONCIDIUM) HYBRID

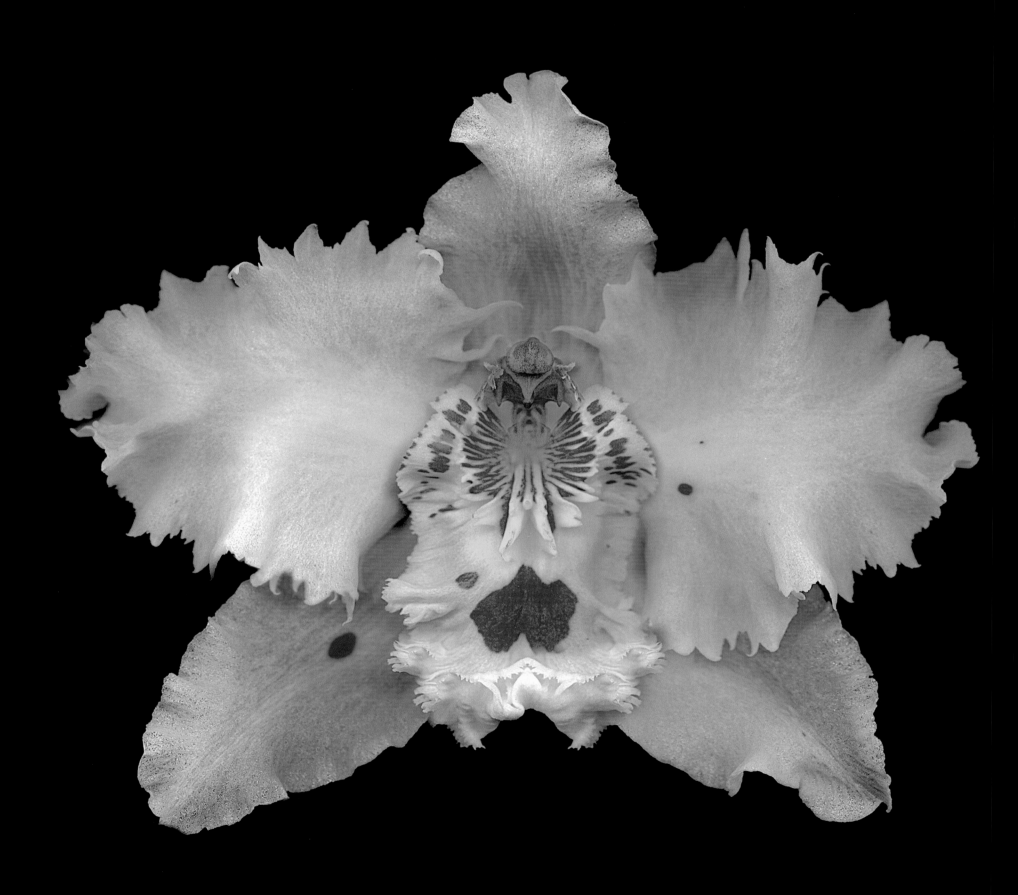

ODONTOGLOSSUM HYBRID

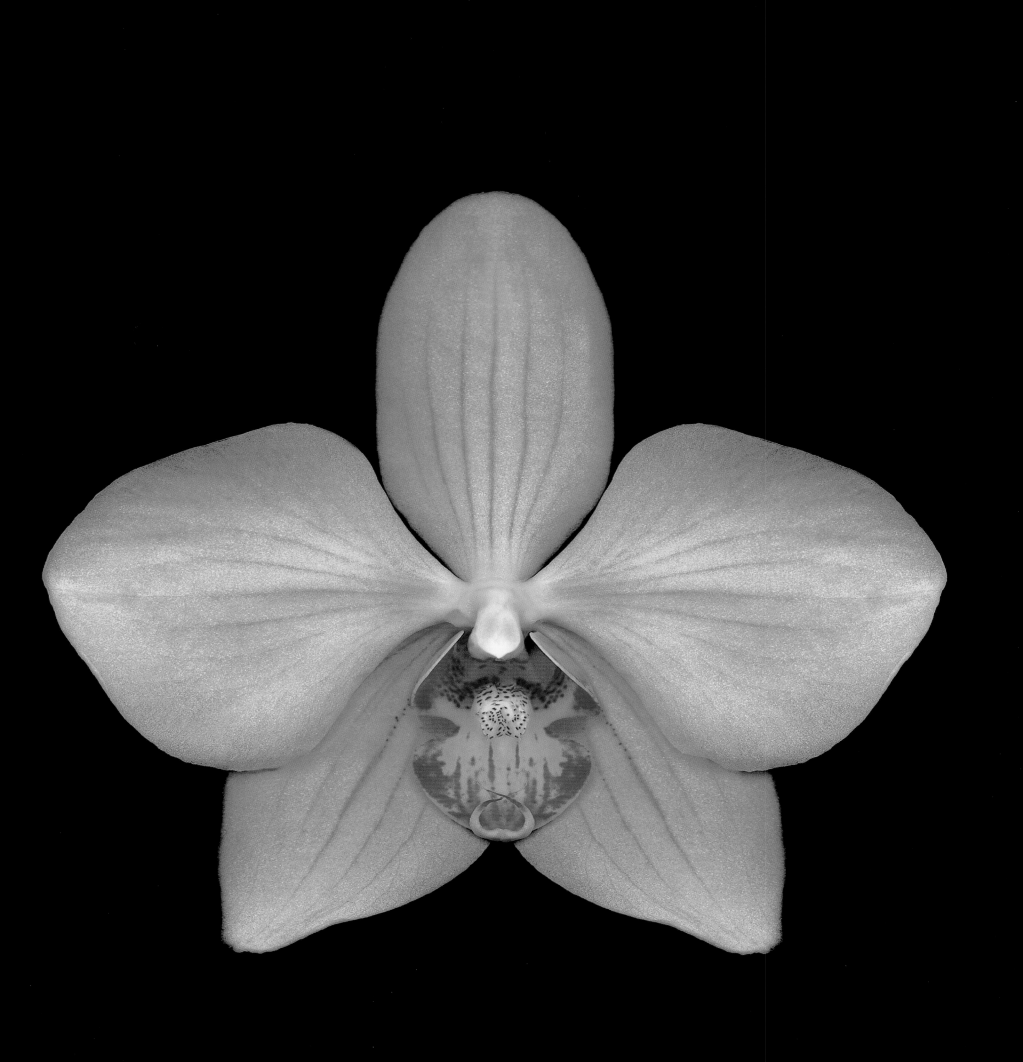

PHALAENOPSIS HYBRID

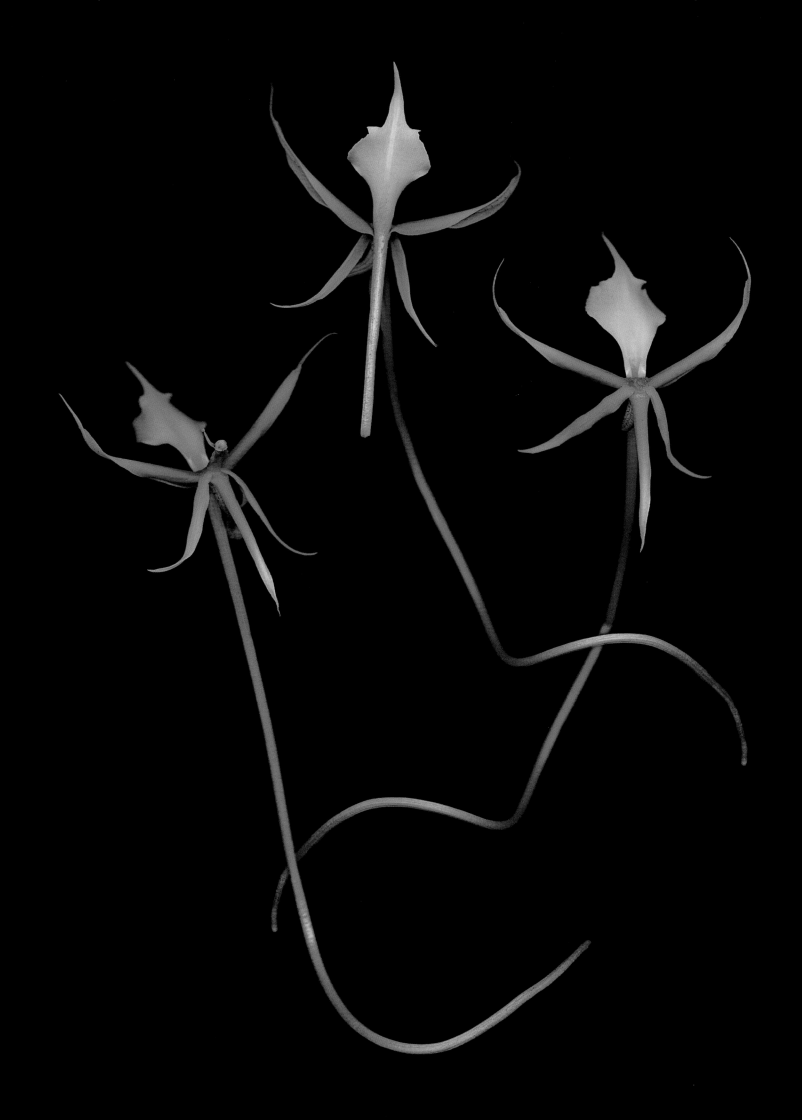

PLECTREMINTHUS SPECIES

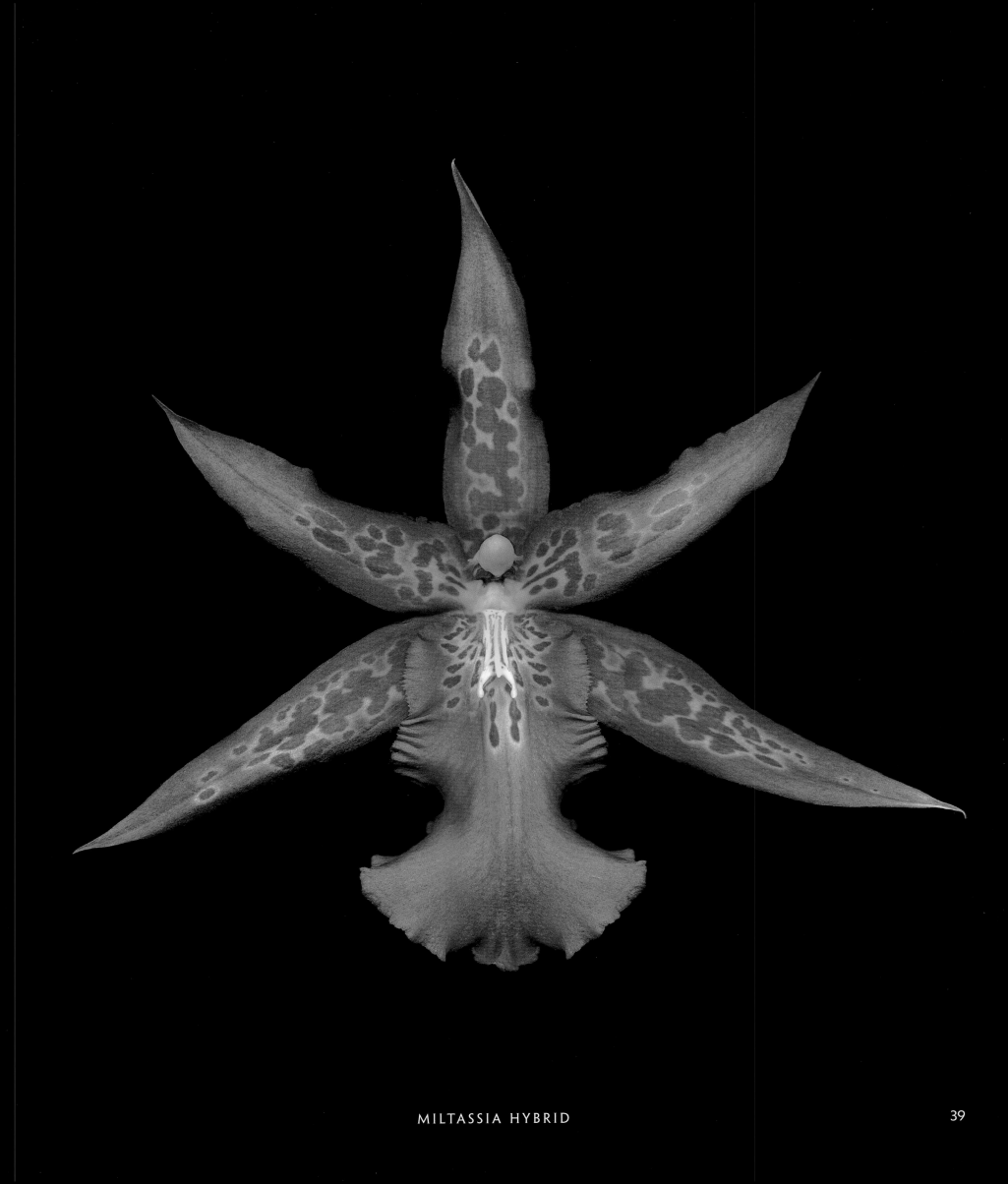

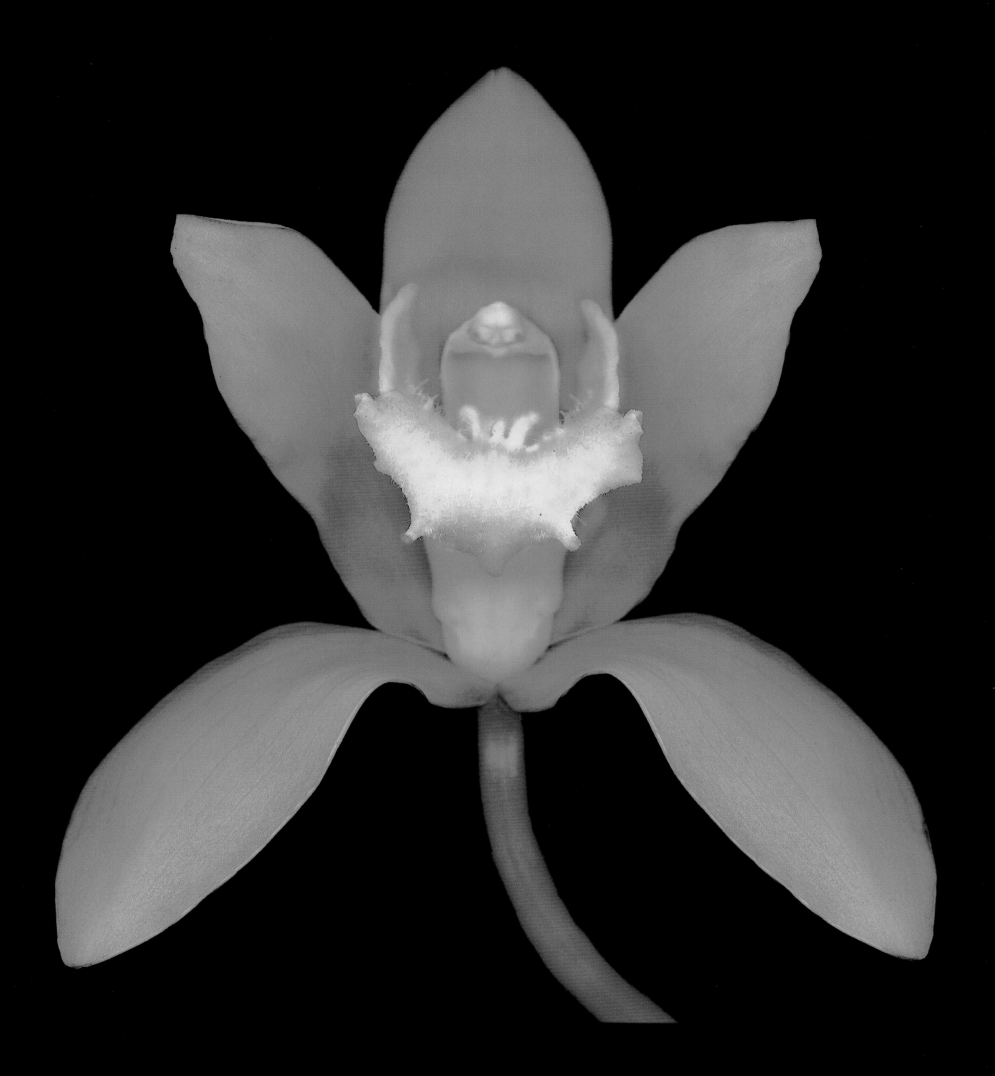

CYMBIDIUM HYBRID

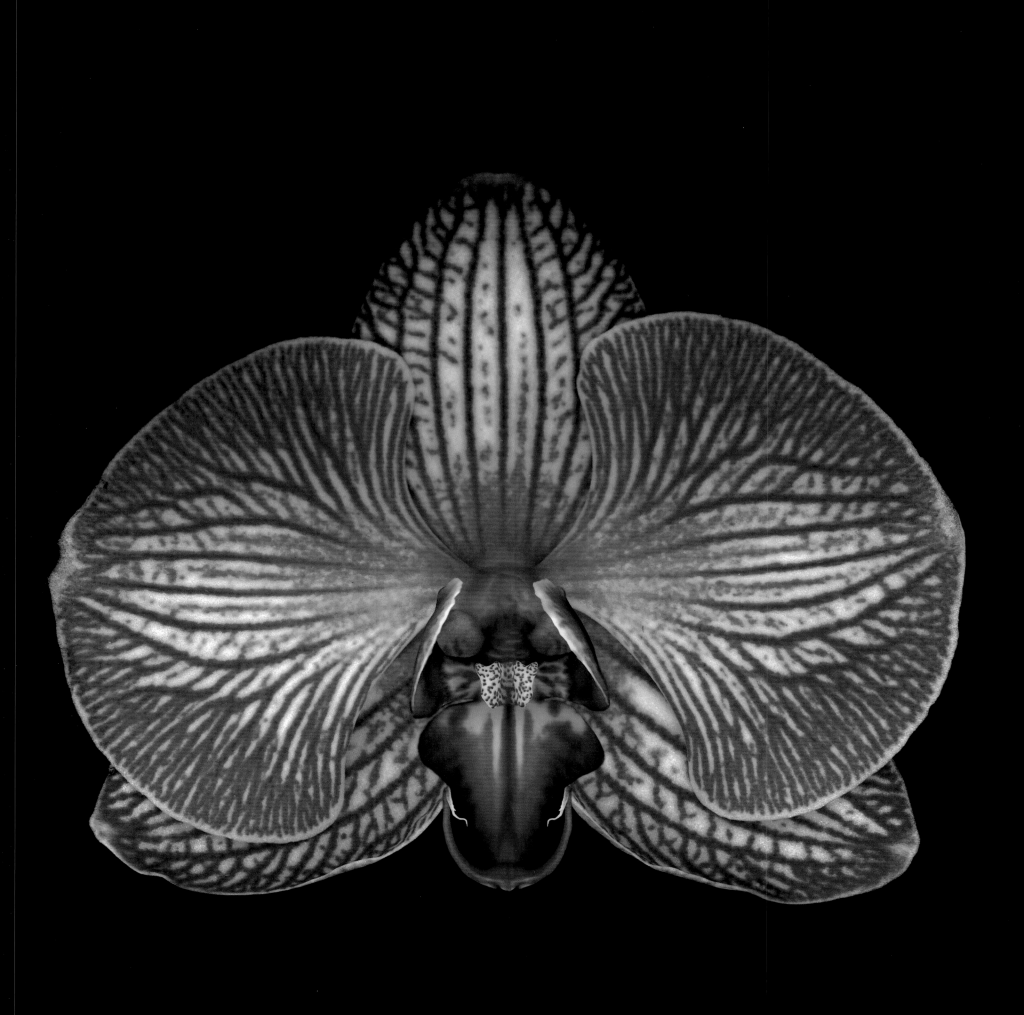

PHALAENOPSIS HYBRID

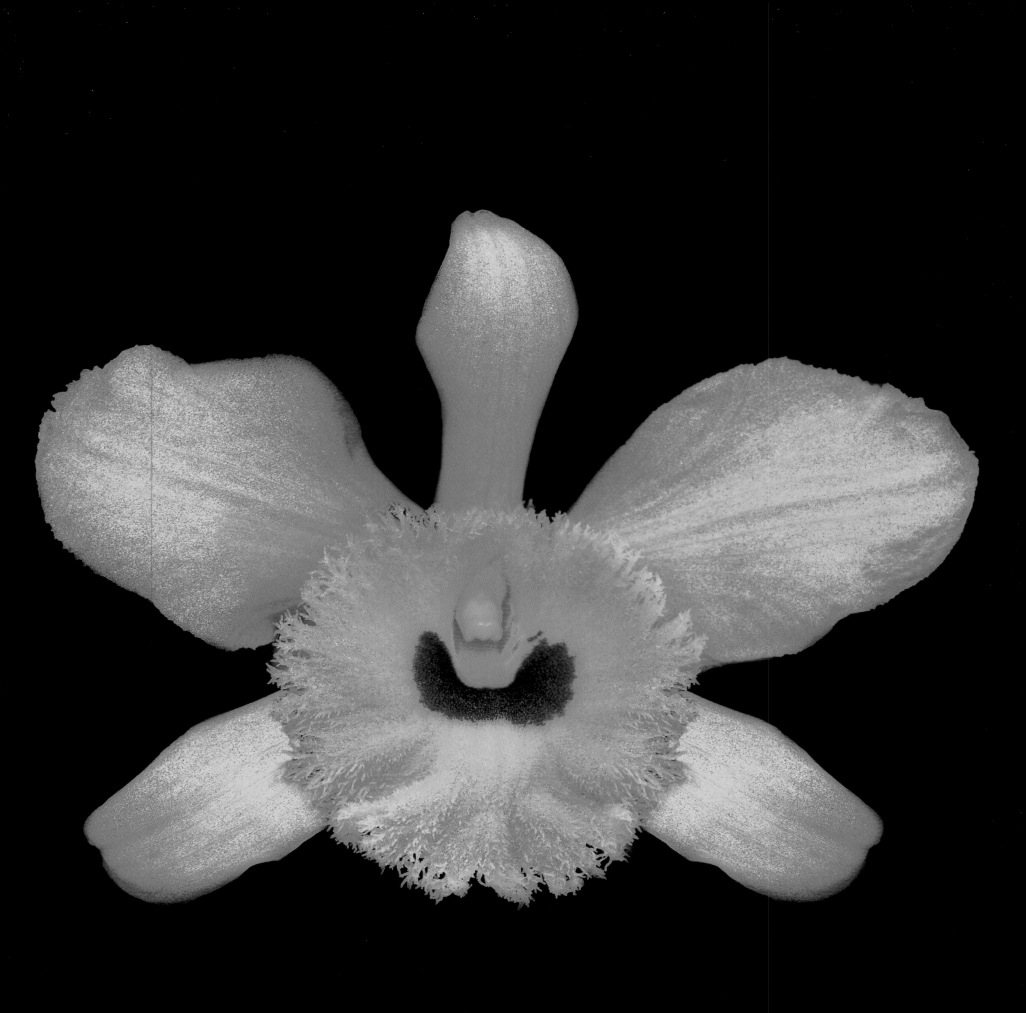

DENDROBIUM HYBRID

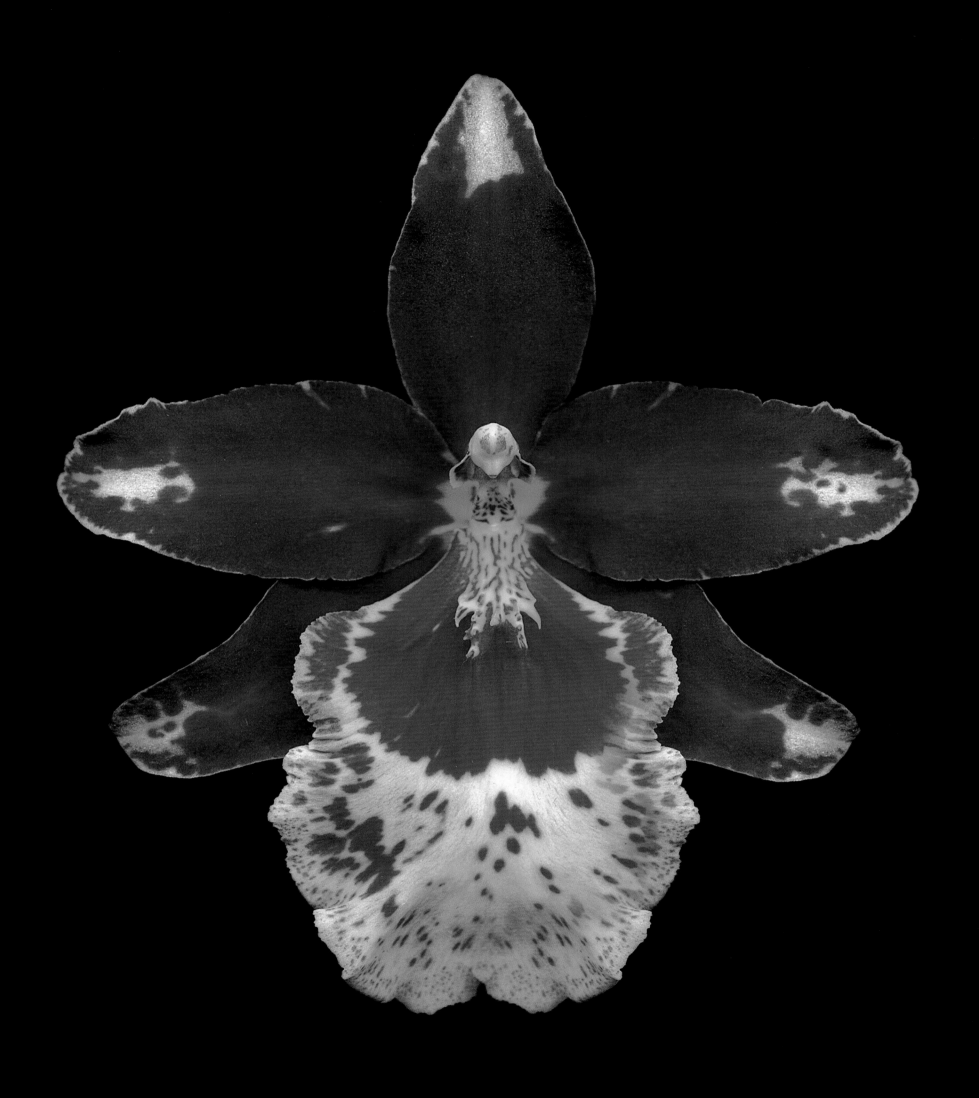

VUYLSTEKEARA (COMPLEX INTERGENERIC) HYBRID

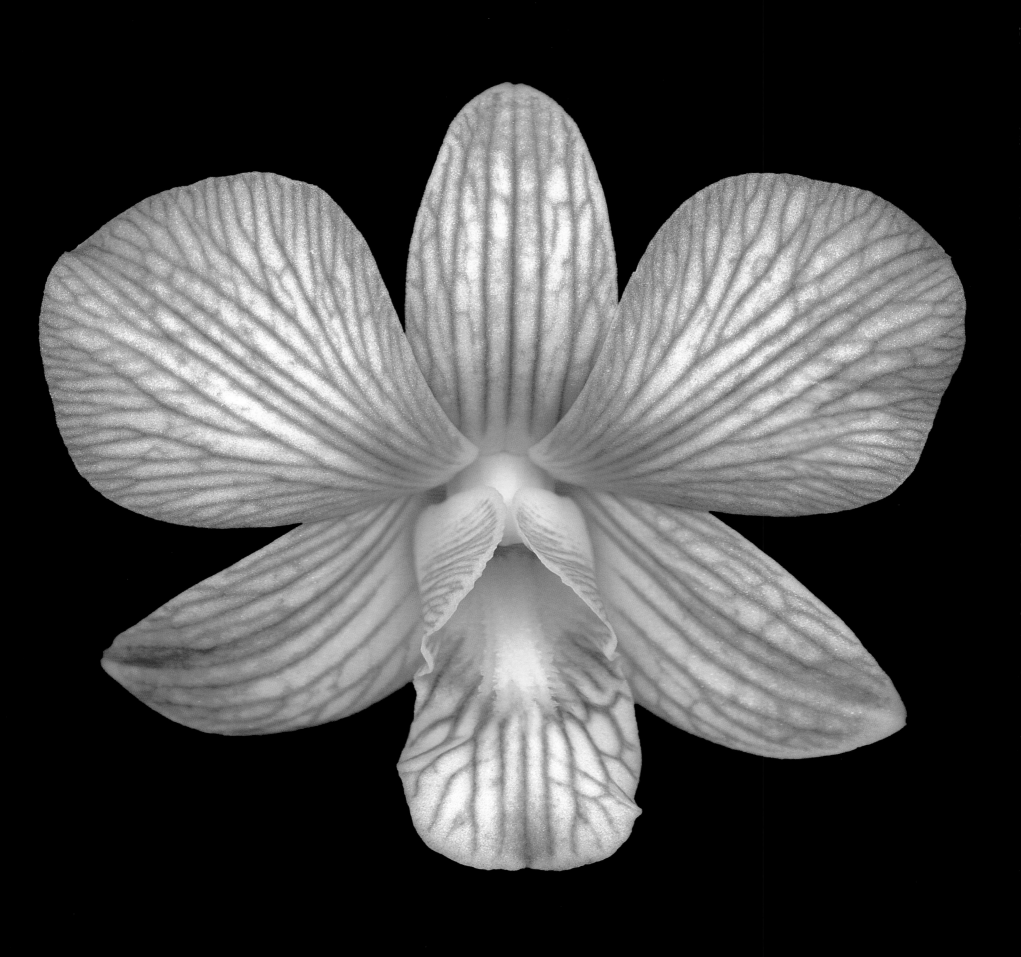

DENDROBIUM HYBRID

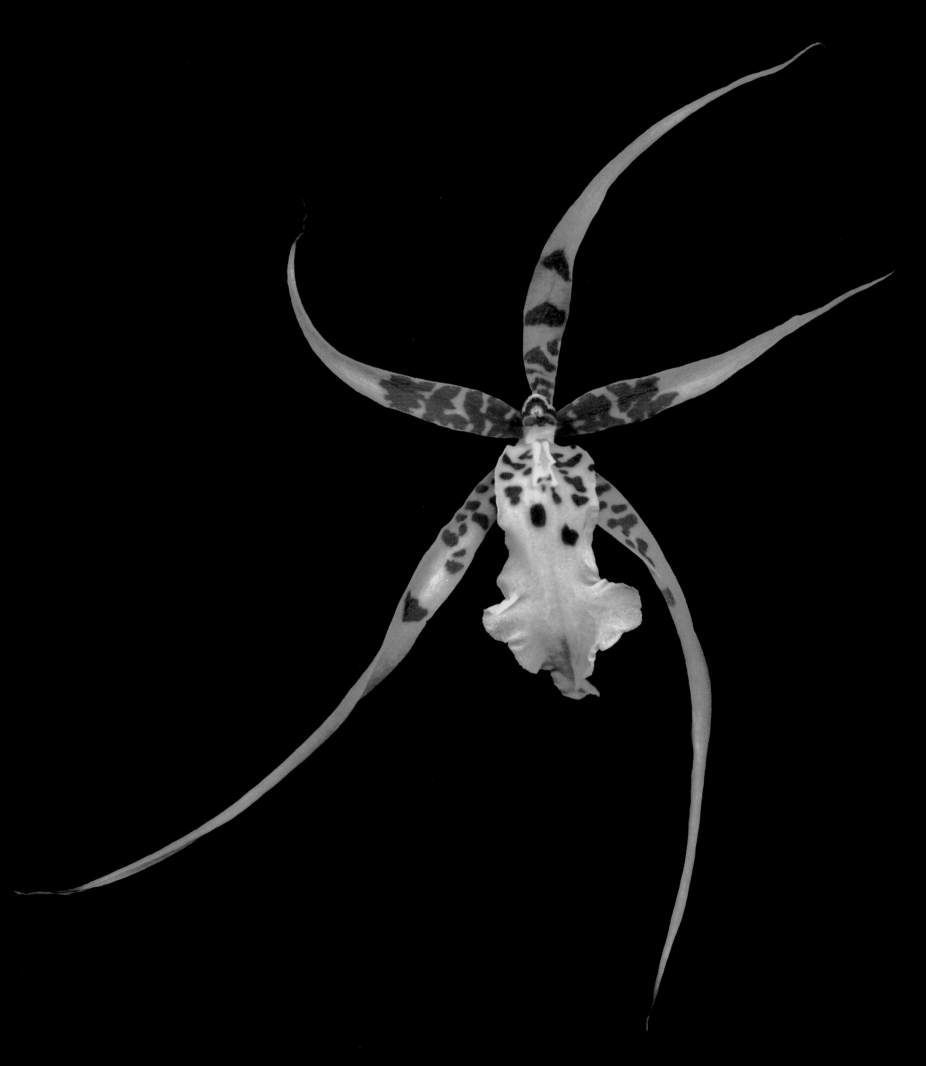

BRASSIDIUM HYBRID

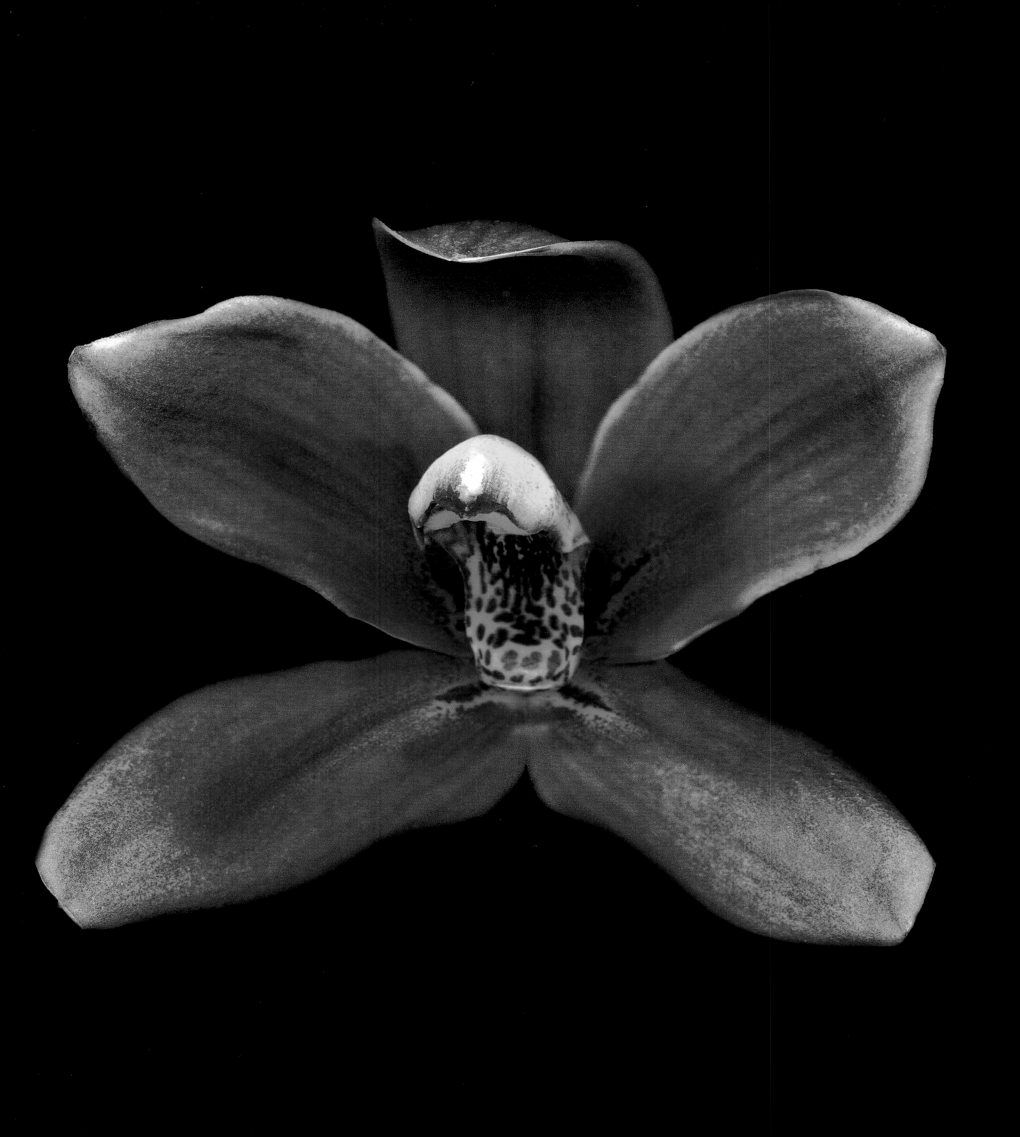

CYMBIDIUM HYBRID

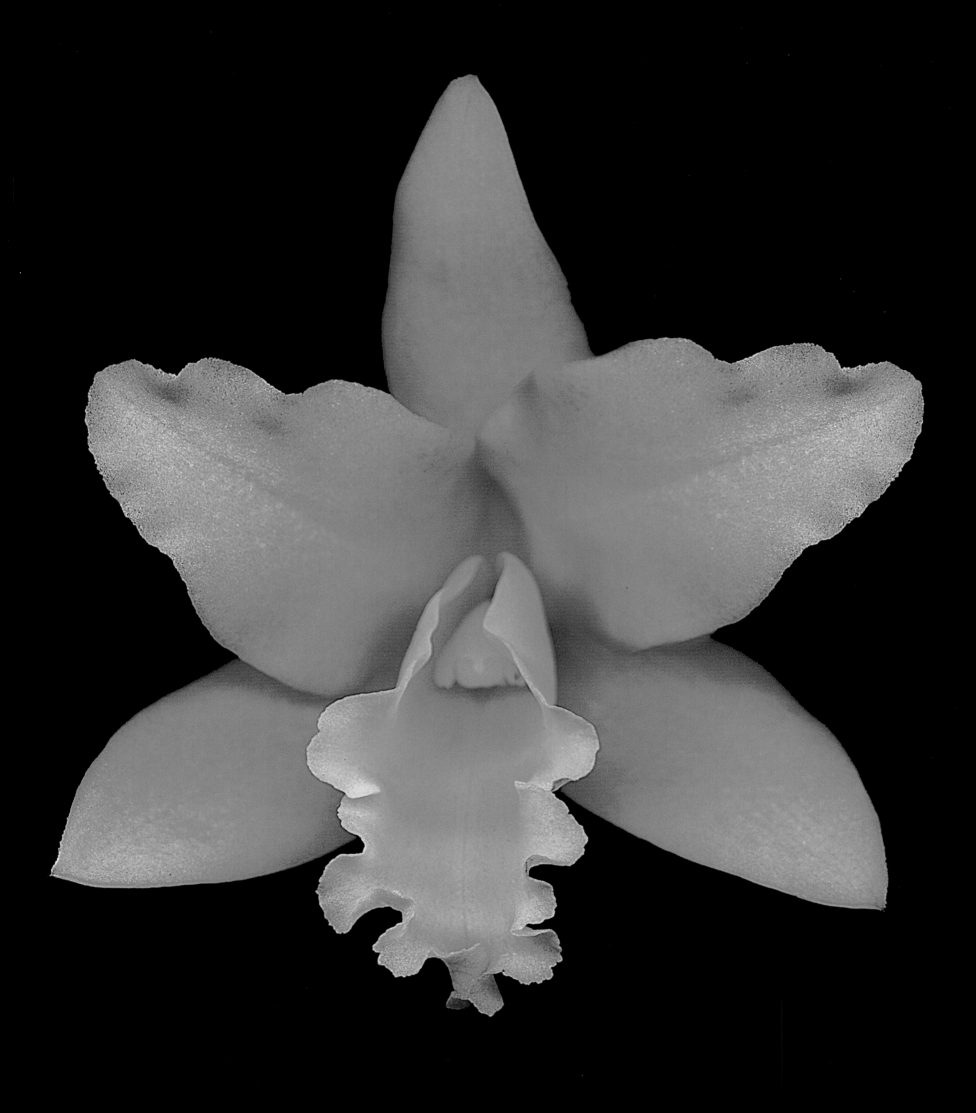

BRASSOLAELIOCATTLEYA HYBRID

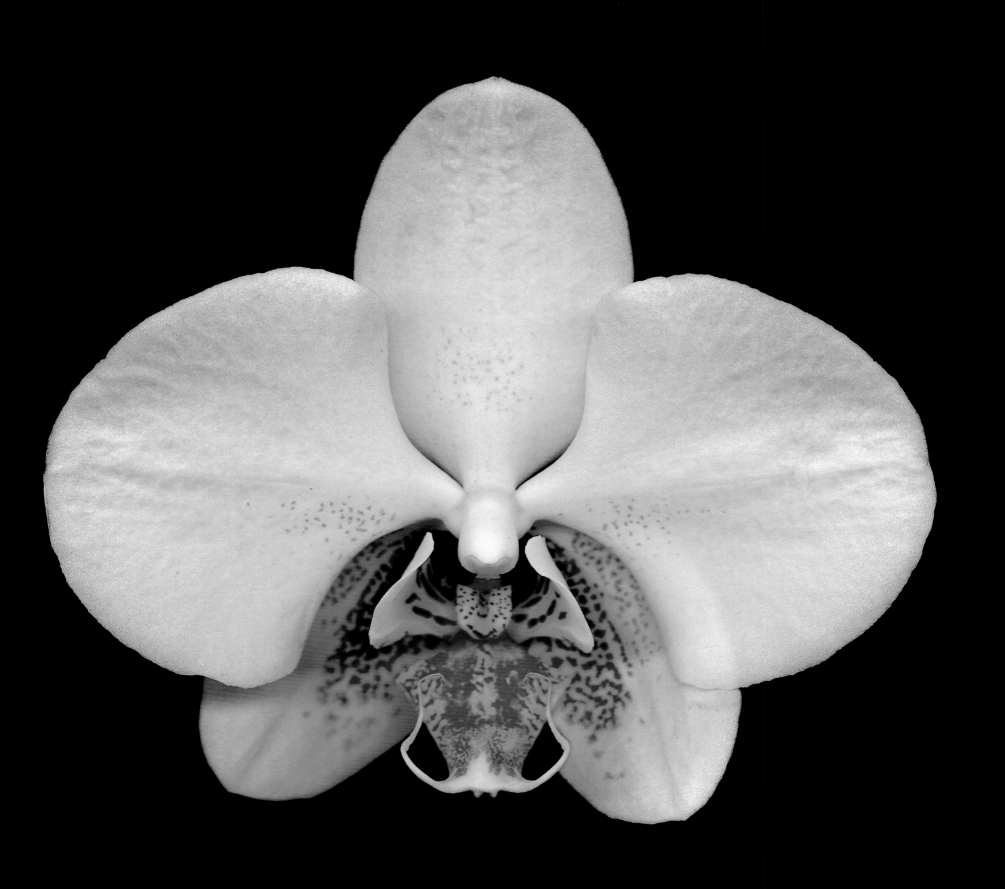

PHALAENOPSIS HYBRID

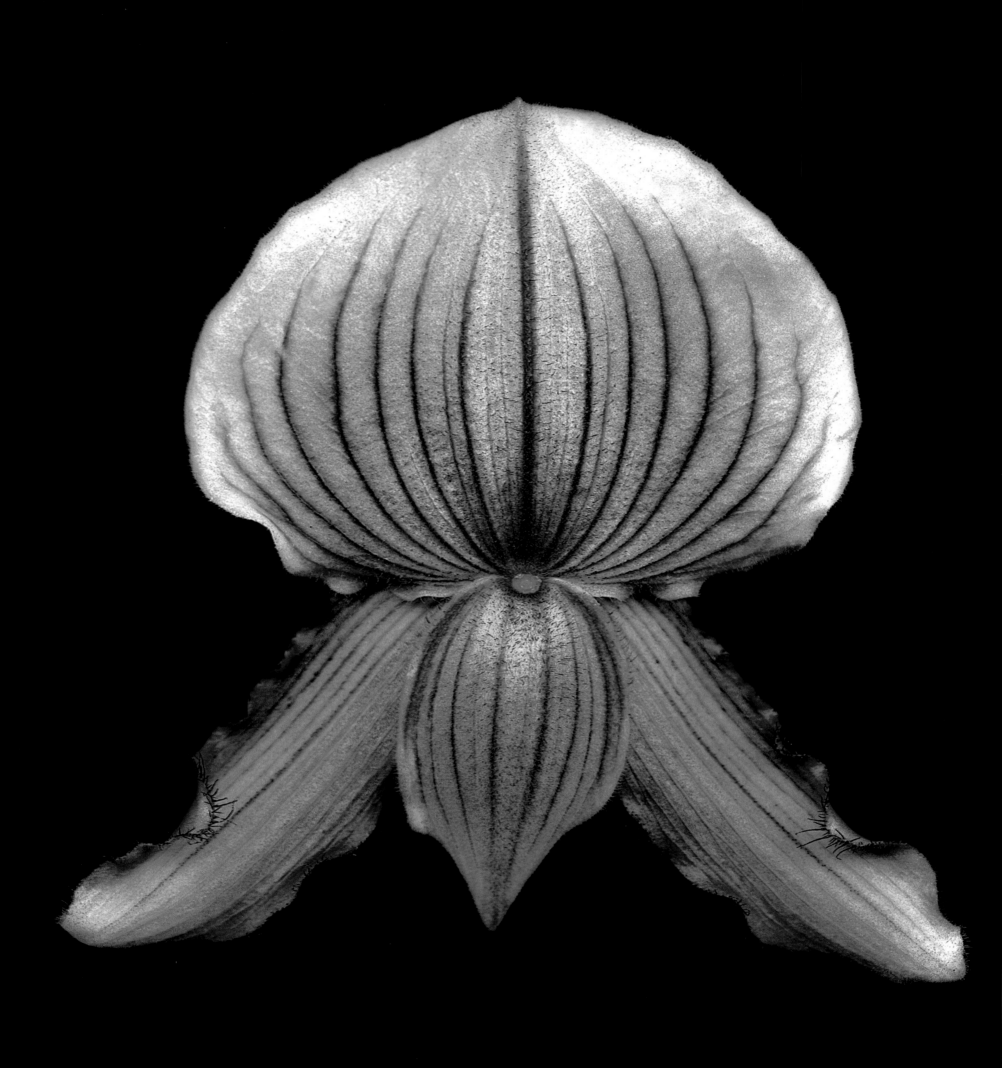

PAPHIOPEDILUM HYBRID (BACK VIEW)

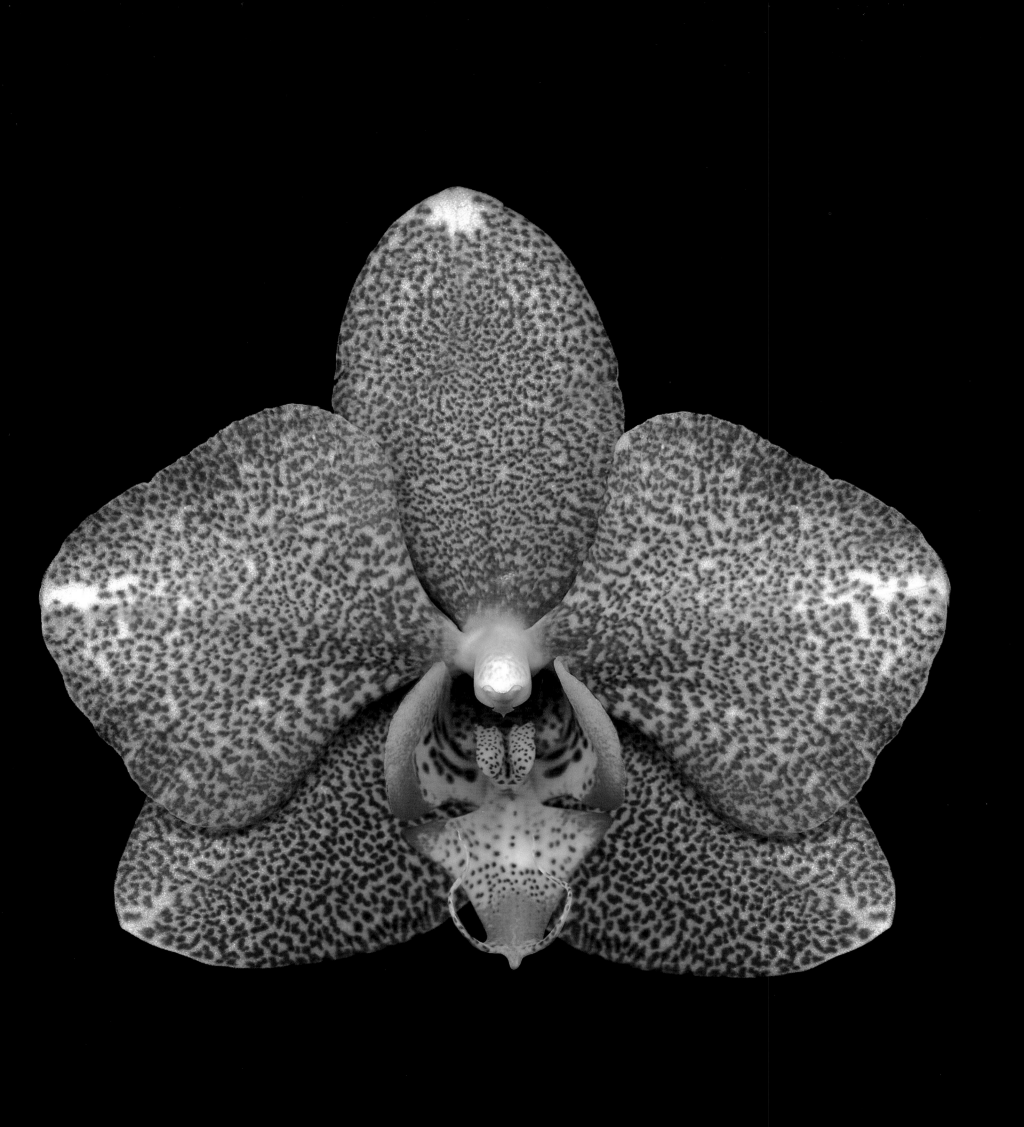

PHALAENOPSIS HYBRID

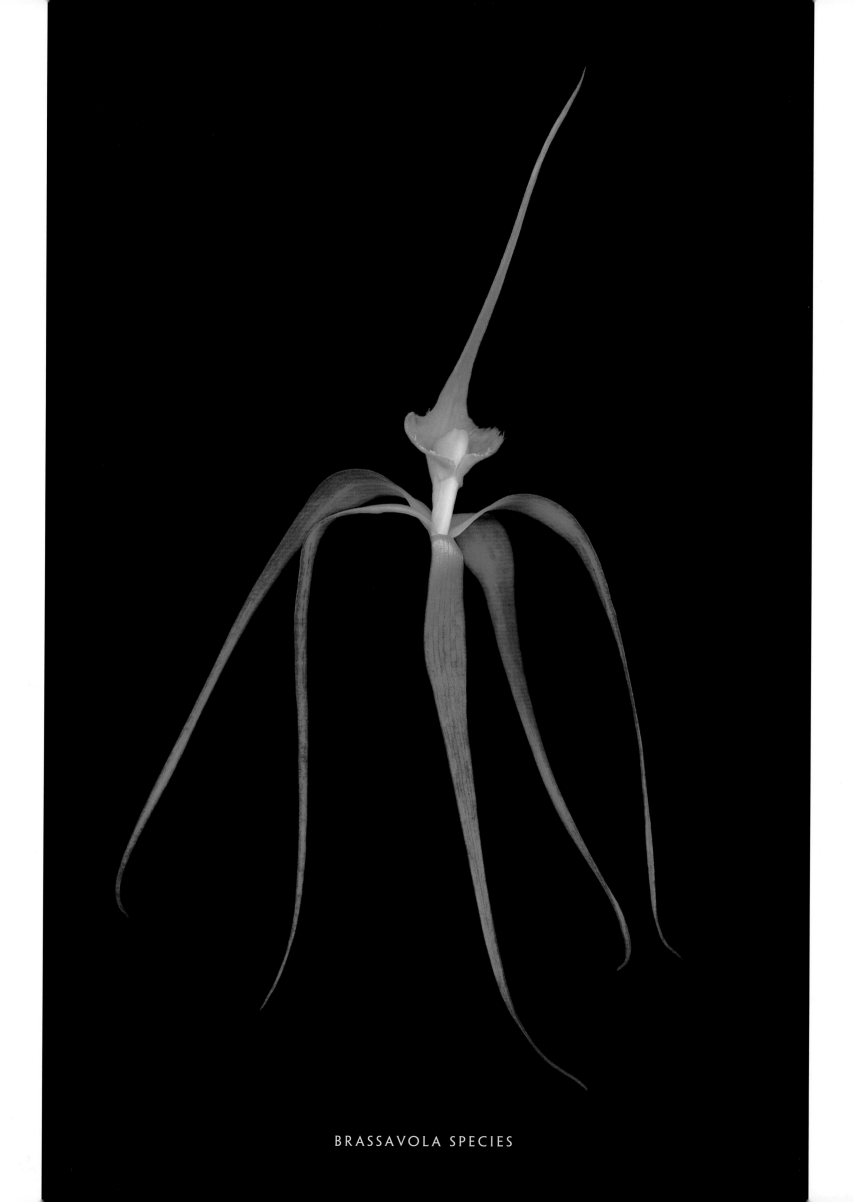

52

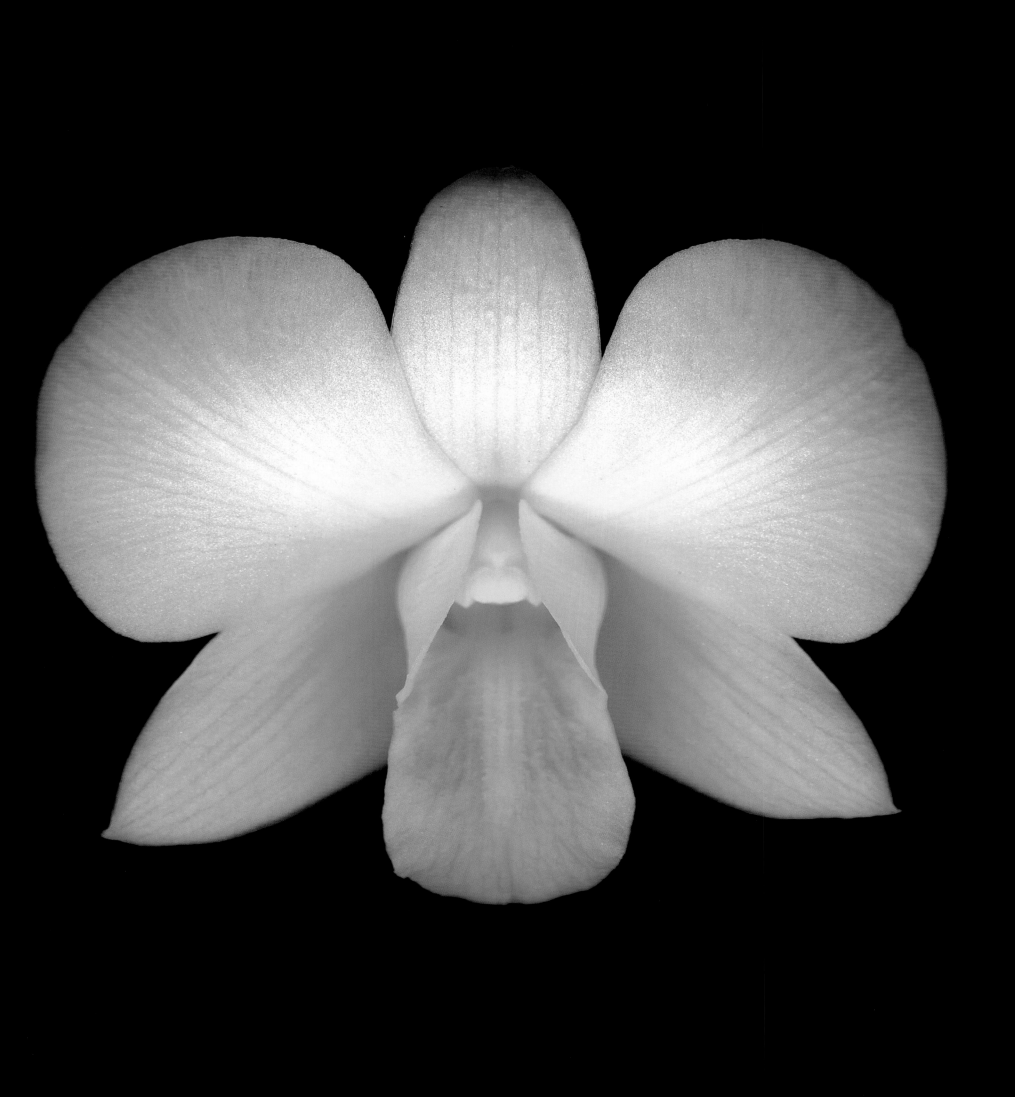

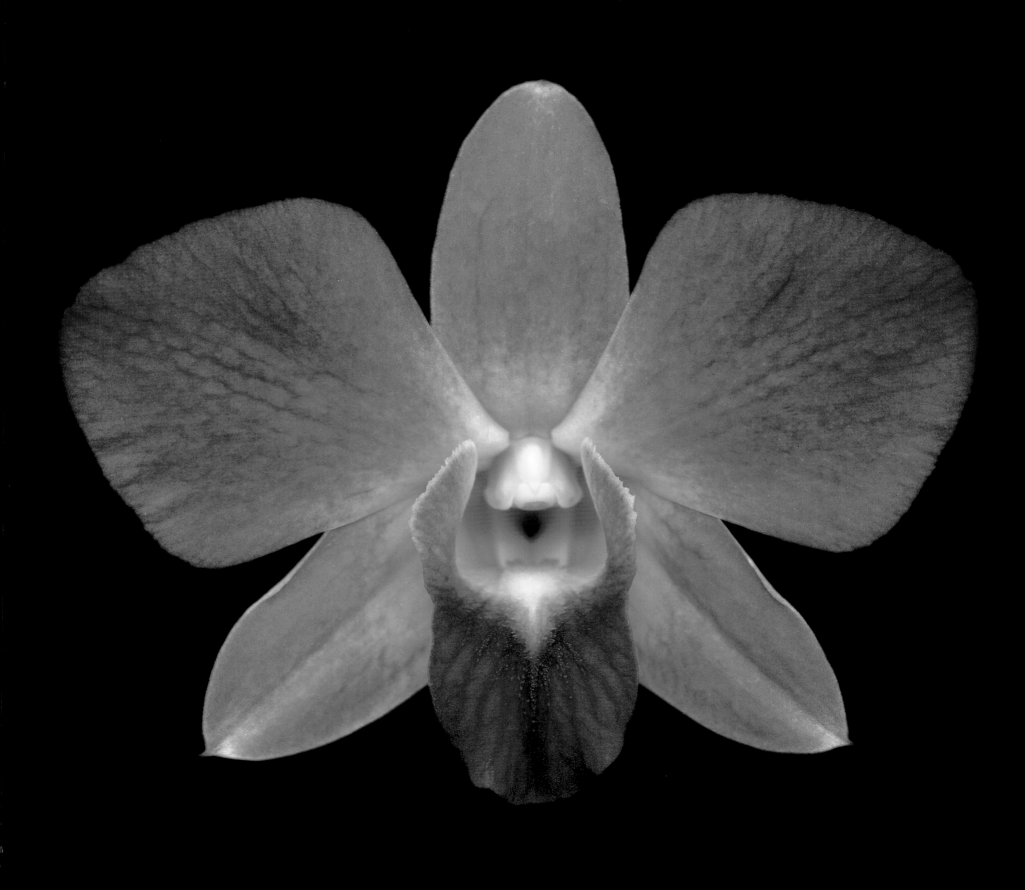

DENDROBIUM HYBRID

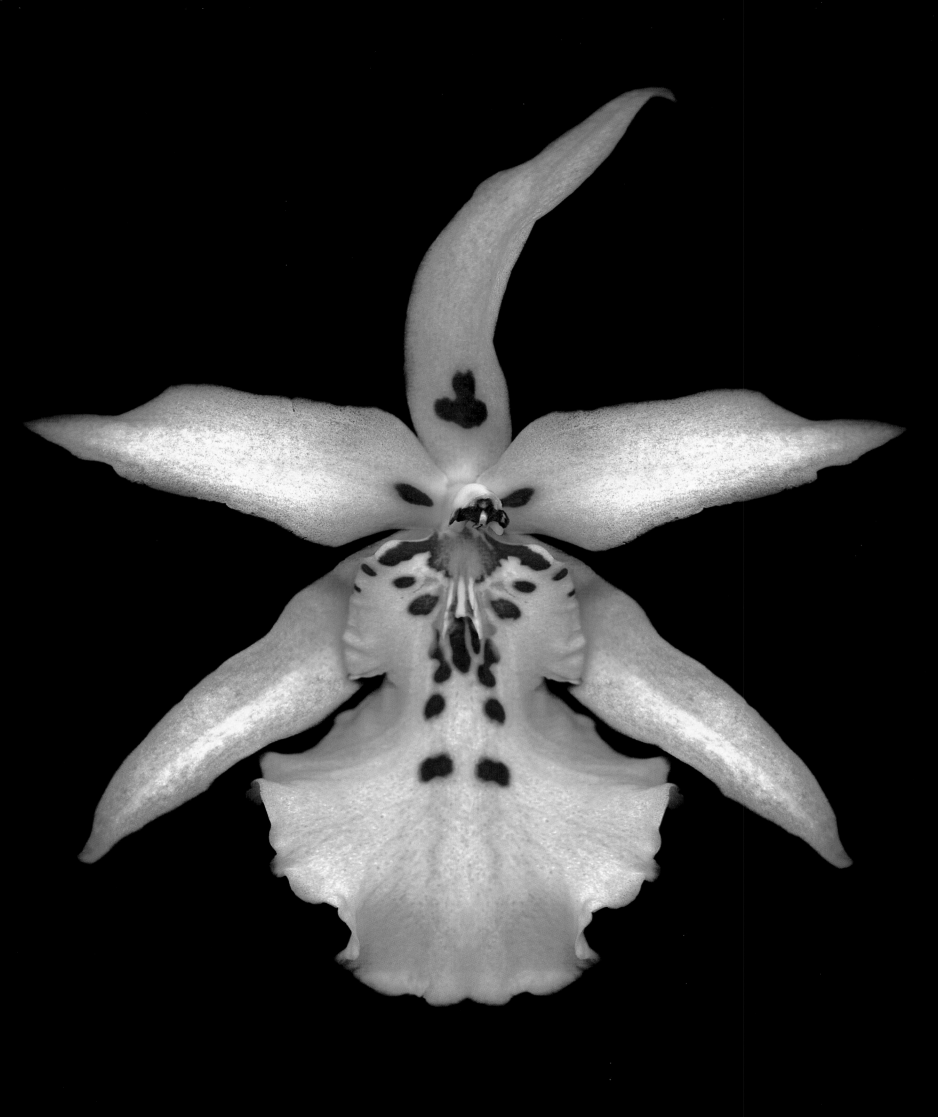

BEALLARA (COMPLEX INTERGENERIC) HYBRID

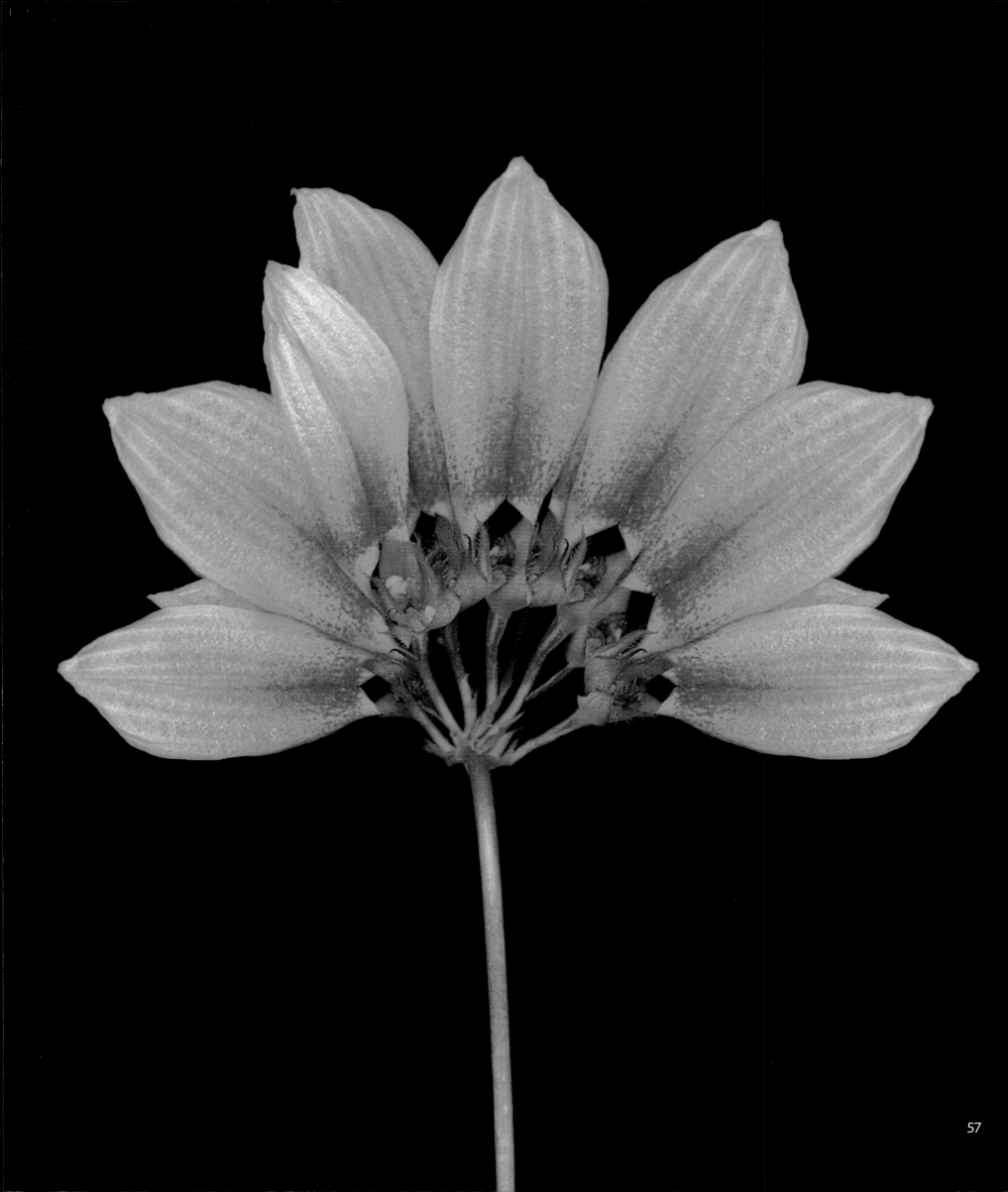

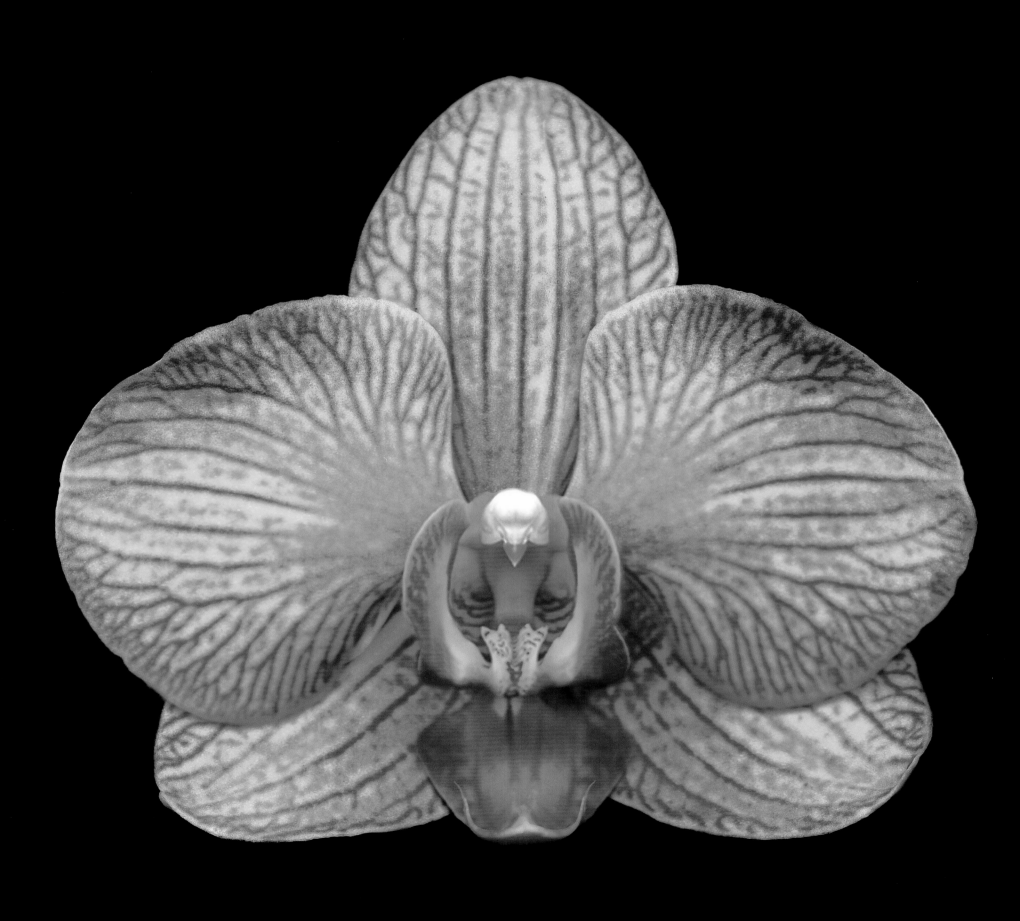

DORITAENOPSIS HYBRID

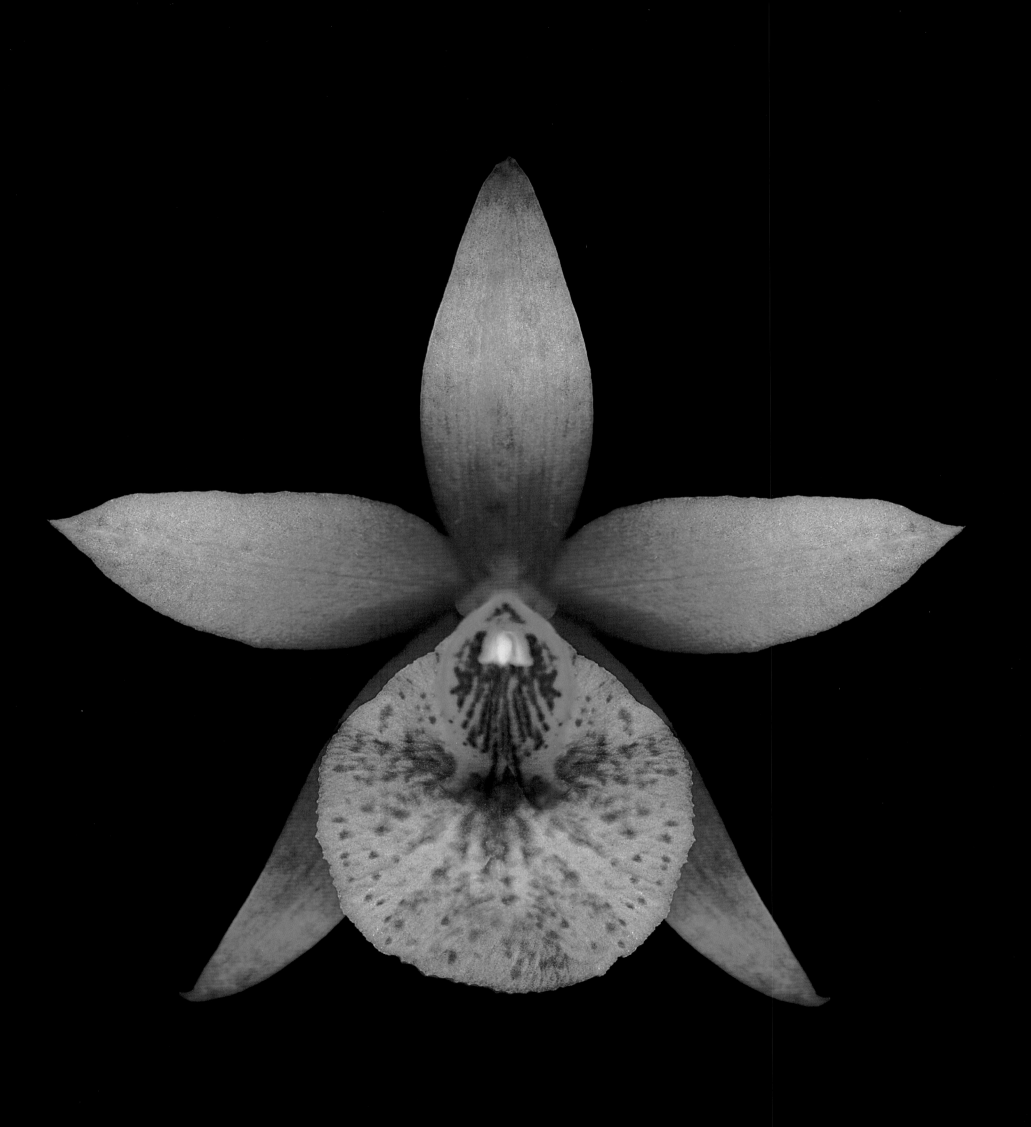

BRASSOCATTLEYA HYBRID

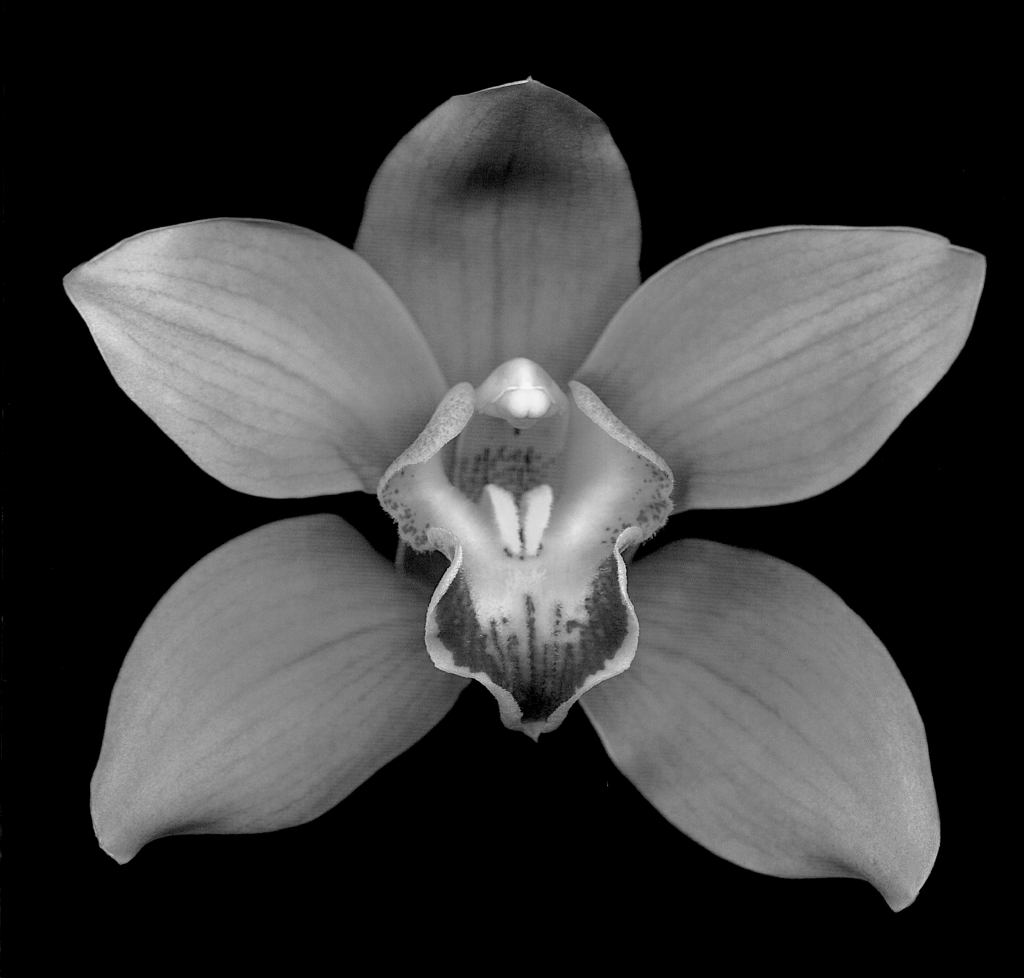

CYMBIDIUM HYBRID

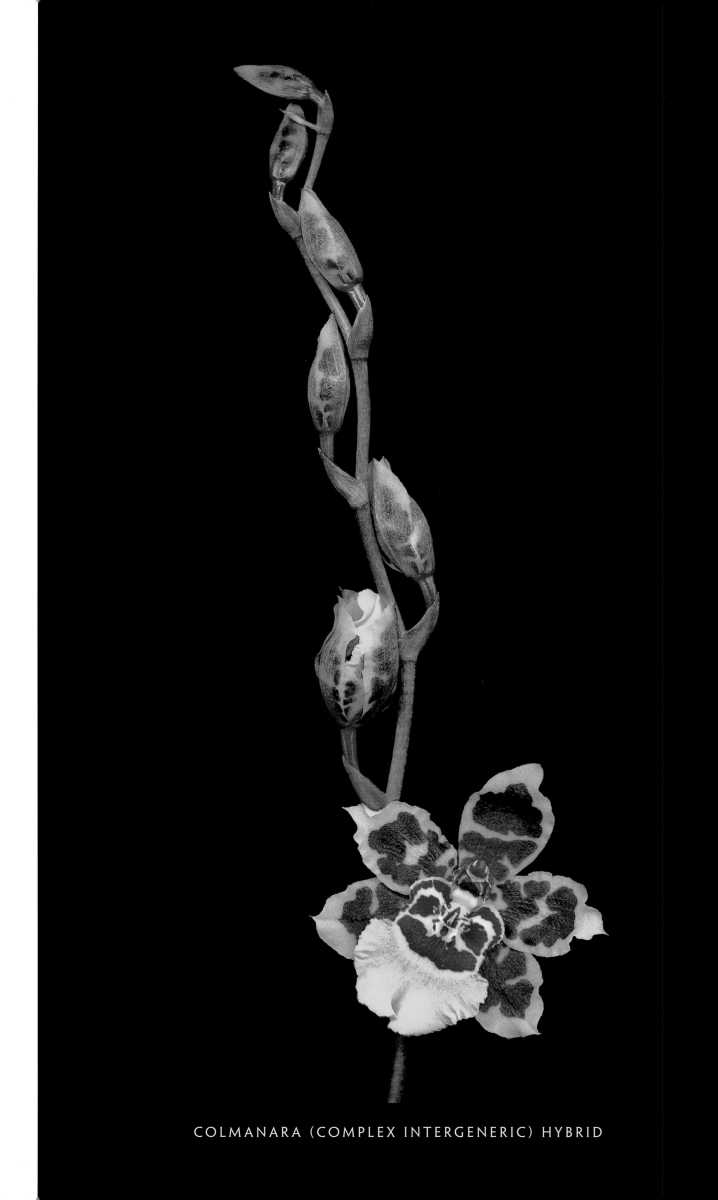

COLMANARA (COMPLEX INTERGENERIC) HYBRID

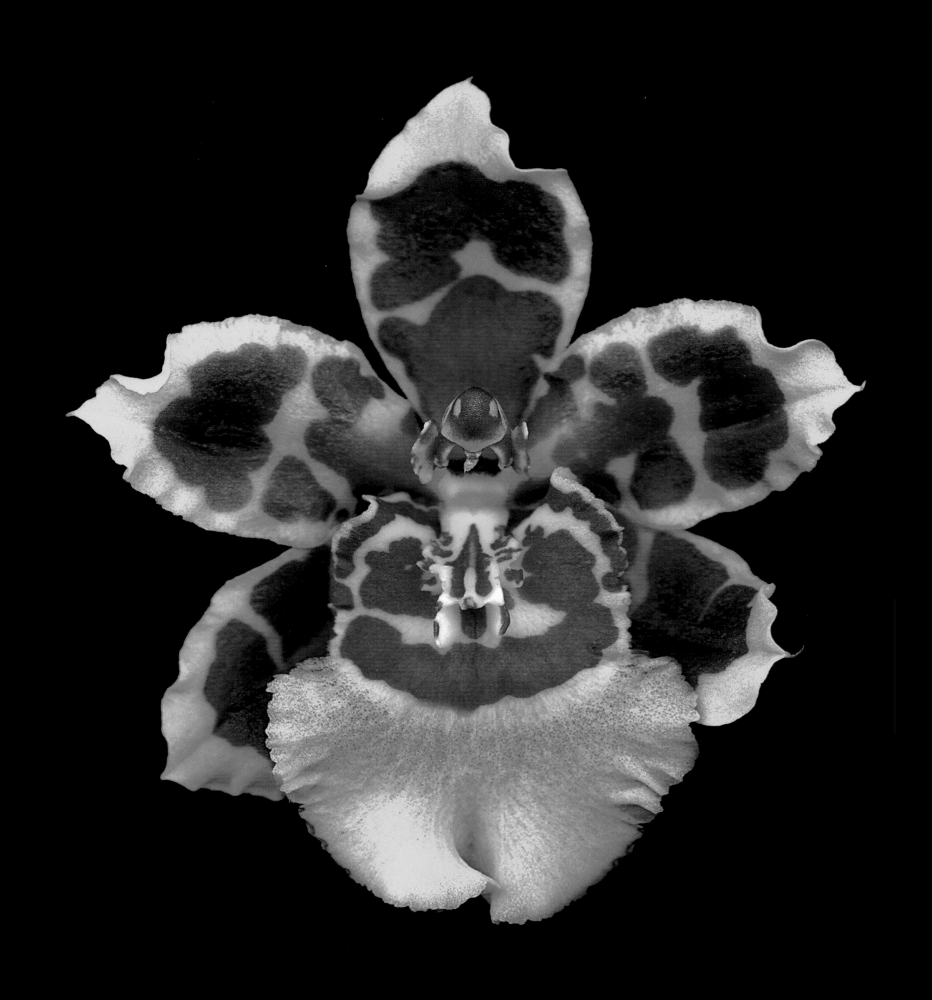

COLMANARA (COMPLEX INTERGENERIC) HYBRID

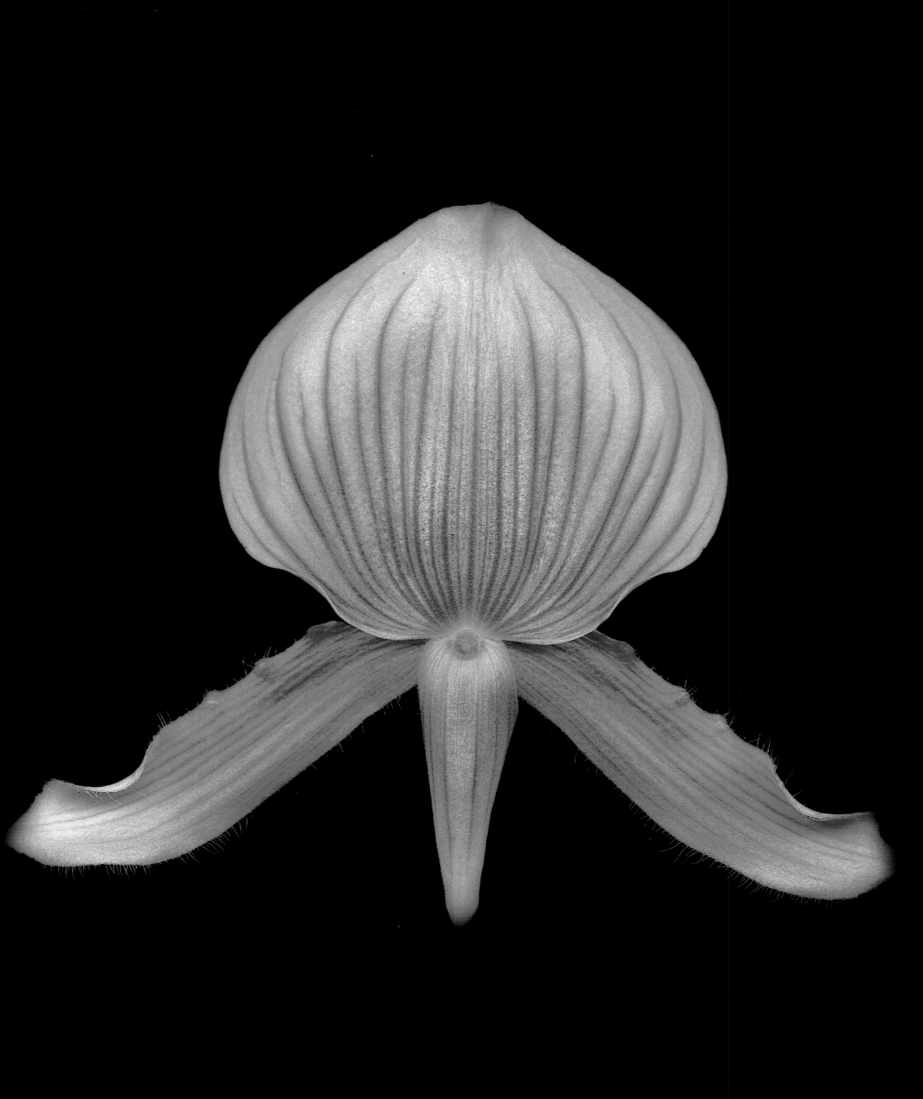

PAPHIOPEDILUM HYBRID (BACK VIEW)

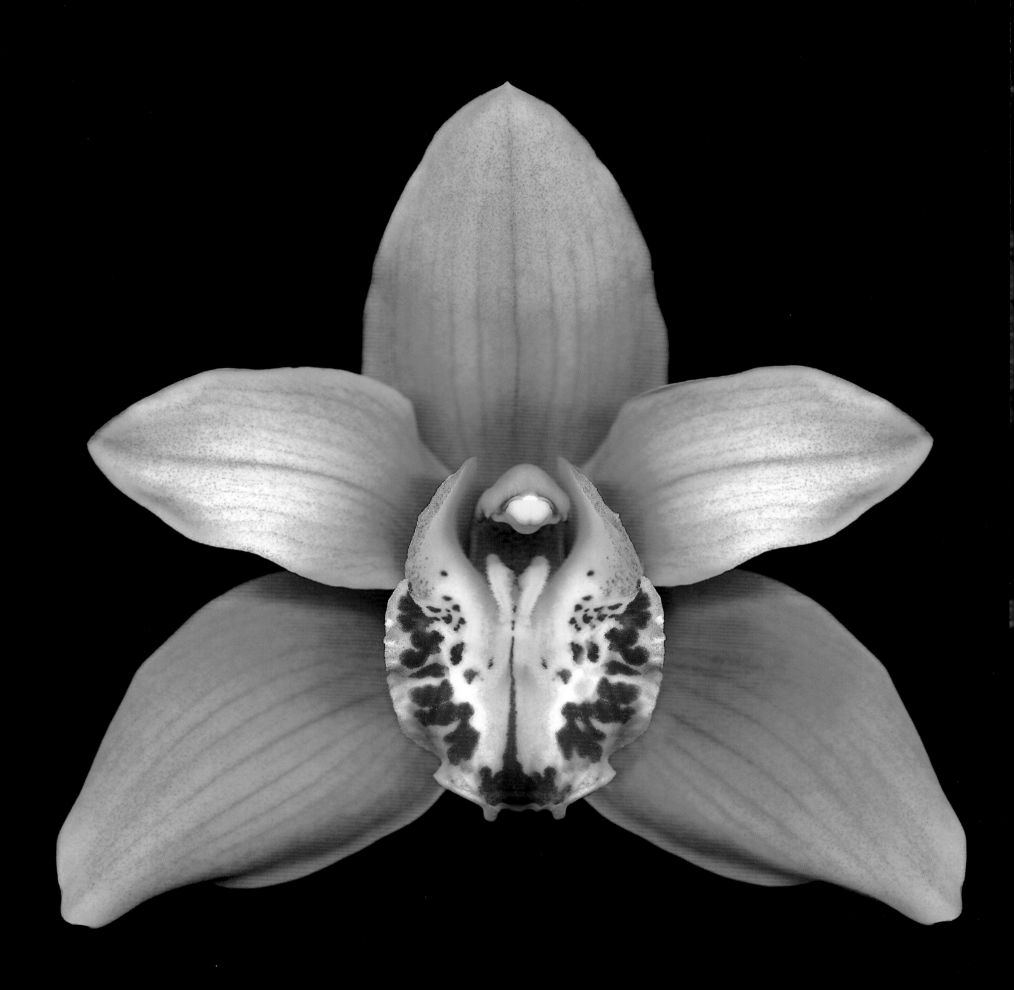

CYMBIDIUM HYBRID

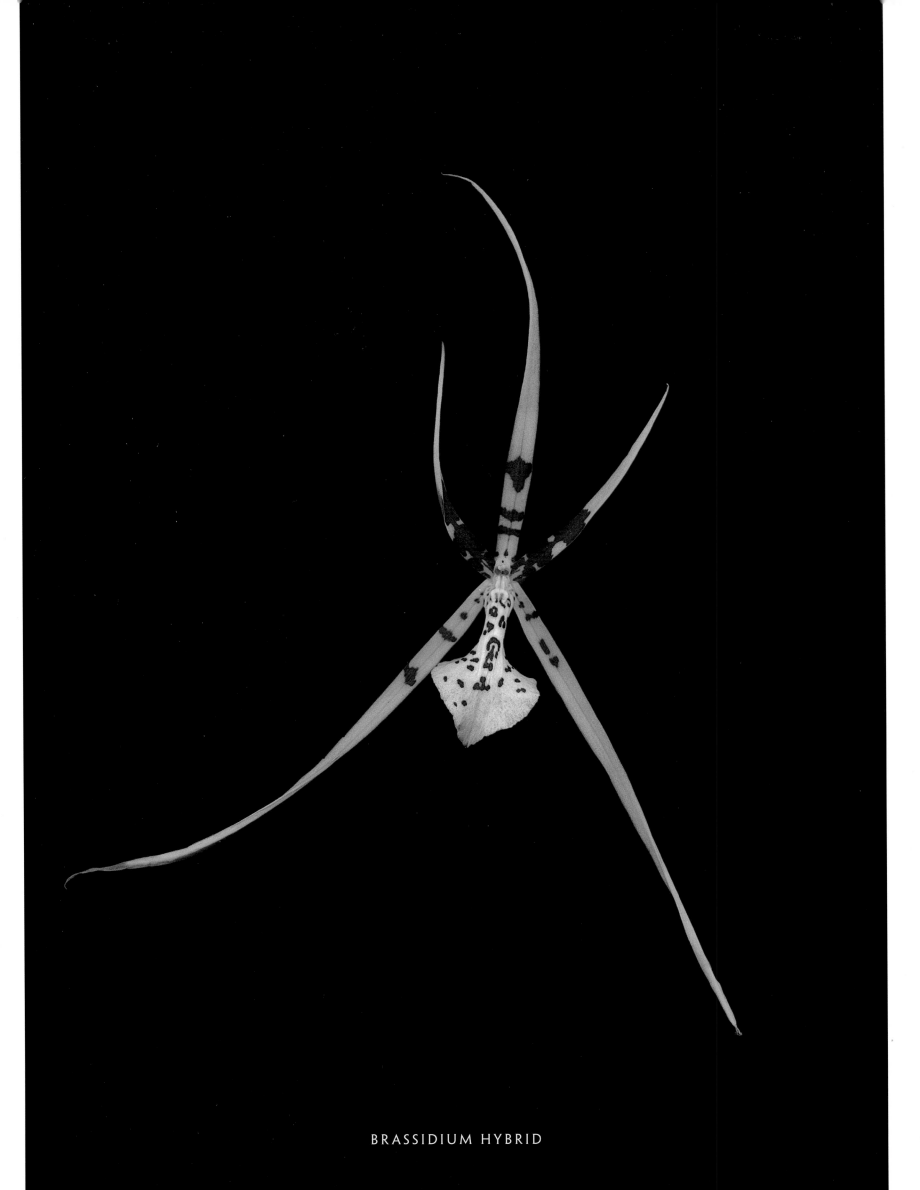

BRASSIDIUM HYBRID

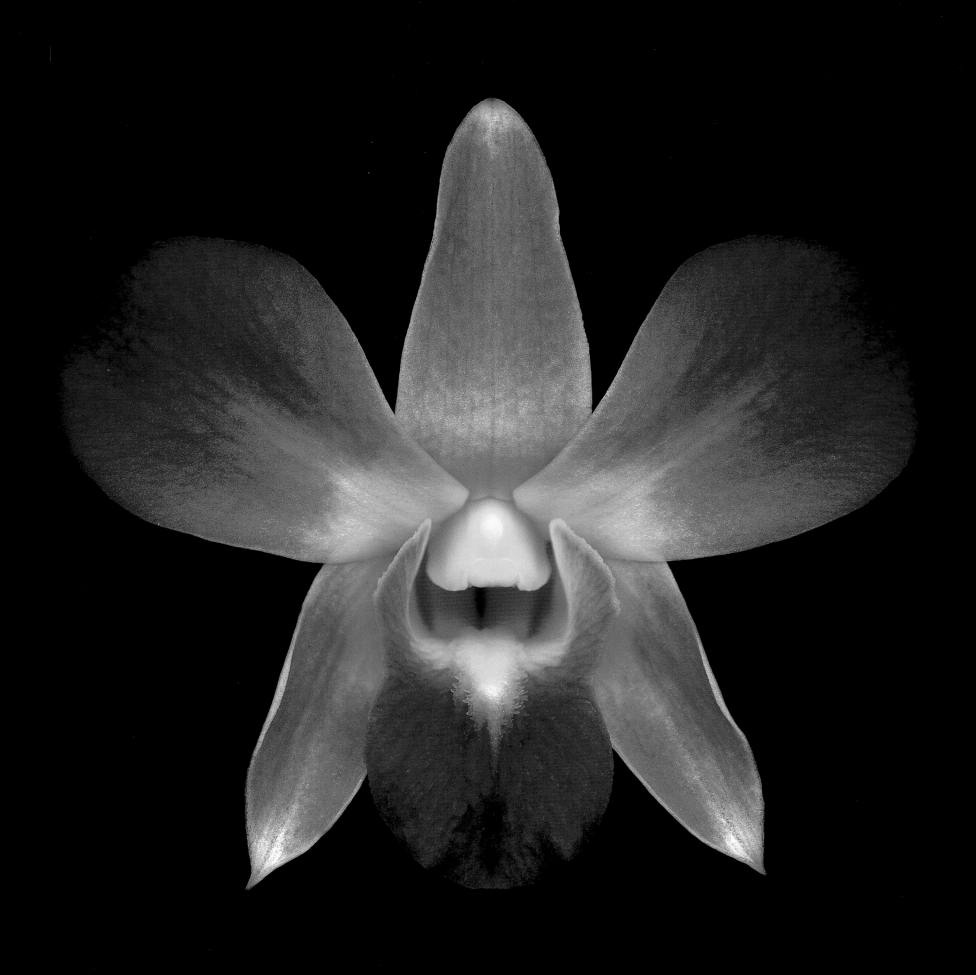

DENDROBIUM HYBRID

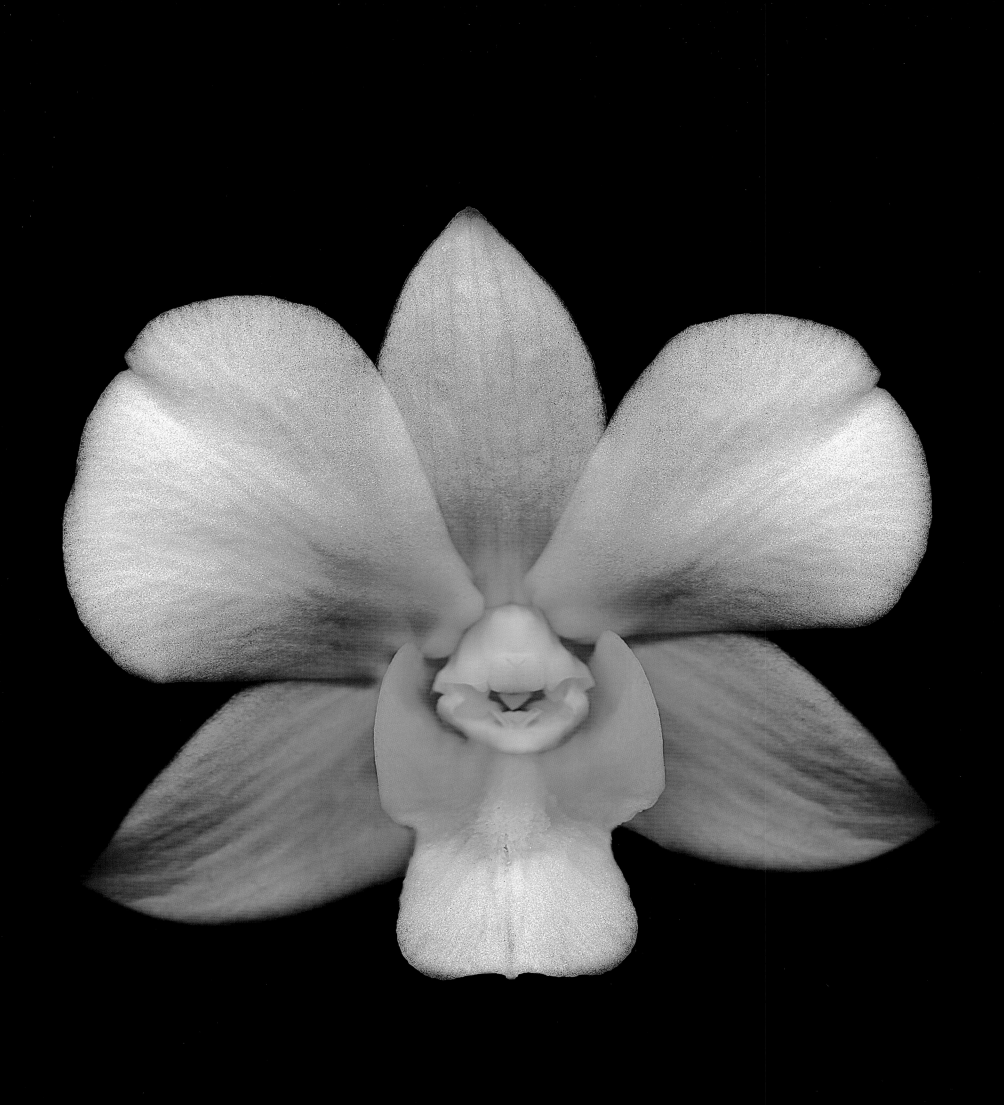

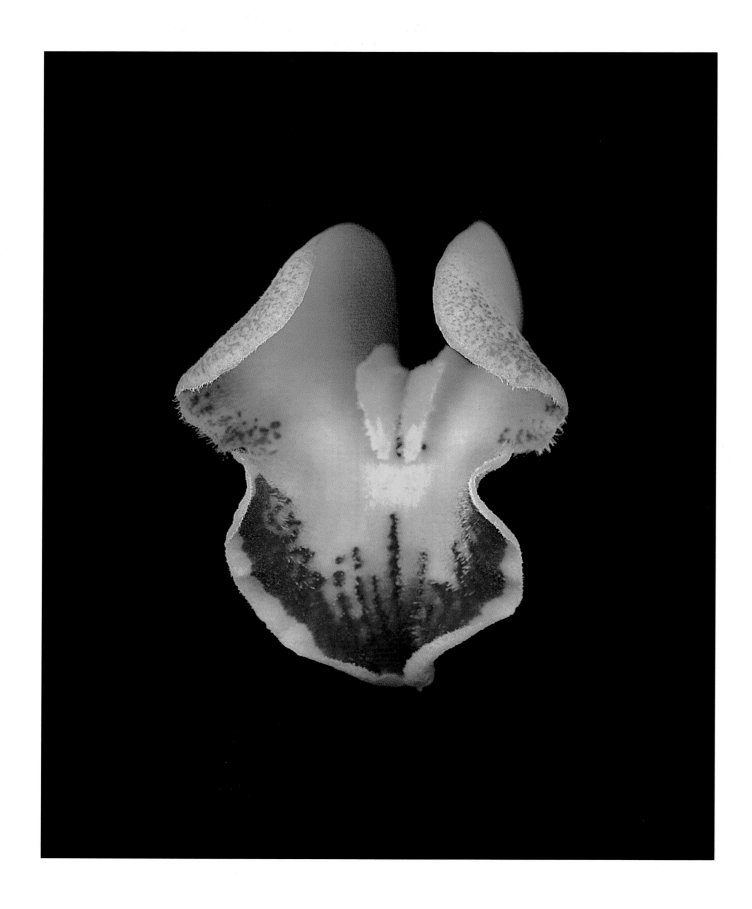

CYMBIDIUM HYBRID (PART)

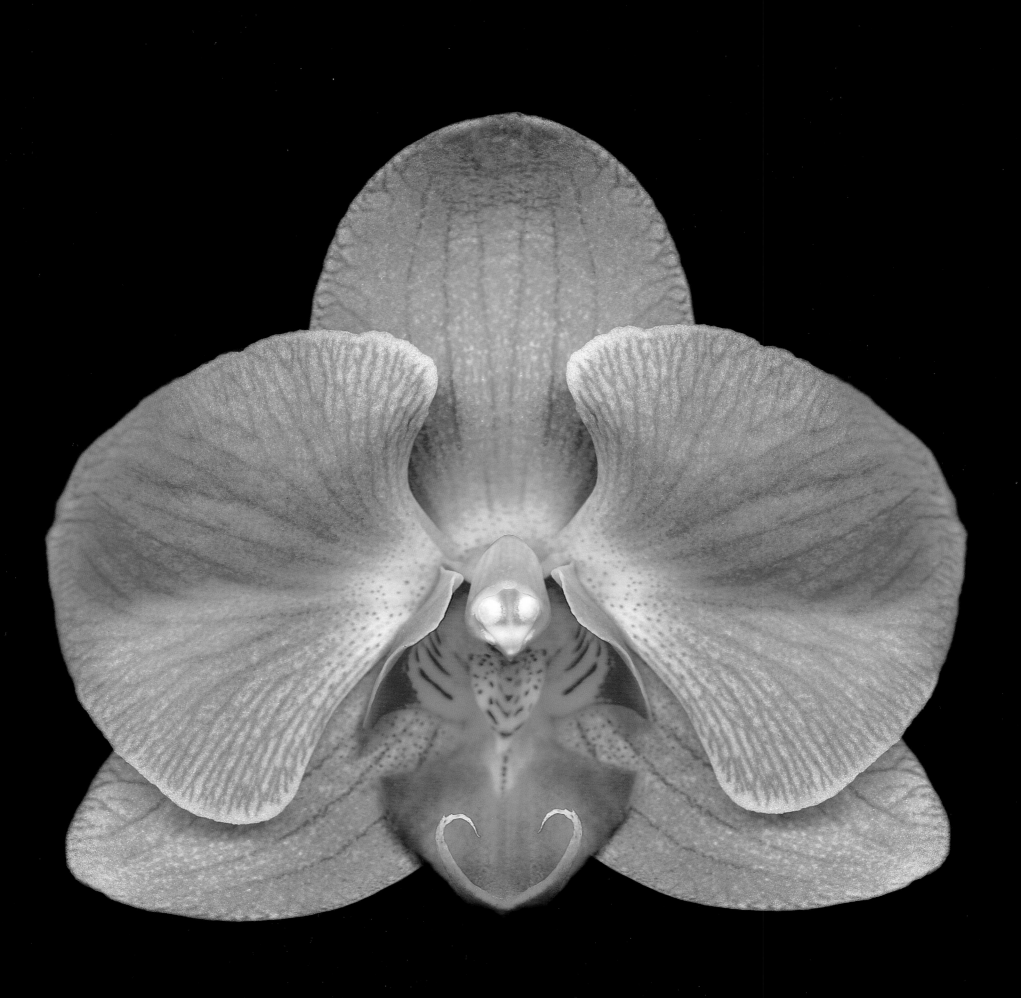

PHALAENOPSIS HYBRID

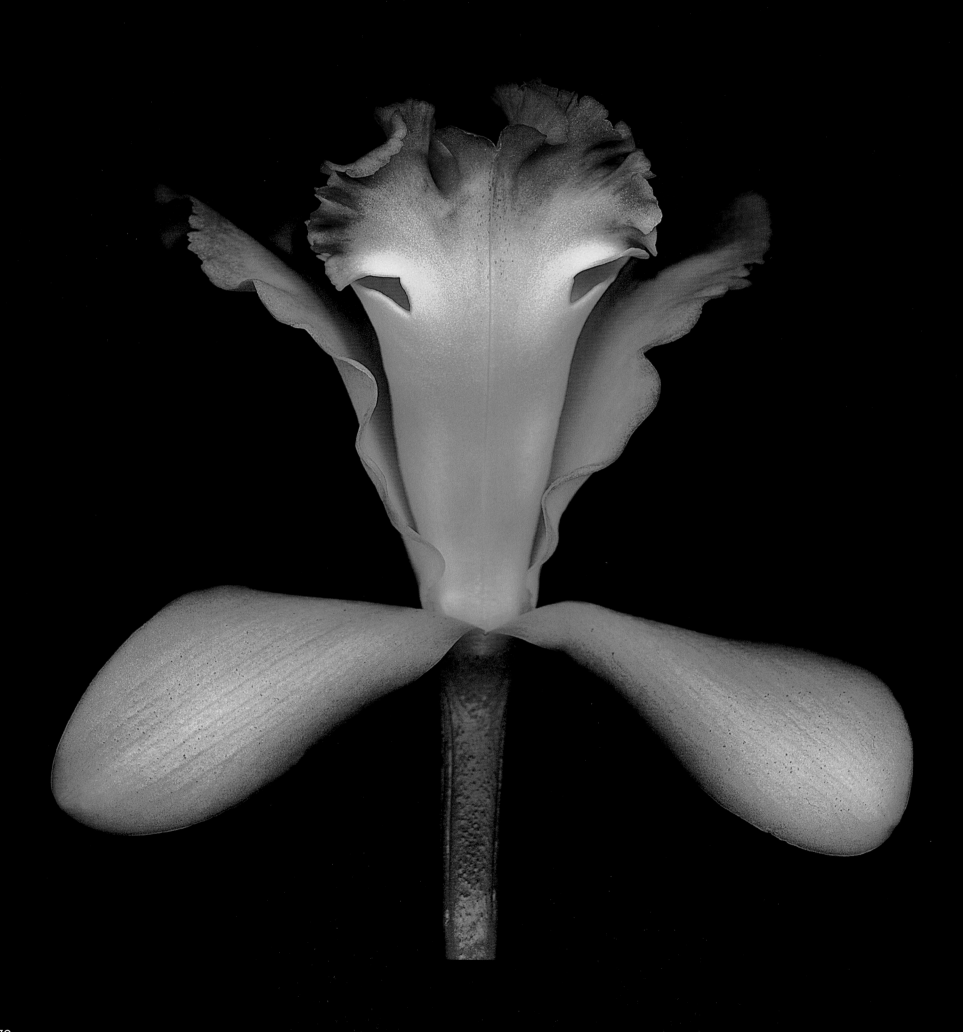

CATTLEYA HYBRID

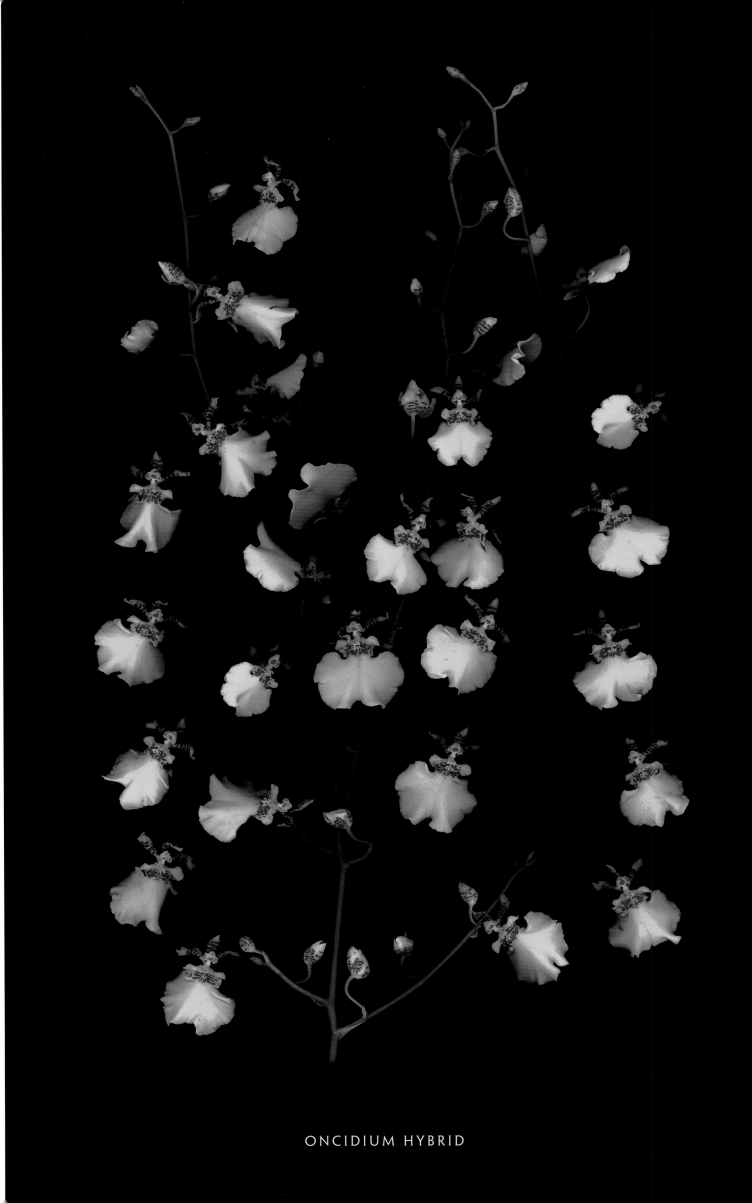

ONCIDIUM HYBRID

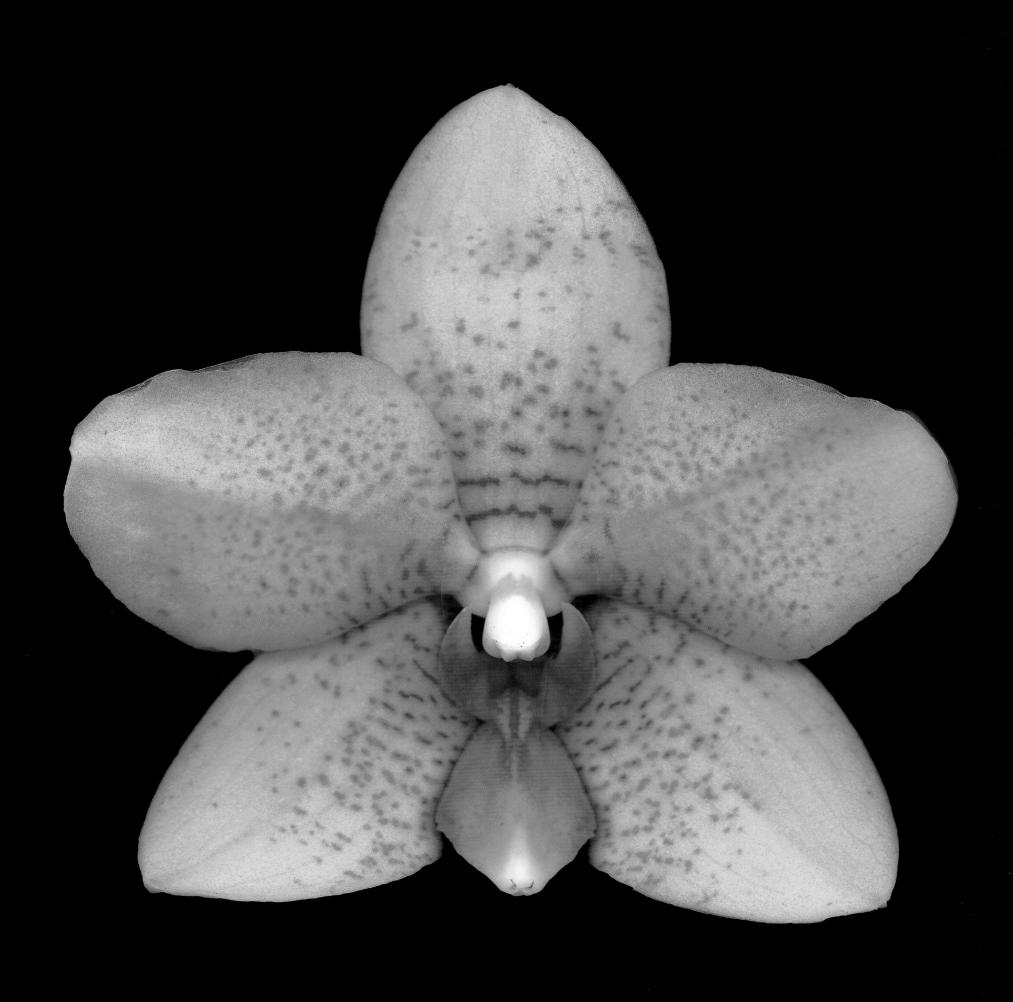

PHALAENOPSIS HYBRID

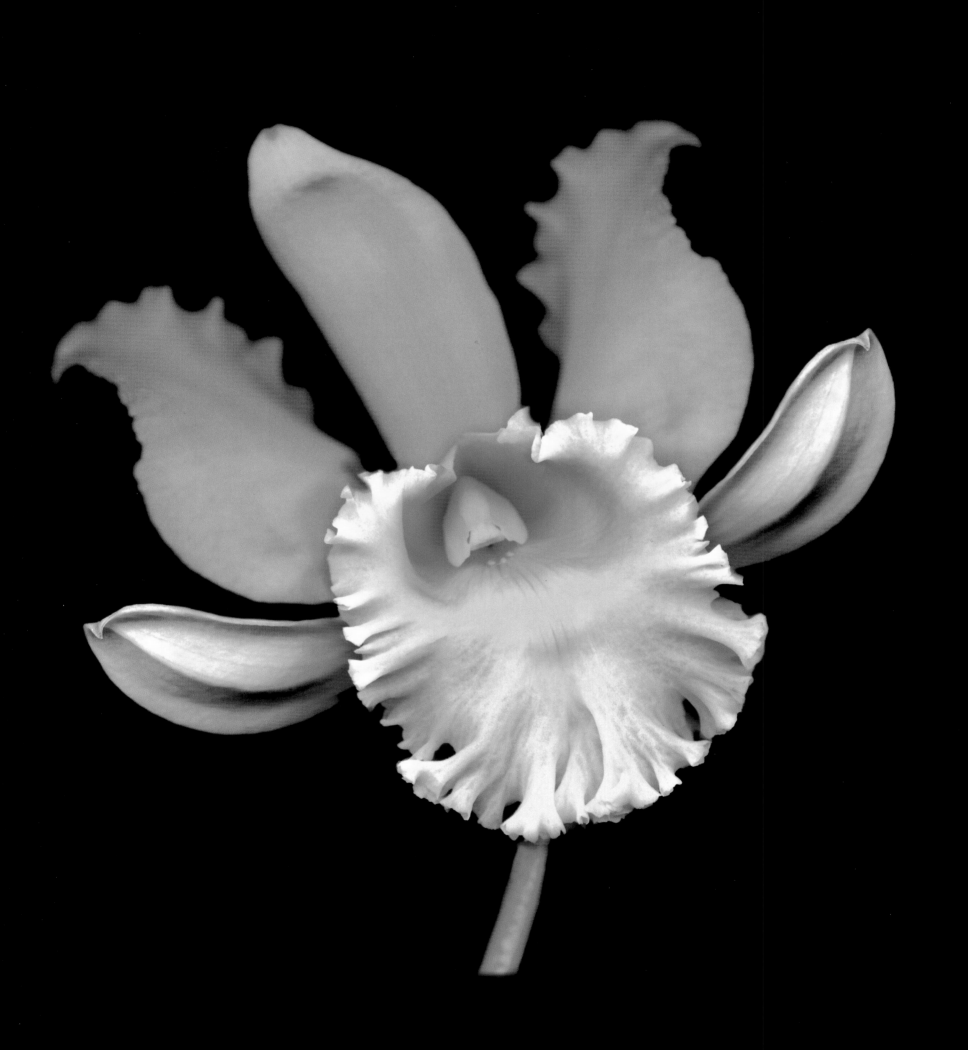

CATTLEYA HYBRID

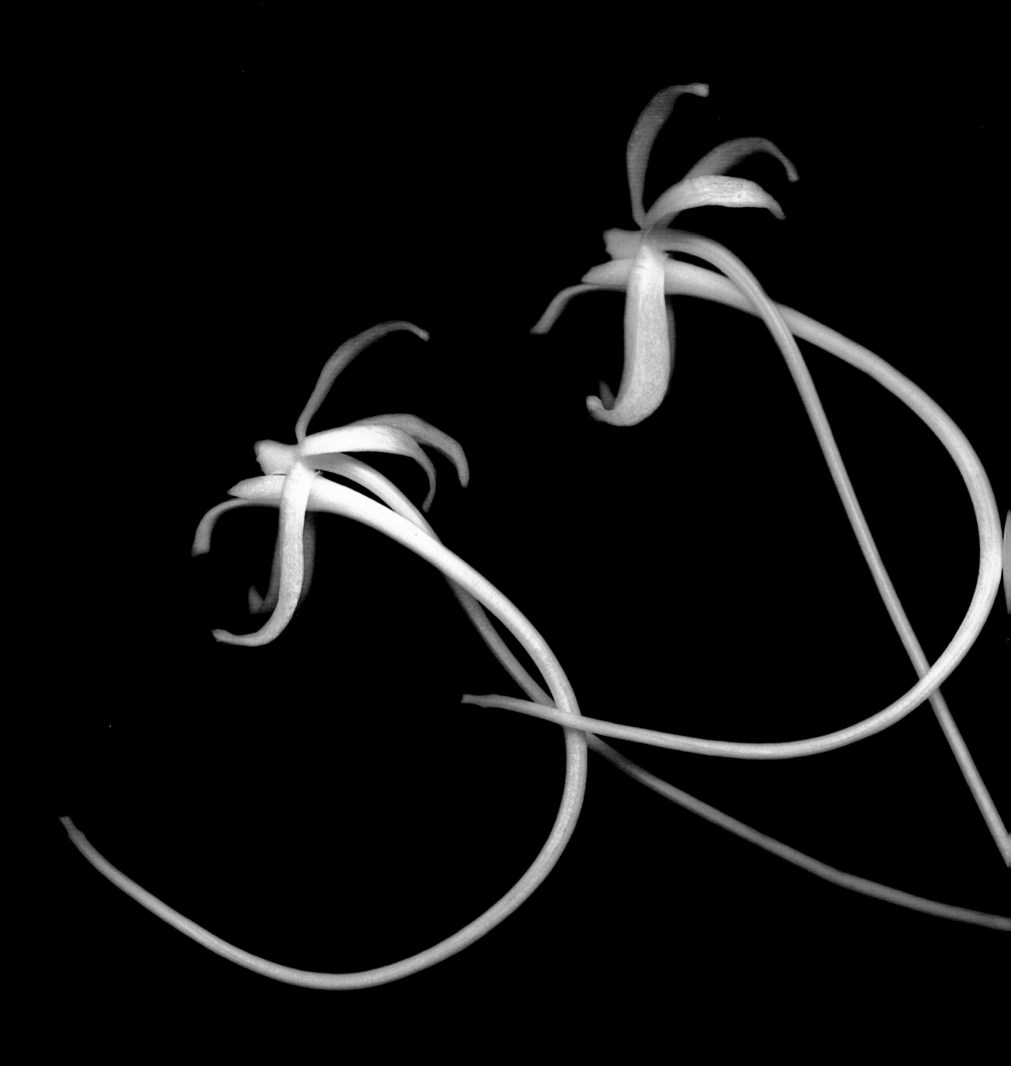

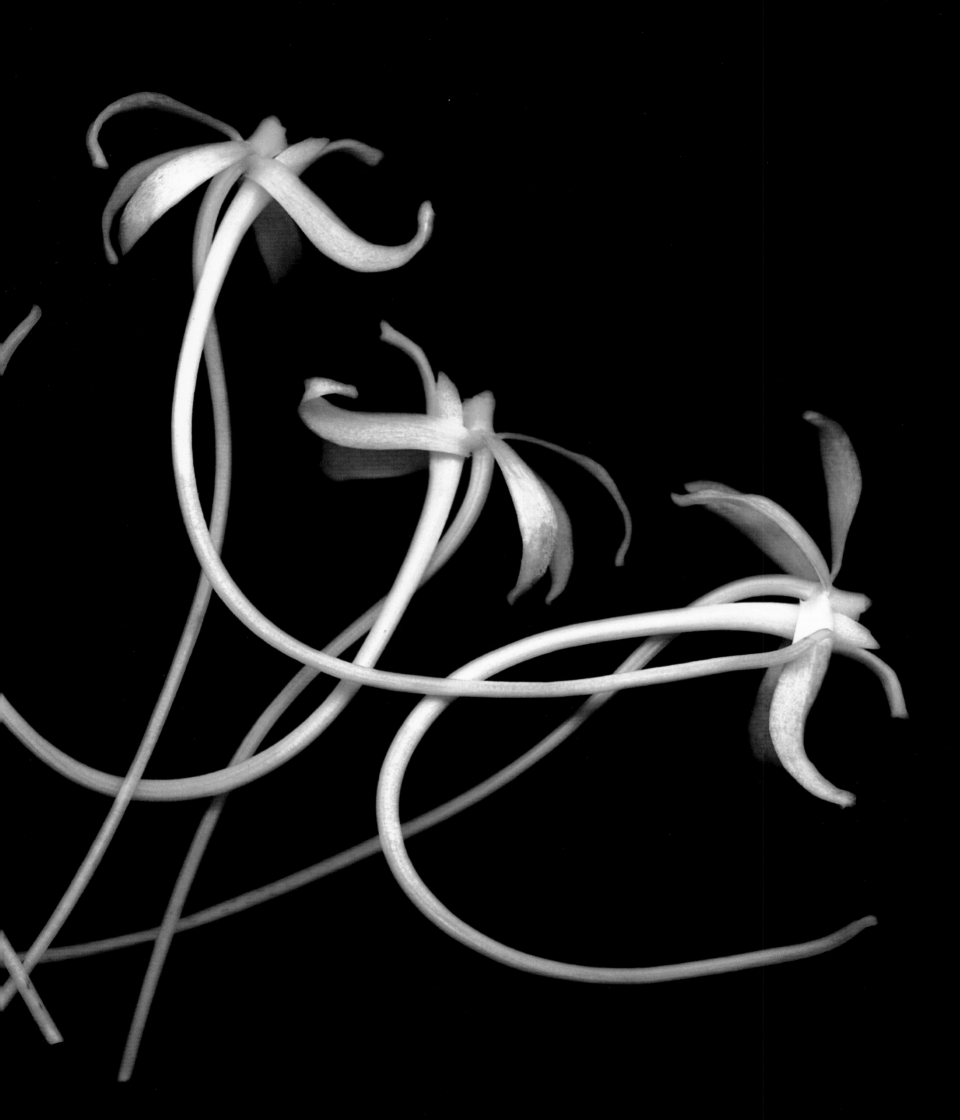

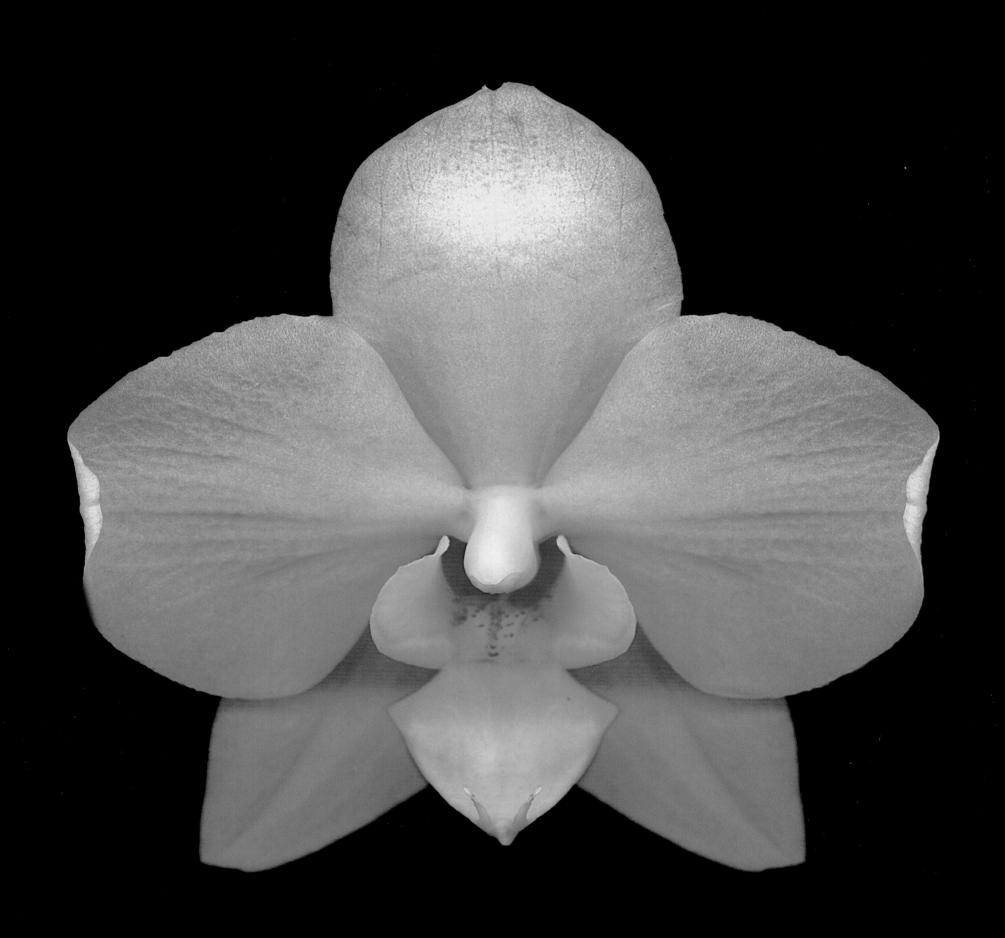

PHALAENOPSIS HYBRID

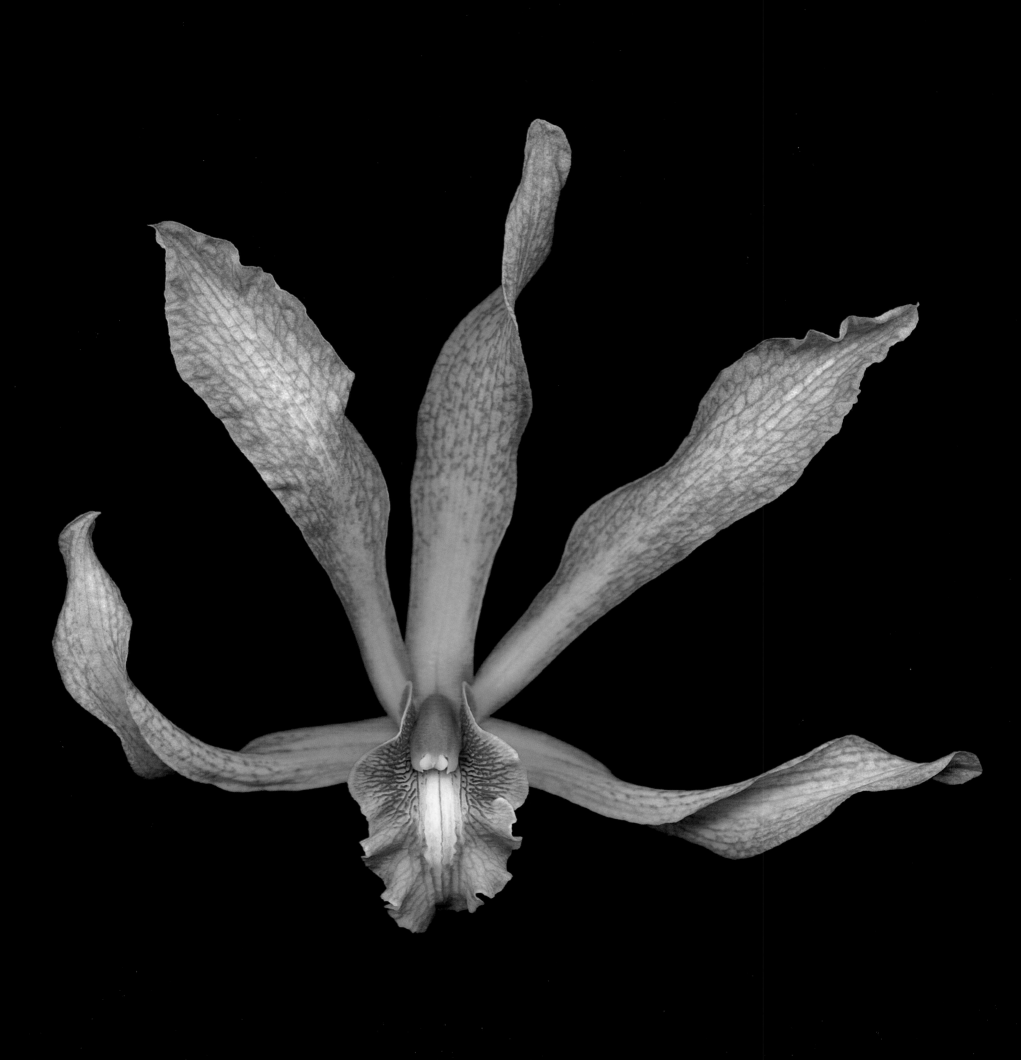

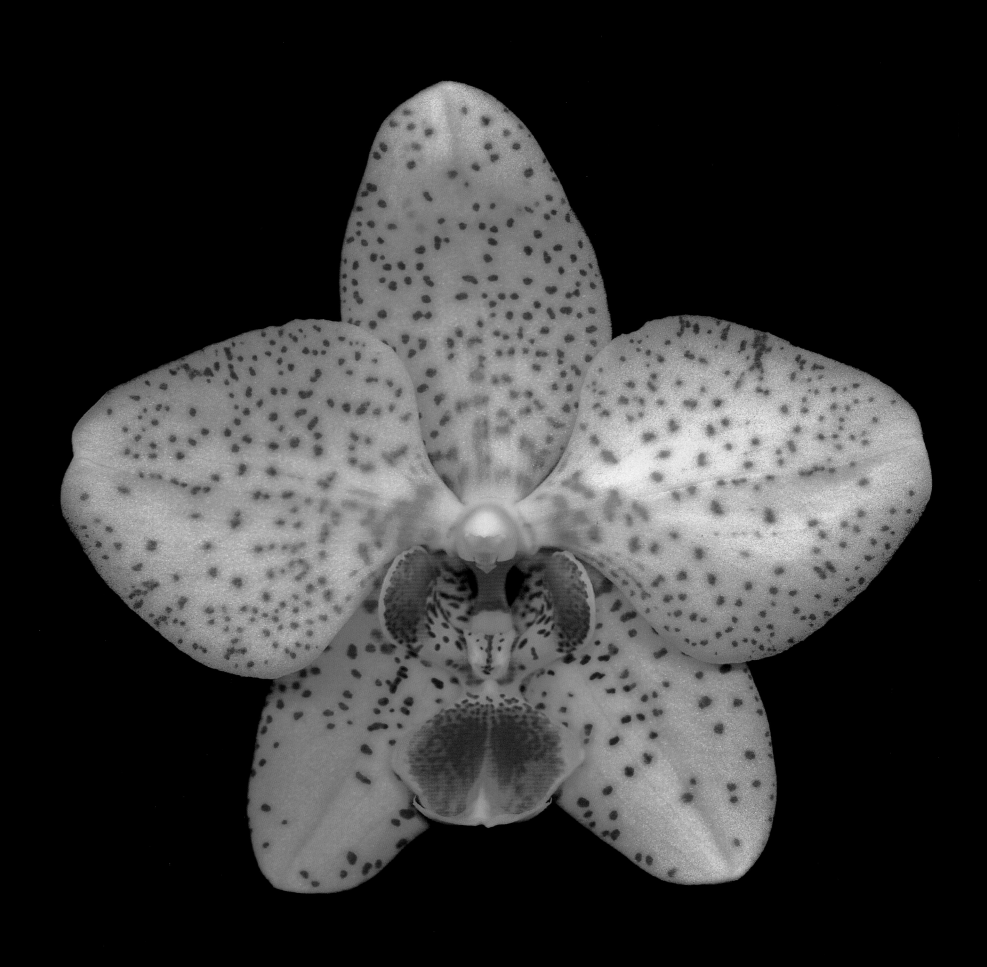

PHALAENOPSIS HYBRID

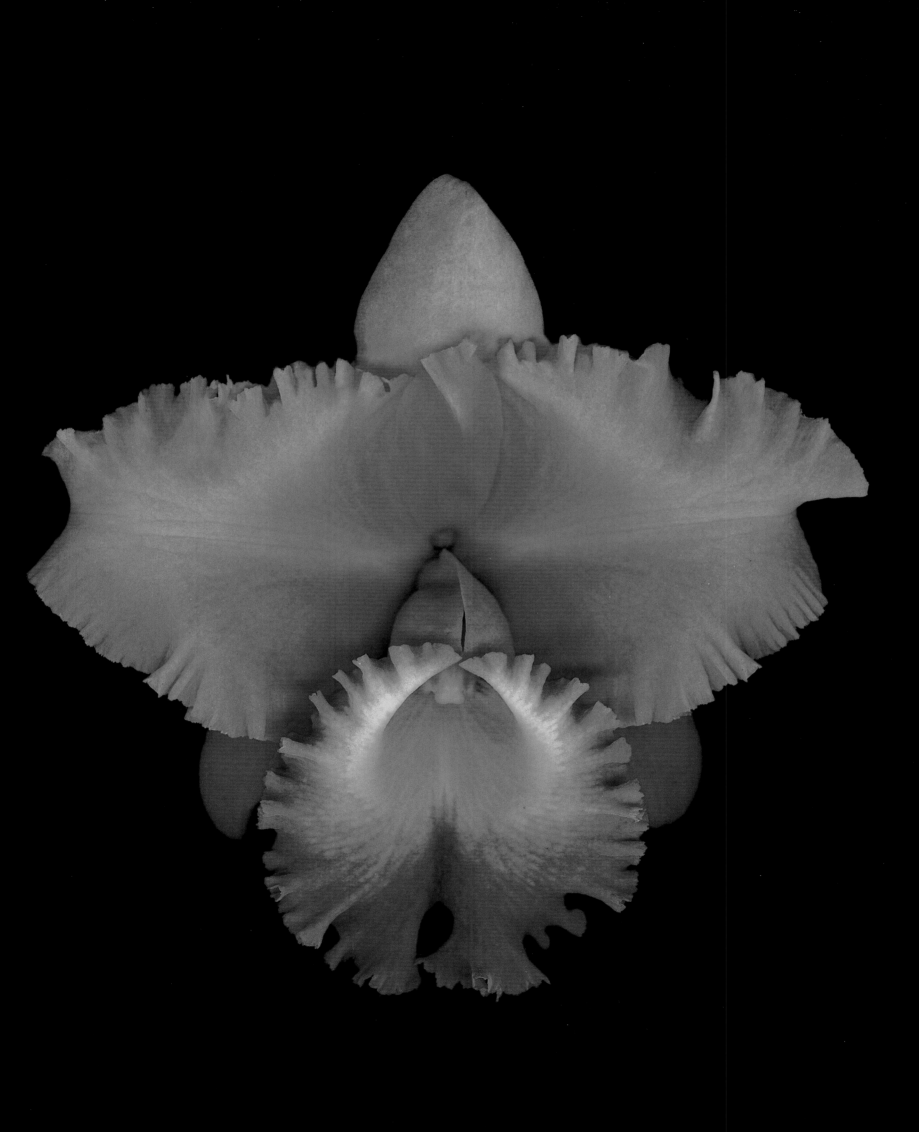

BRASSOLAELIOCATTLEYA HYBRID

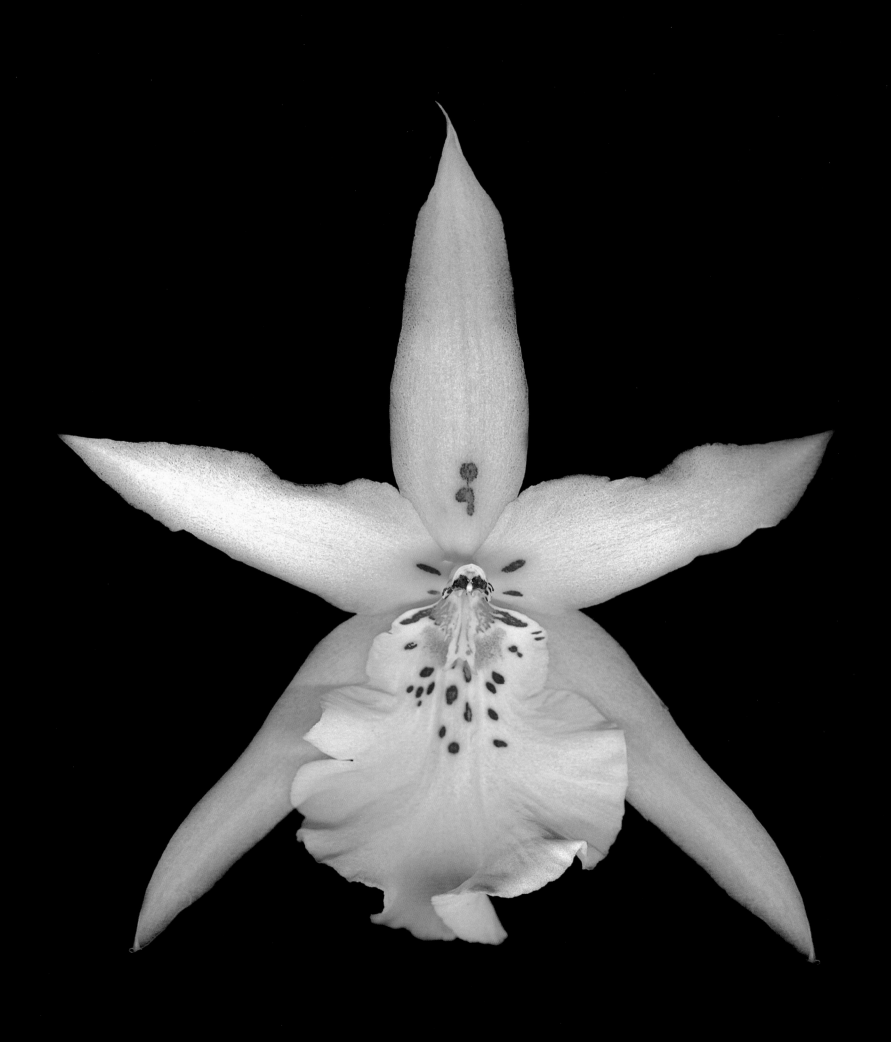

BEALLARA (COMPLEX INTERGENERIC) HYBRID

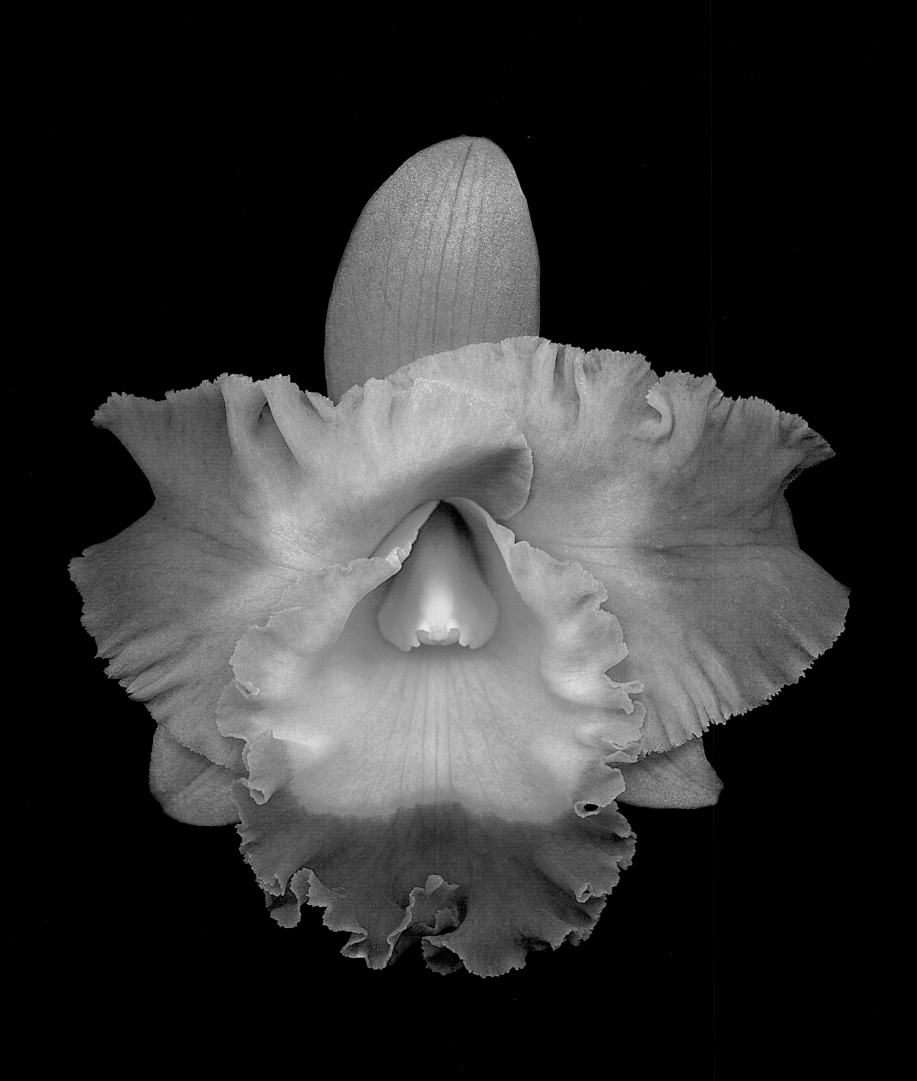

BRASSOLAELIOCATTLEYA HYBRID

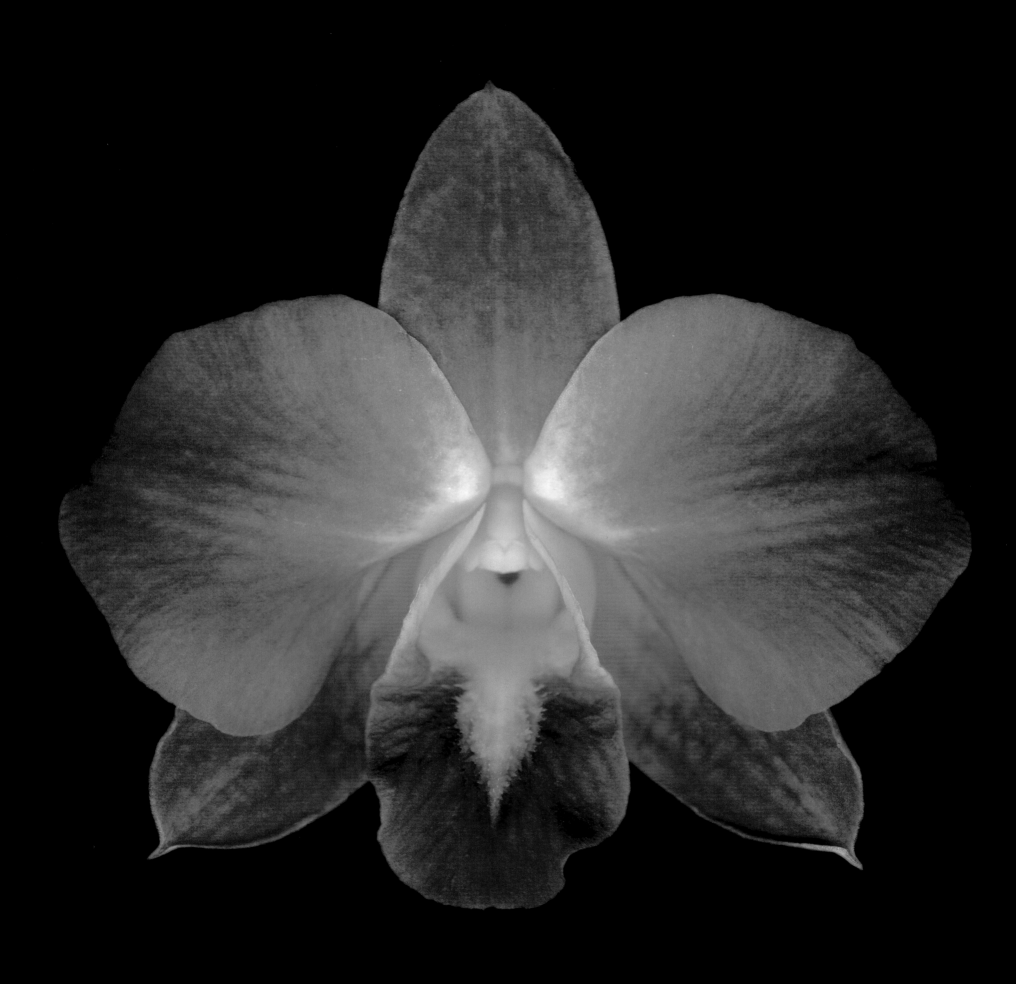

DENDROBIUM HYBRID

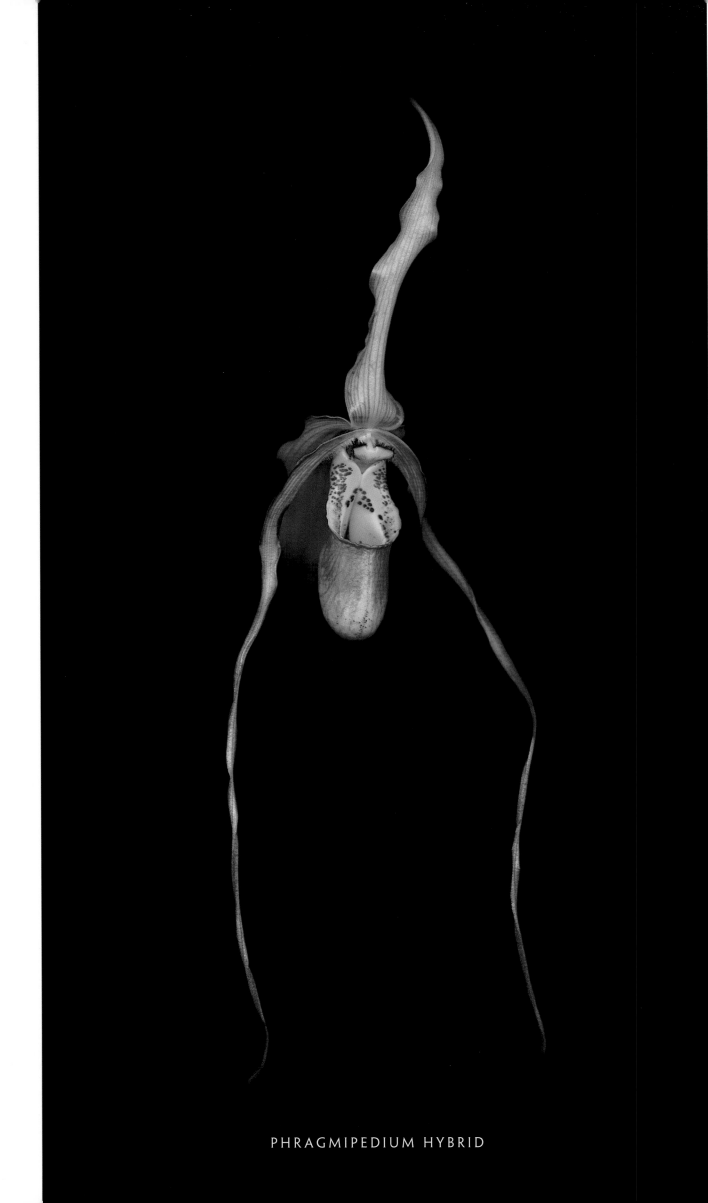

PHRAGMIPEDIUM HYBRID

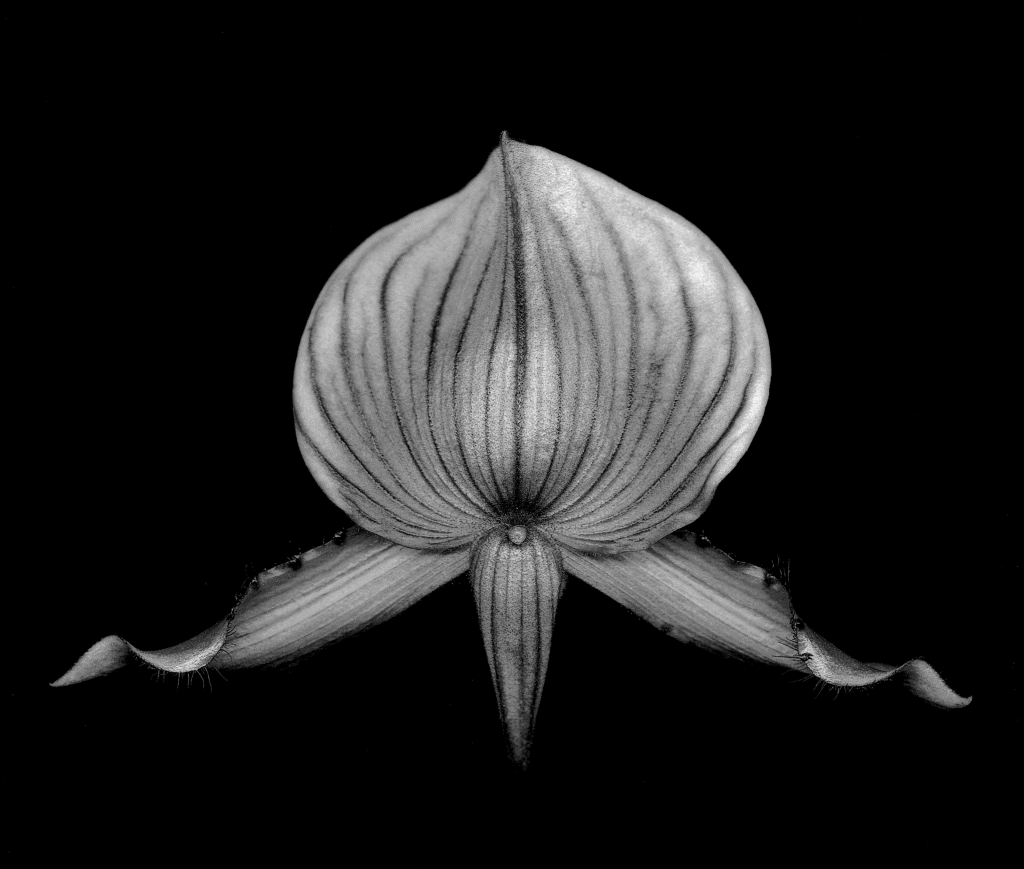

PAPHIOPEDILUM HYBRID

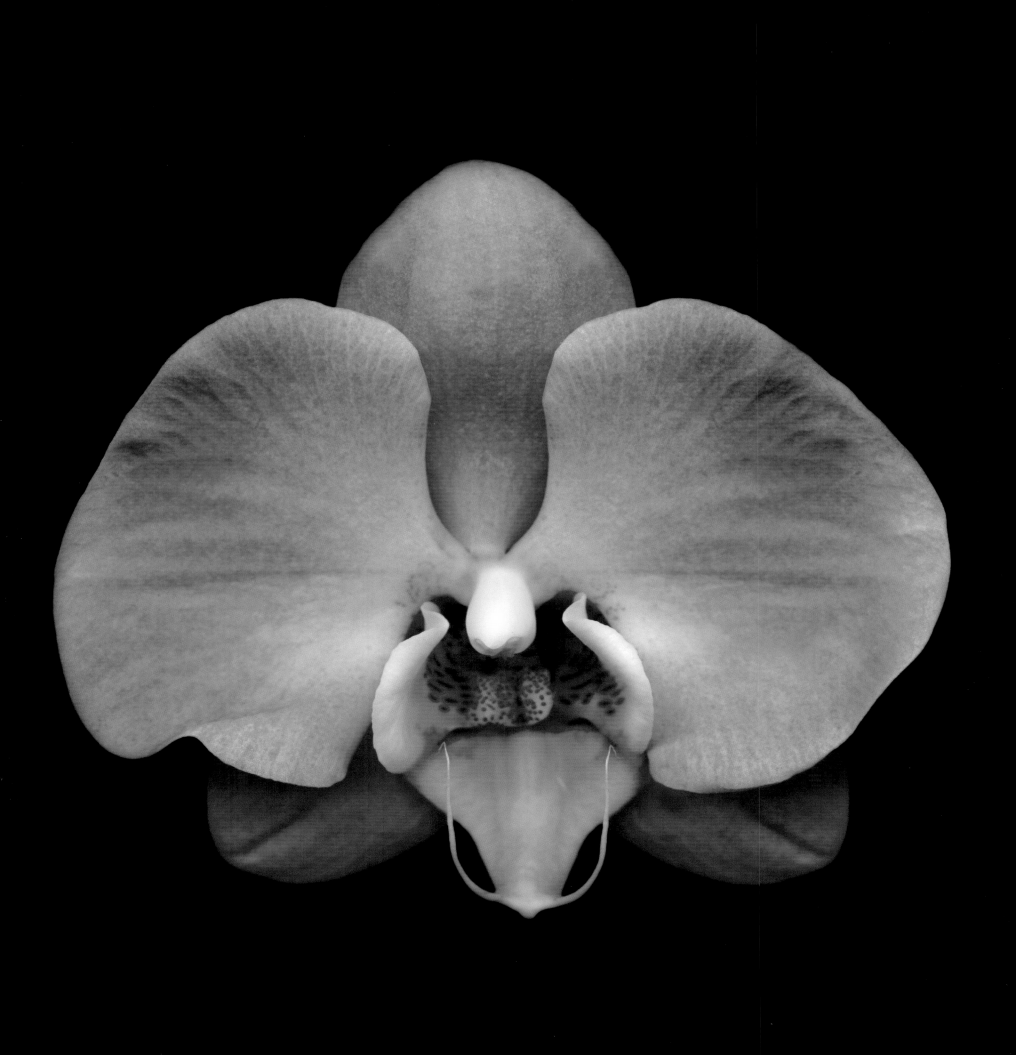

PHALAENOPSIS HYBRID

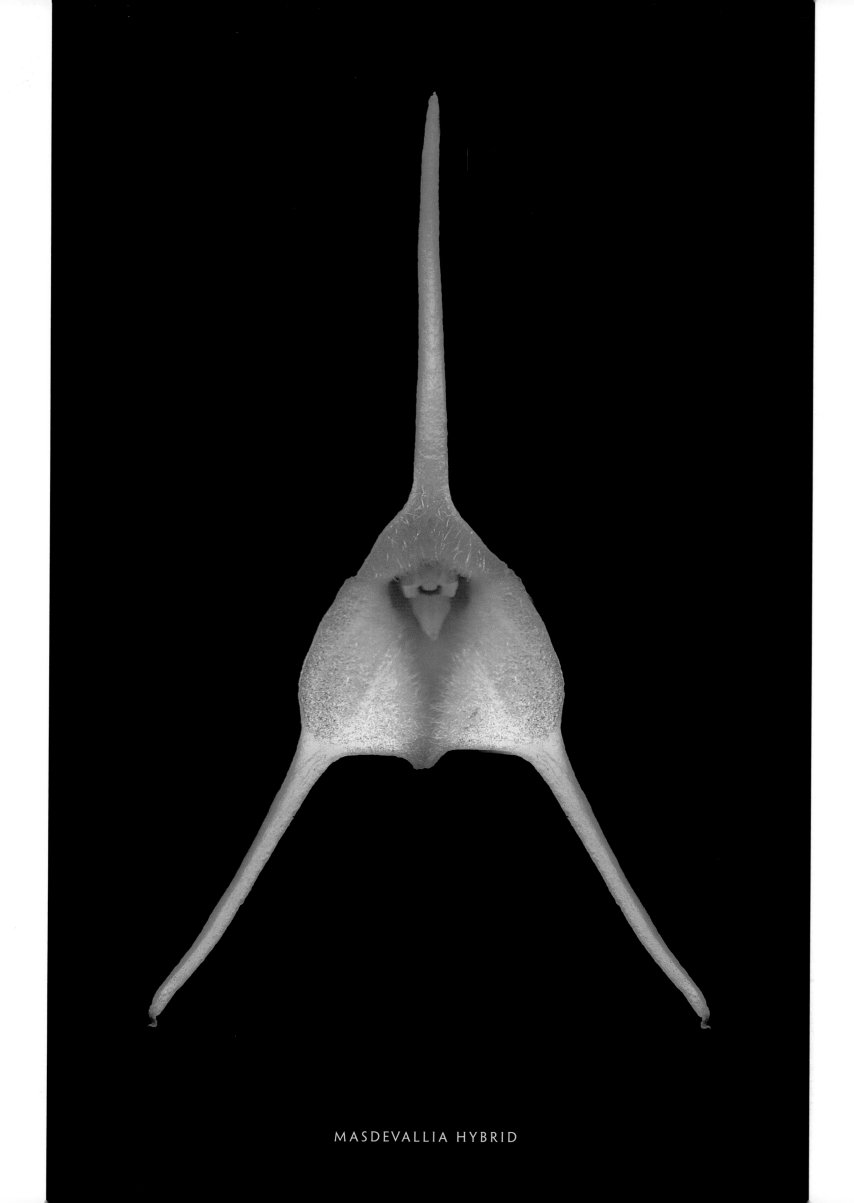

MASDEVALLIA HYBRID

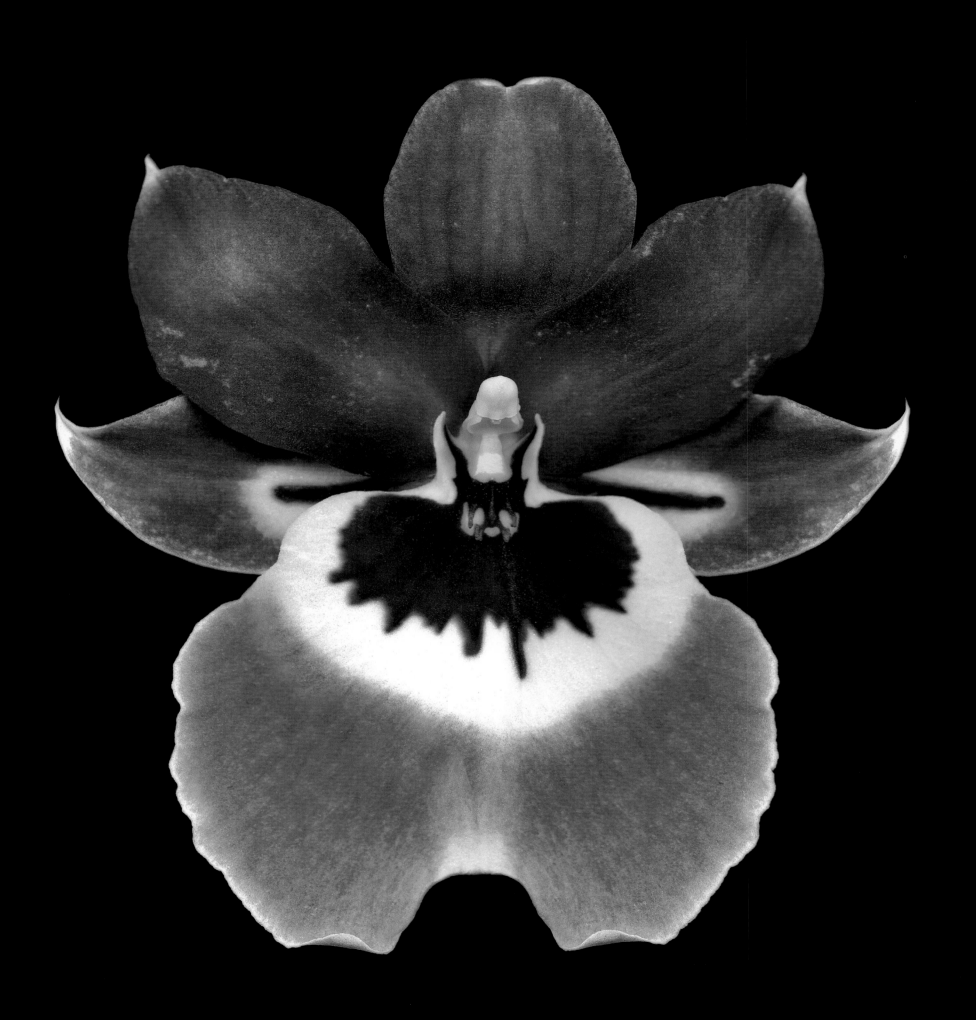

MILTONIOPSIS HYBRID

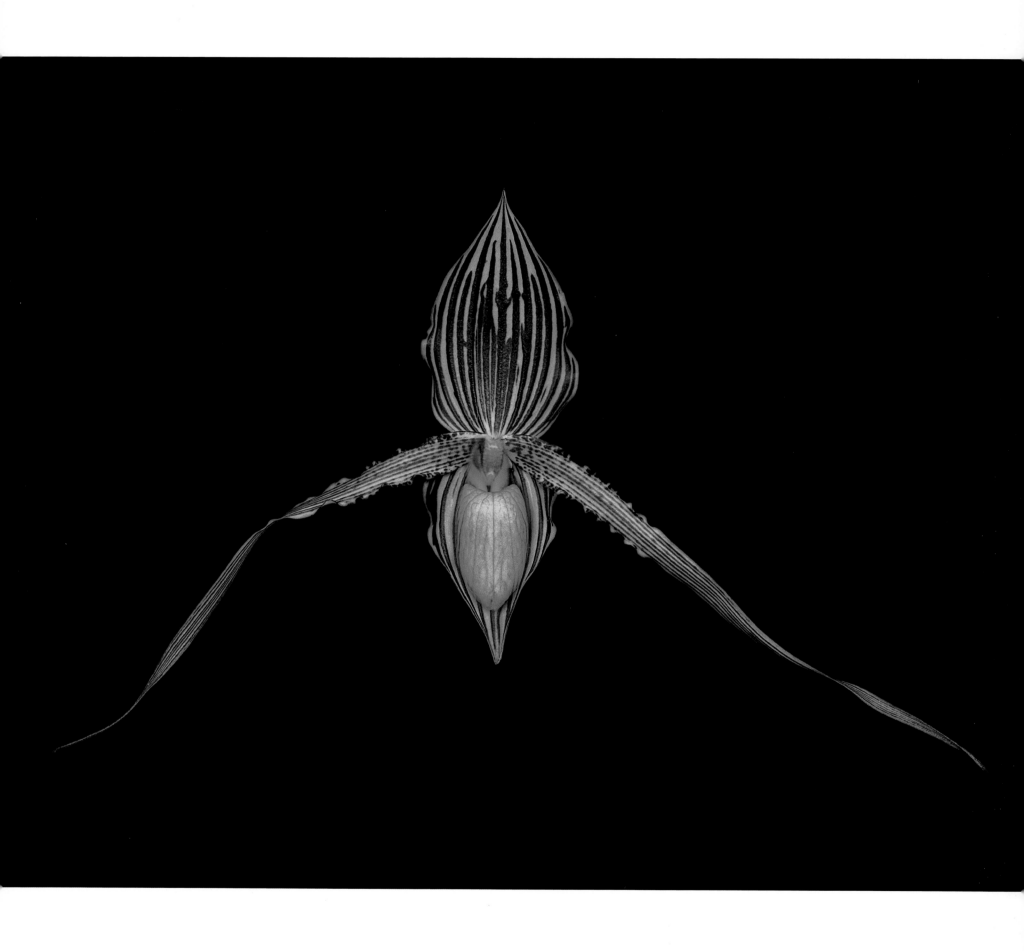

PAPHIOPEDILUM HYBRID

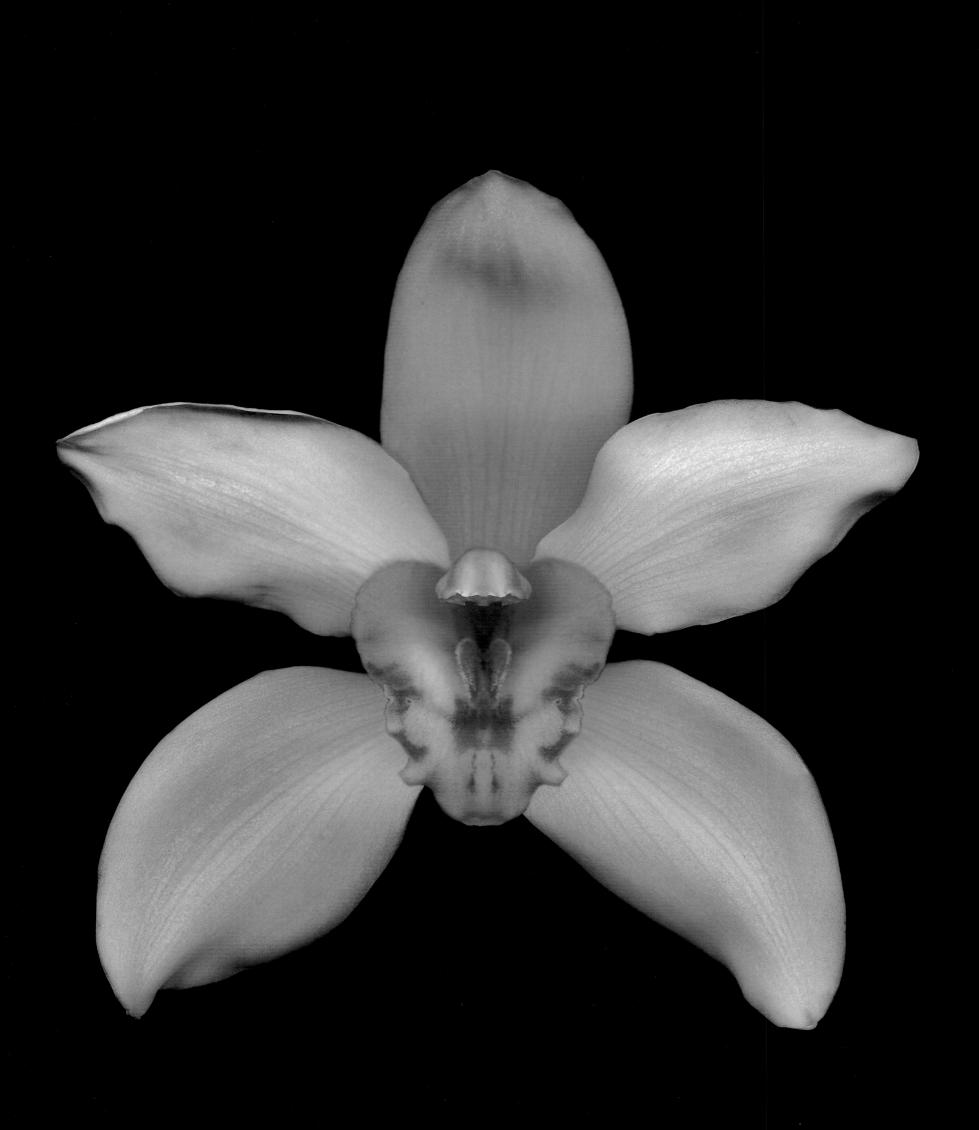

CYMBIDIUM HYBRID

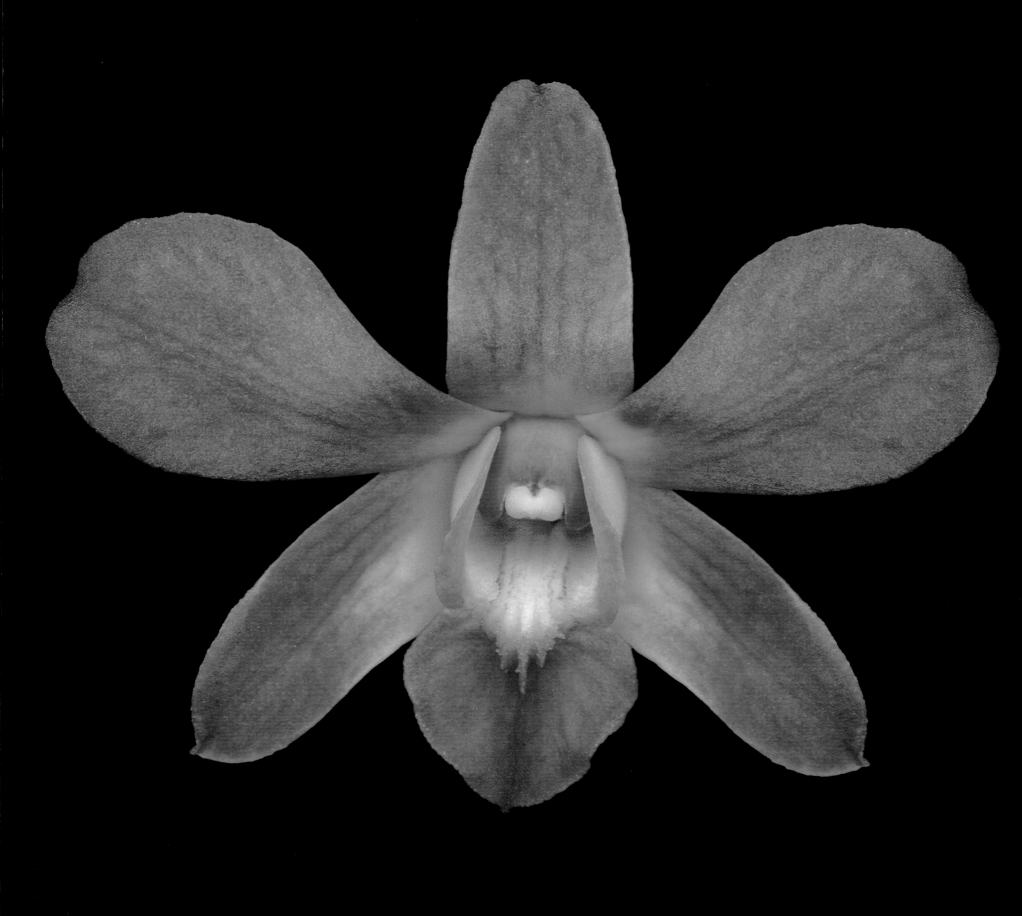

DENDROBIUM HYBRID

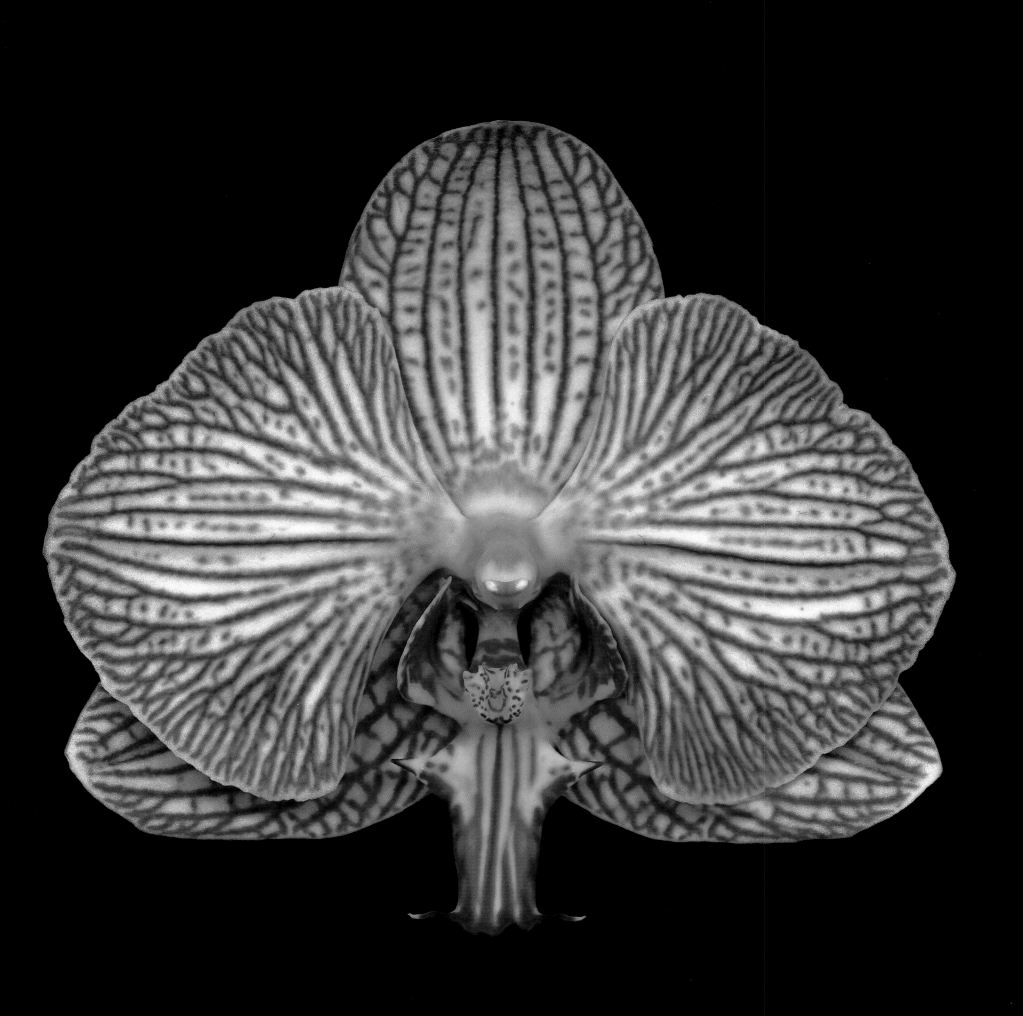

PHALAENOPSIS HYBRID

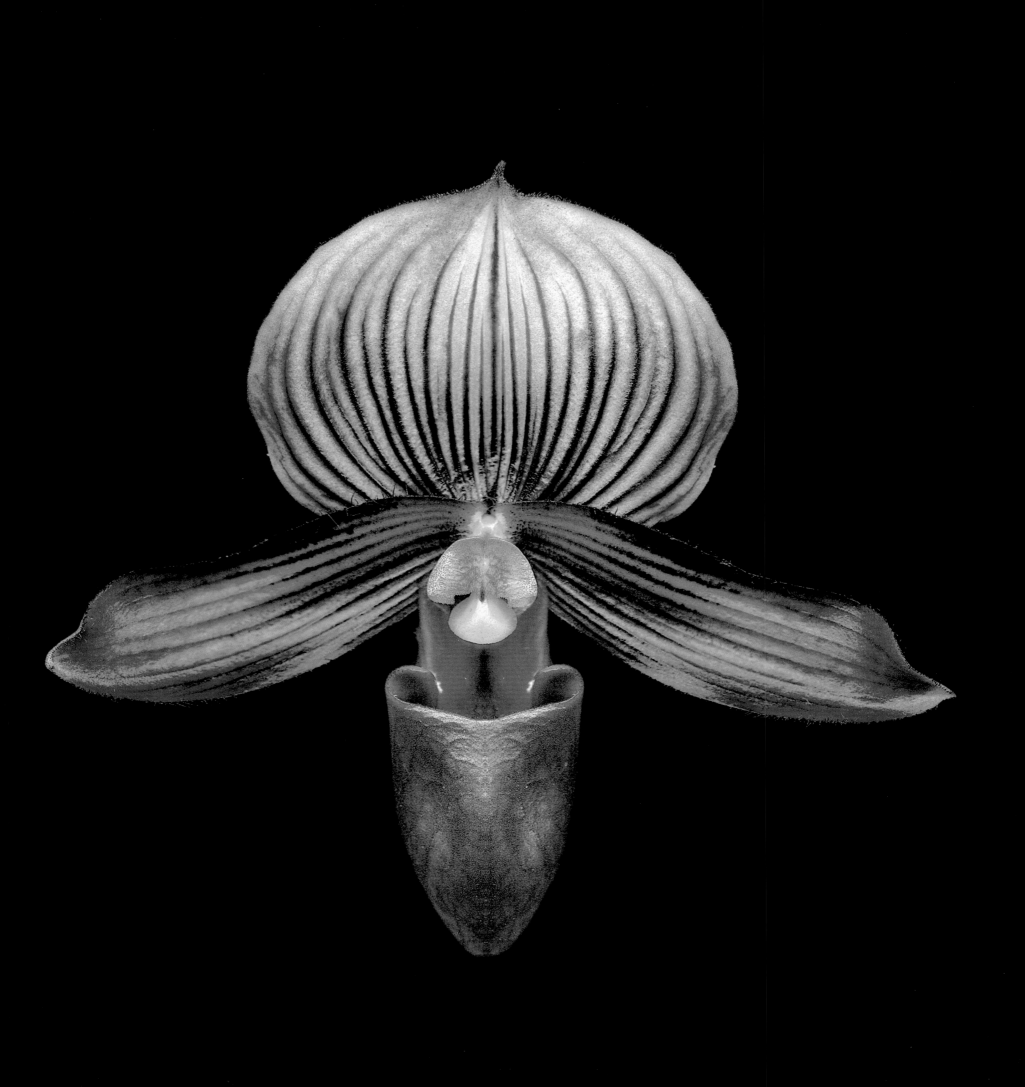

PAPHIOPEDILUM HYBRID

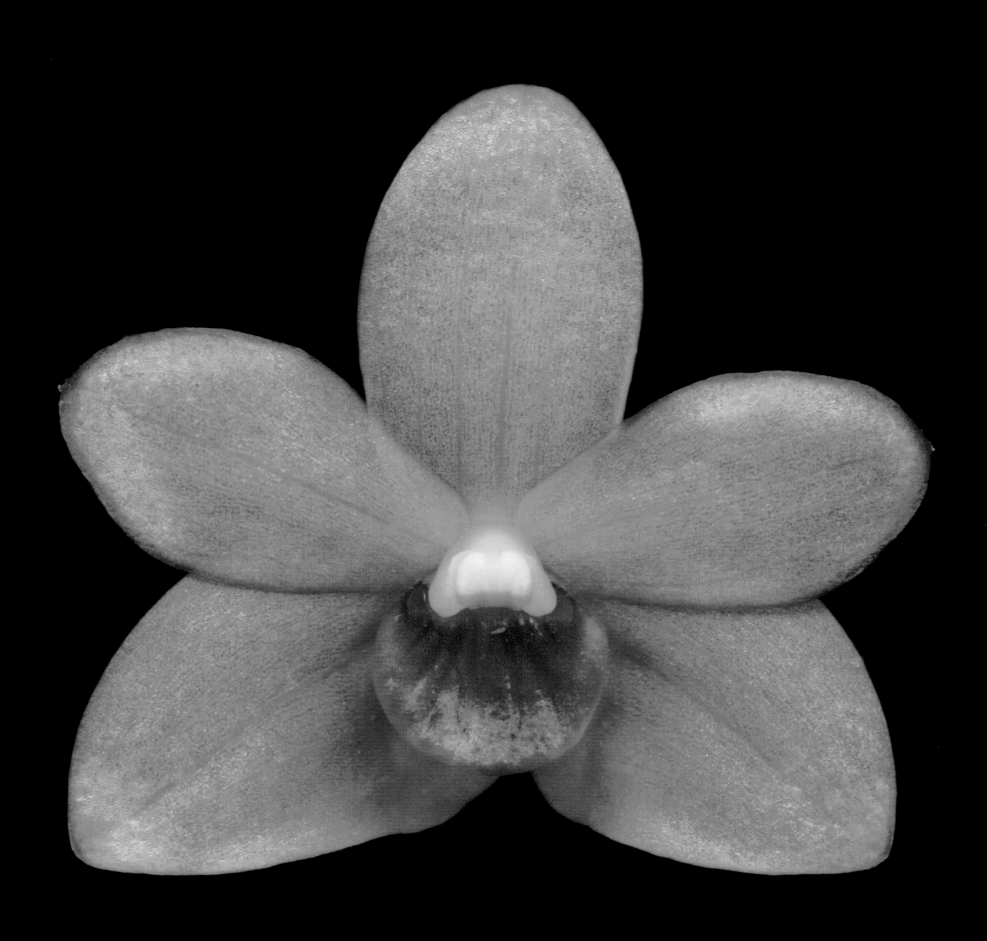

DENDROBIUM HYBRID

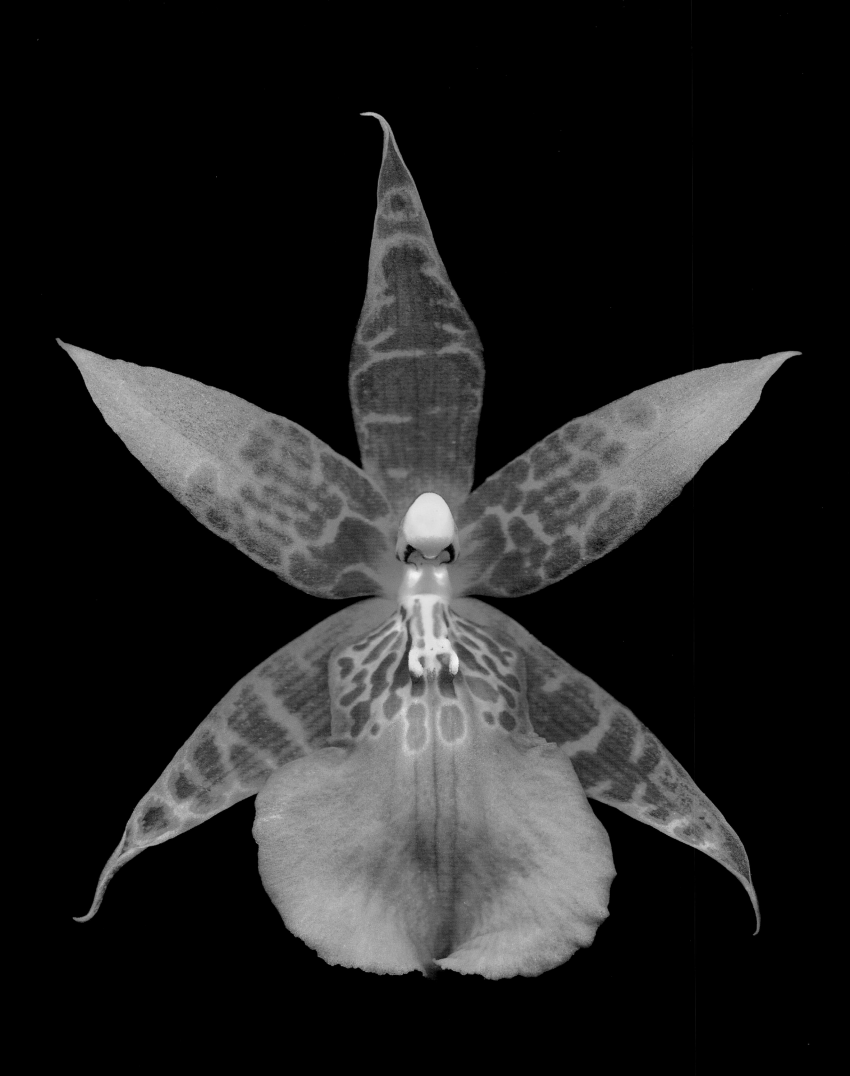

MILTASSIA HYBRID

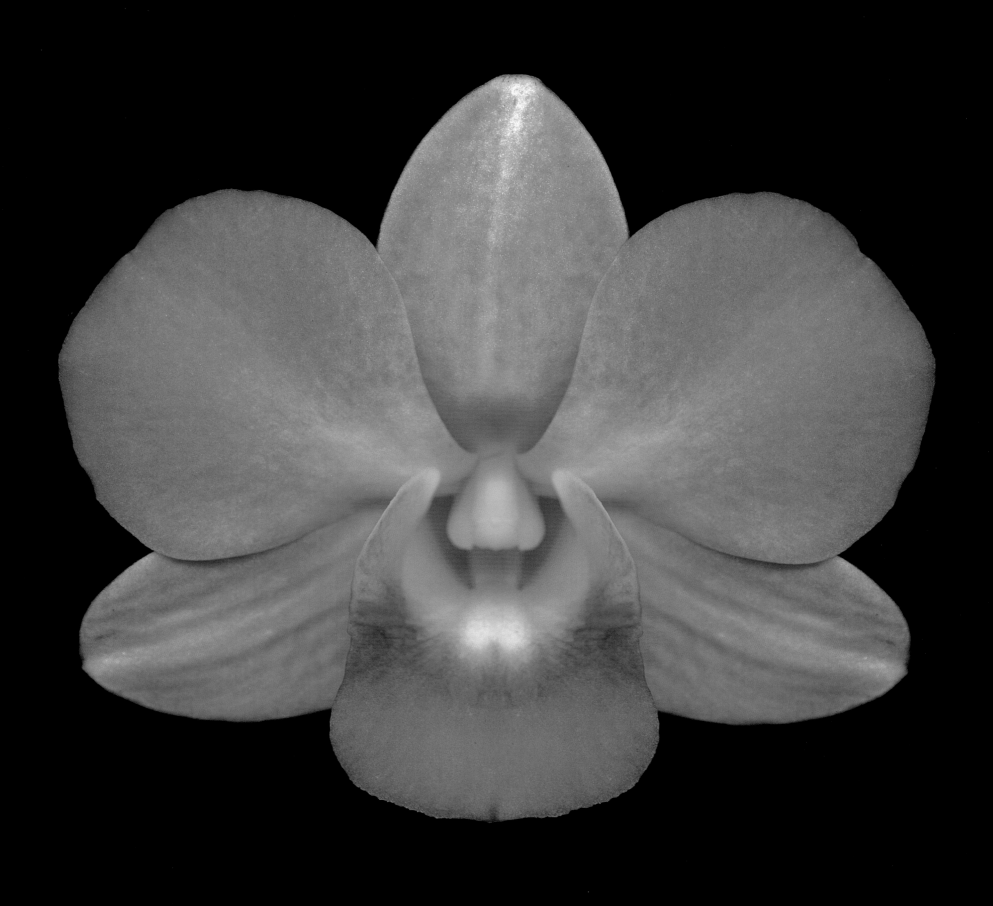

DENDROBIUM HYBRID

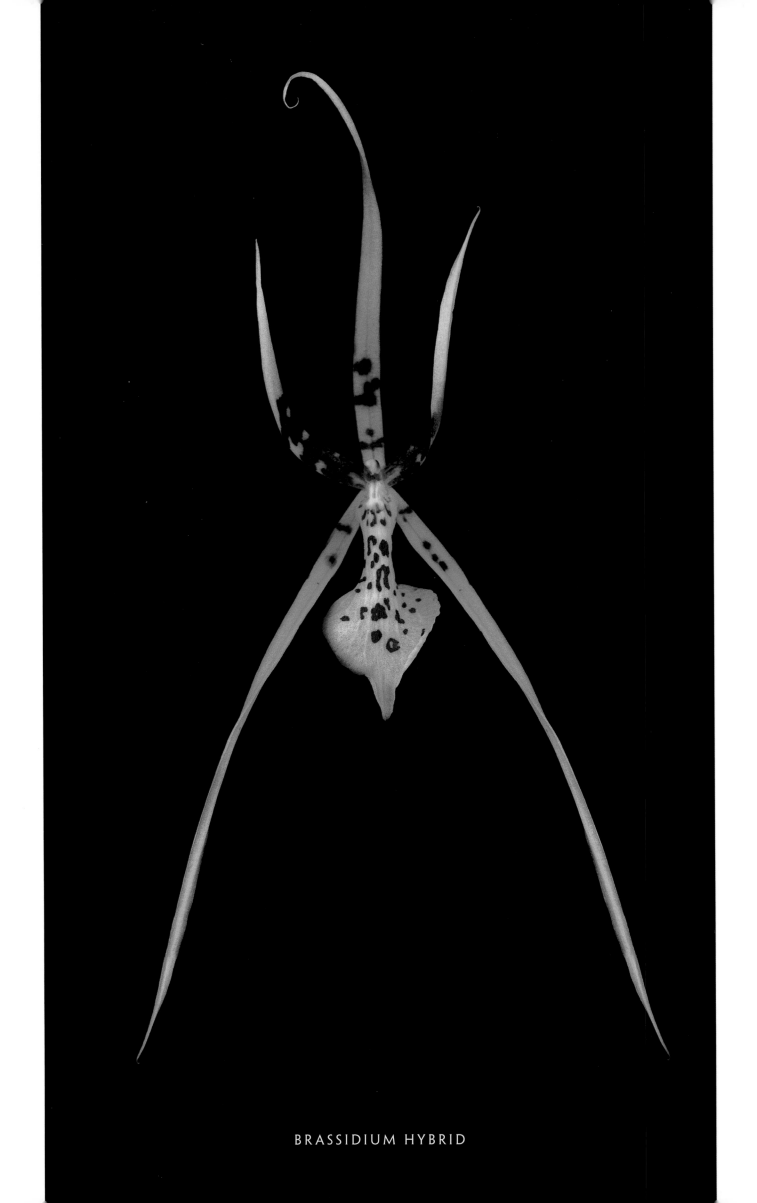

BRASSIDIUM HYBRID

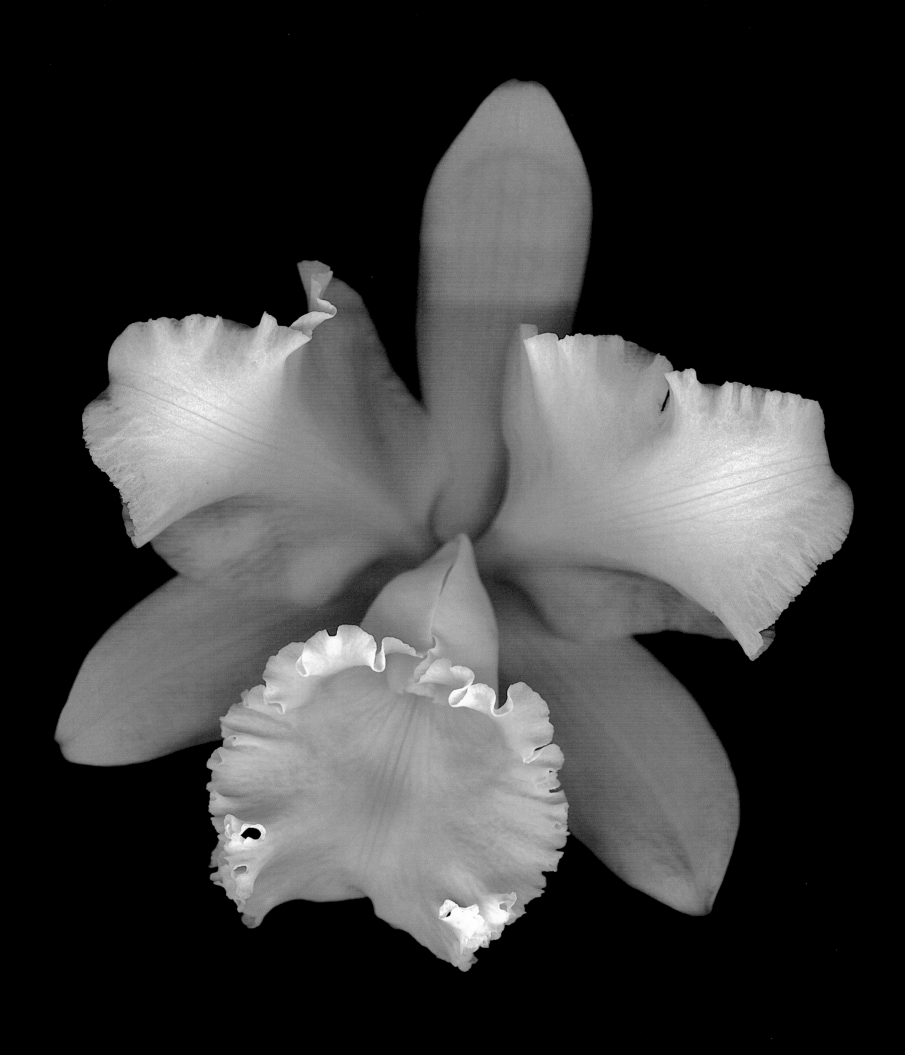

CATTLEYA HYBRID

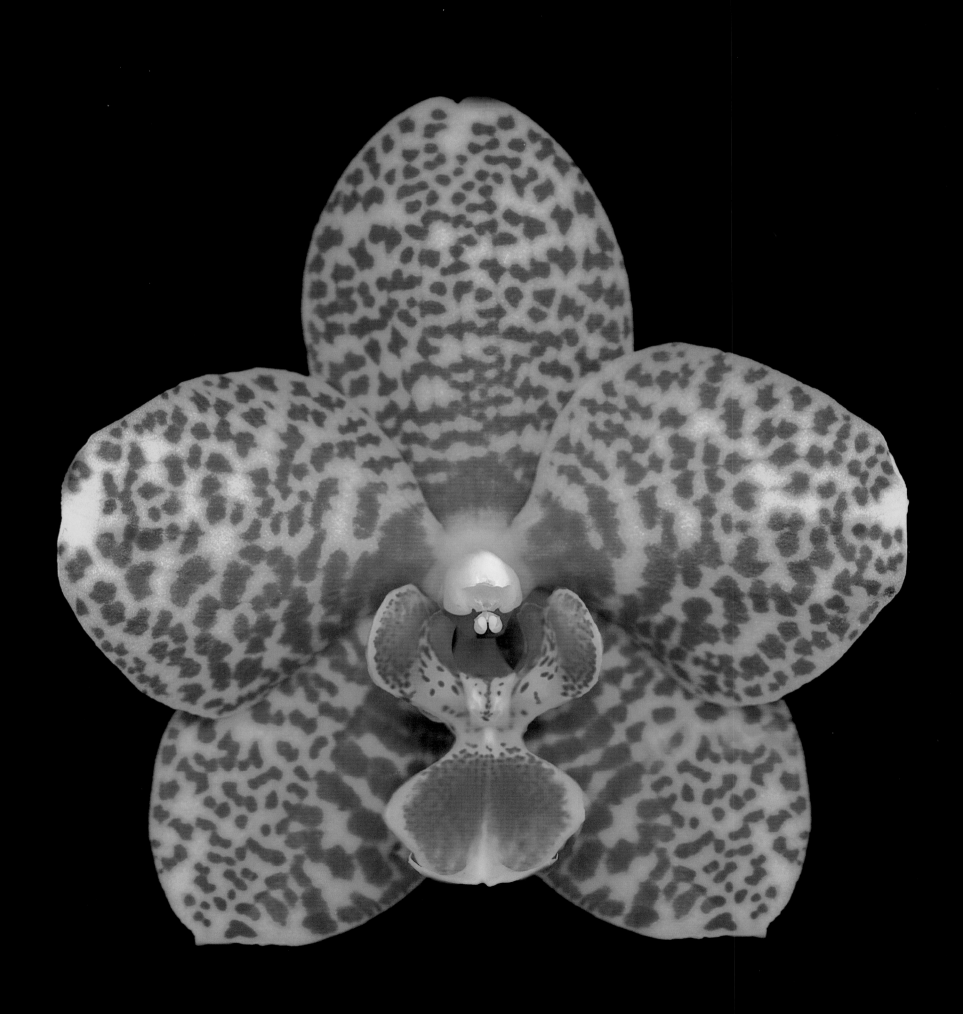

PHALAENOPSIS HYBRID

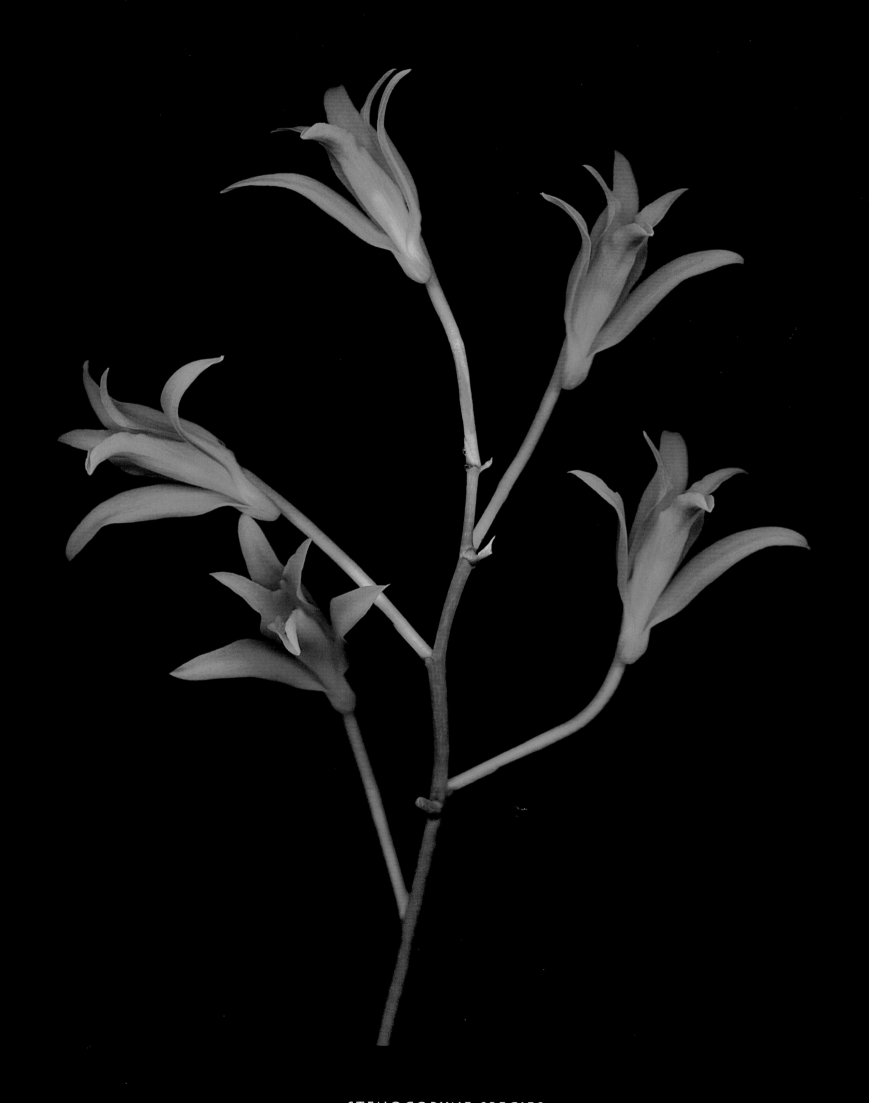

STENOCORYNE SPECIES

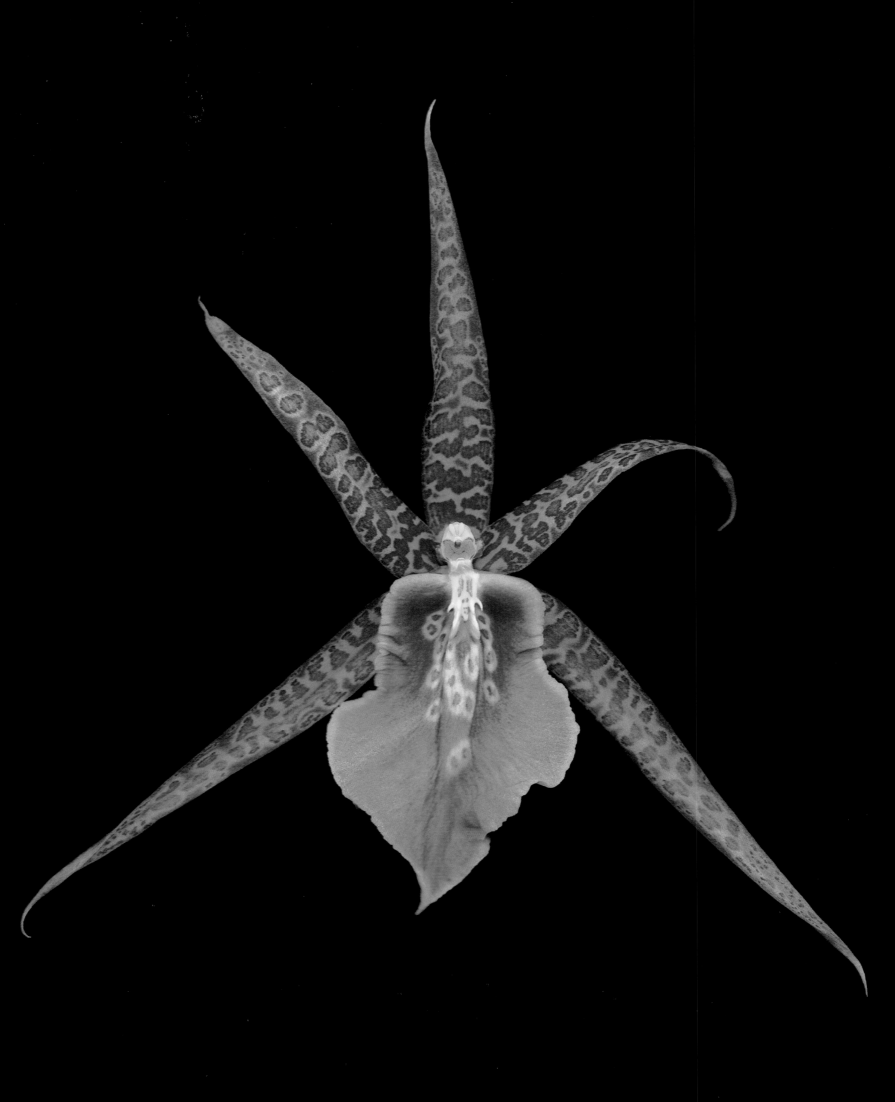

ALICEARA (COMPLEX INTERGENERIC) HYBRID

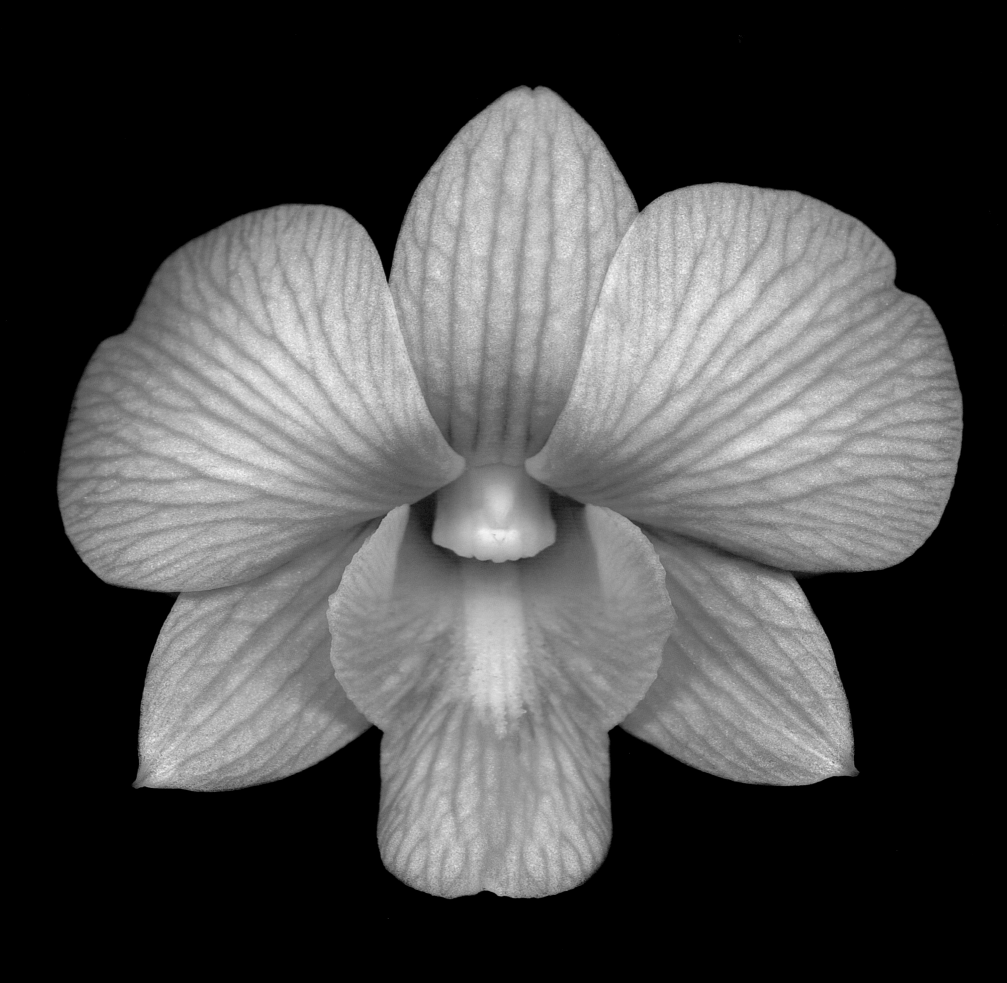

DENDROBIUM HYBRID

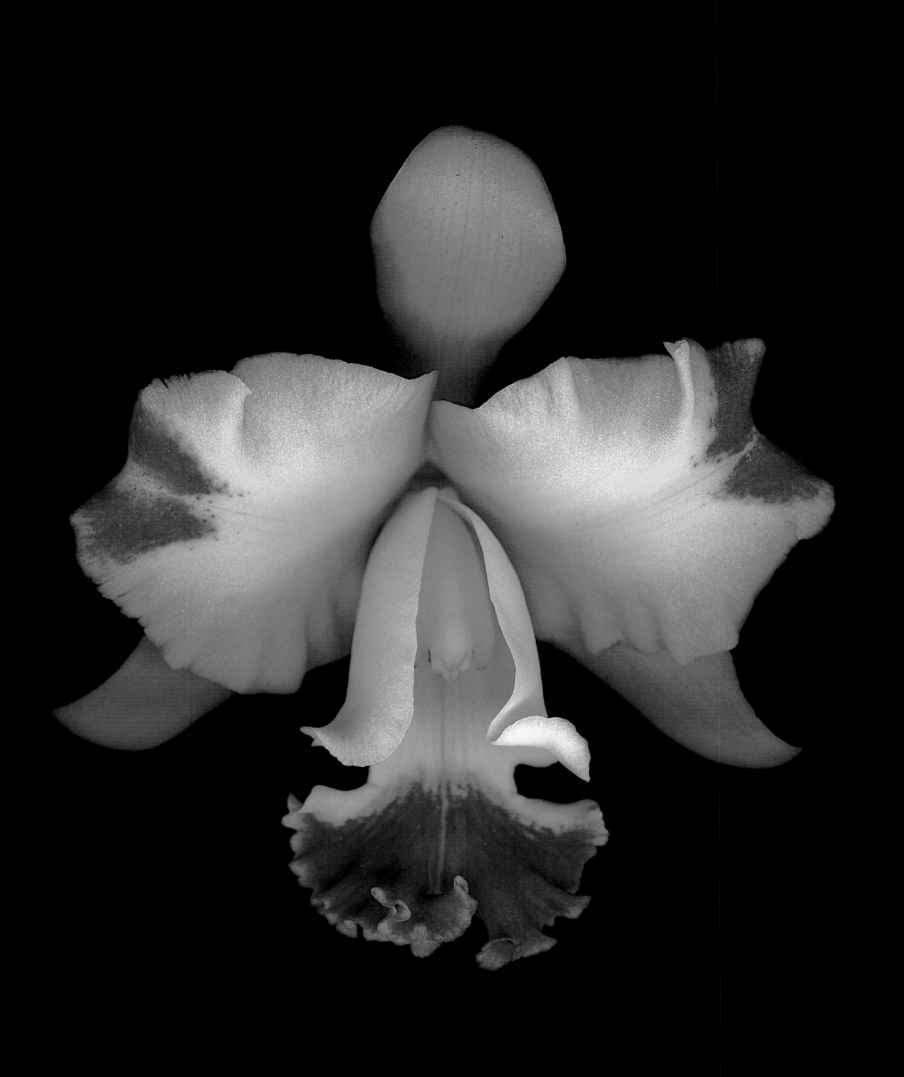

CATTLEYA HYBRID

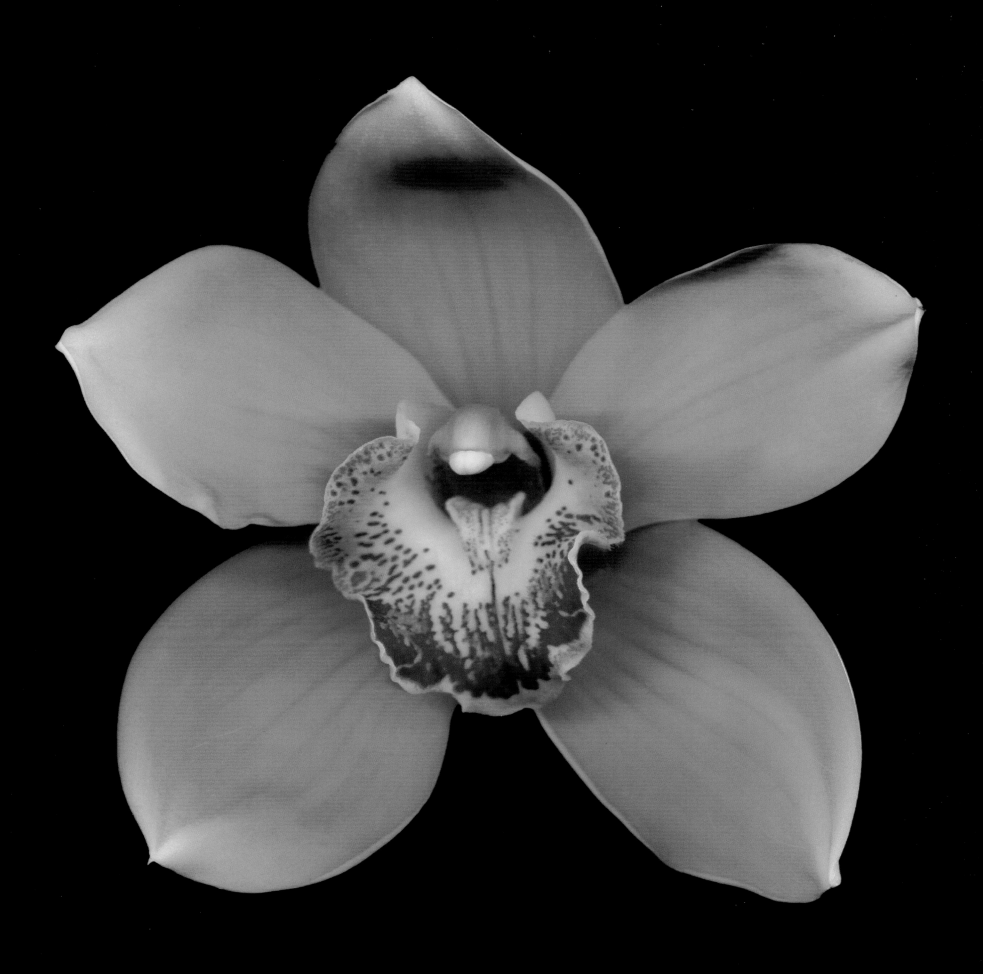

CYMBIDIUM HYBRID

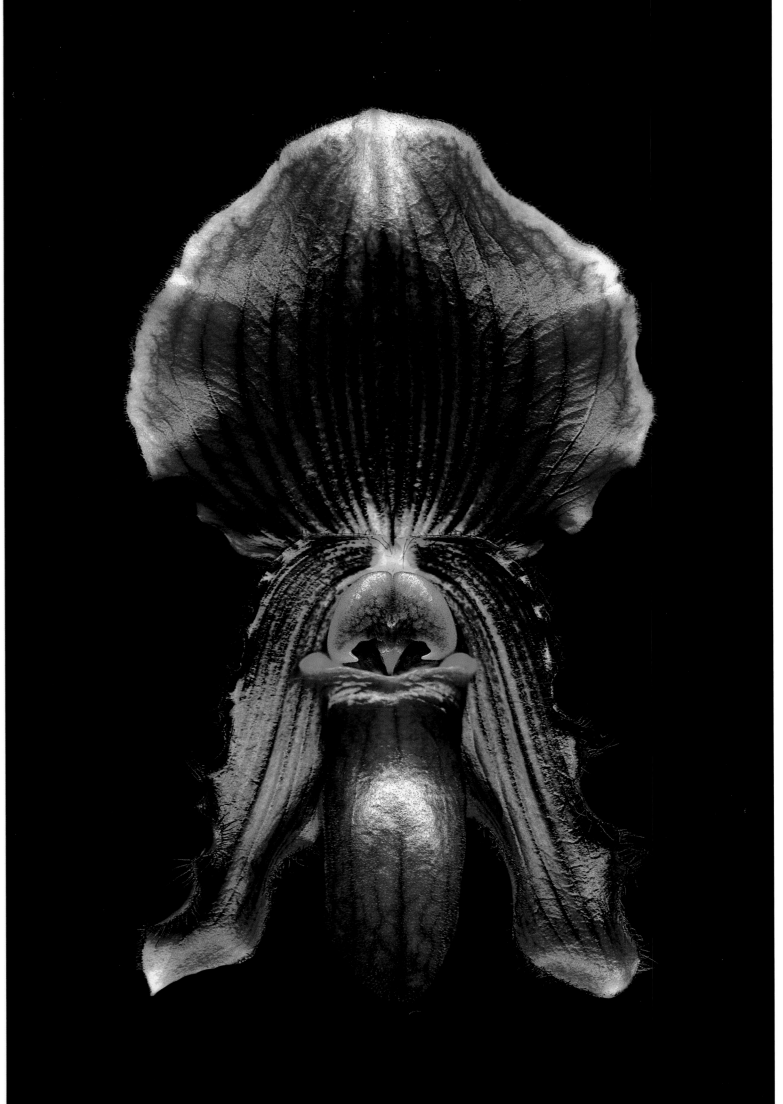

PAPHIOPEDILUM HYBRID

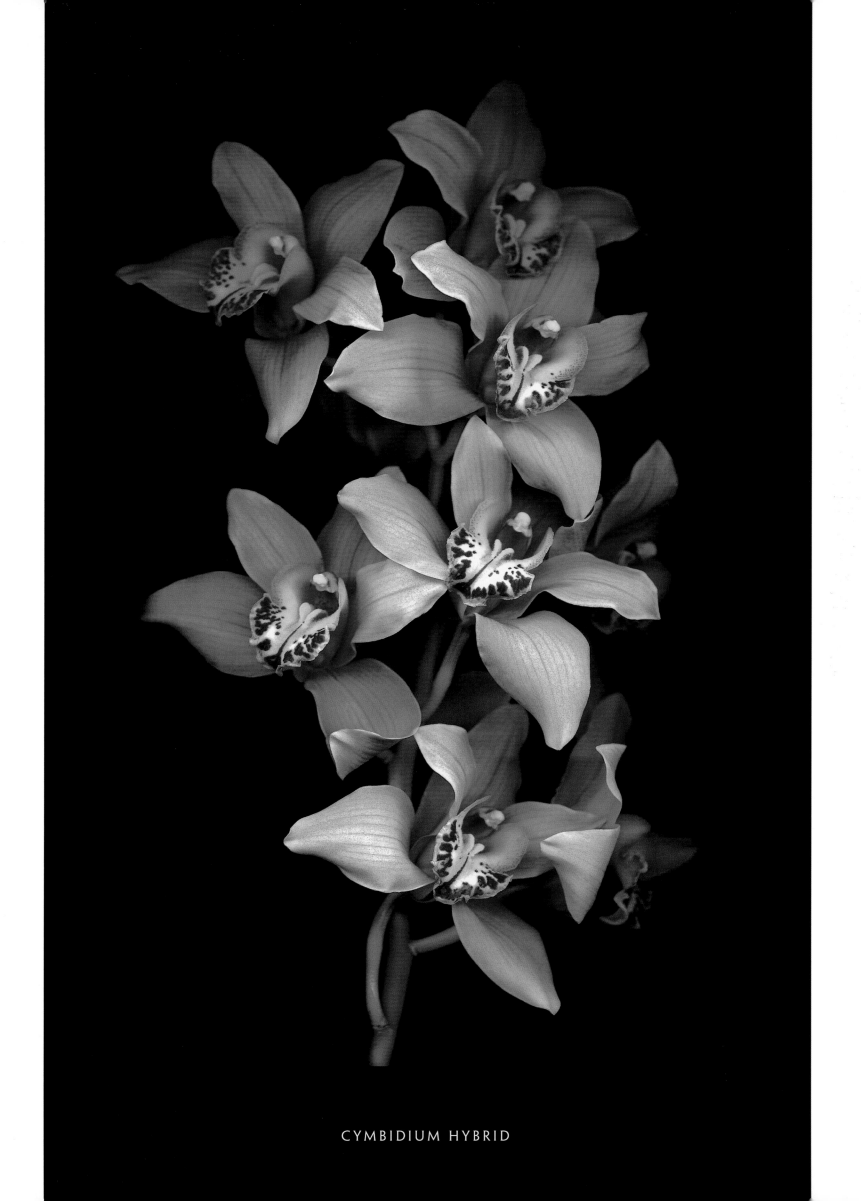

CYMBIDIUM HYBRID

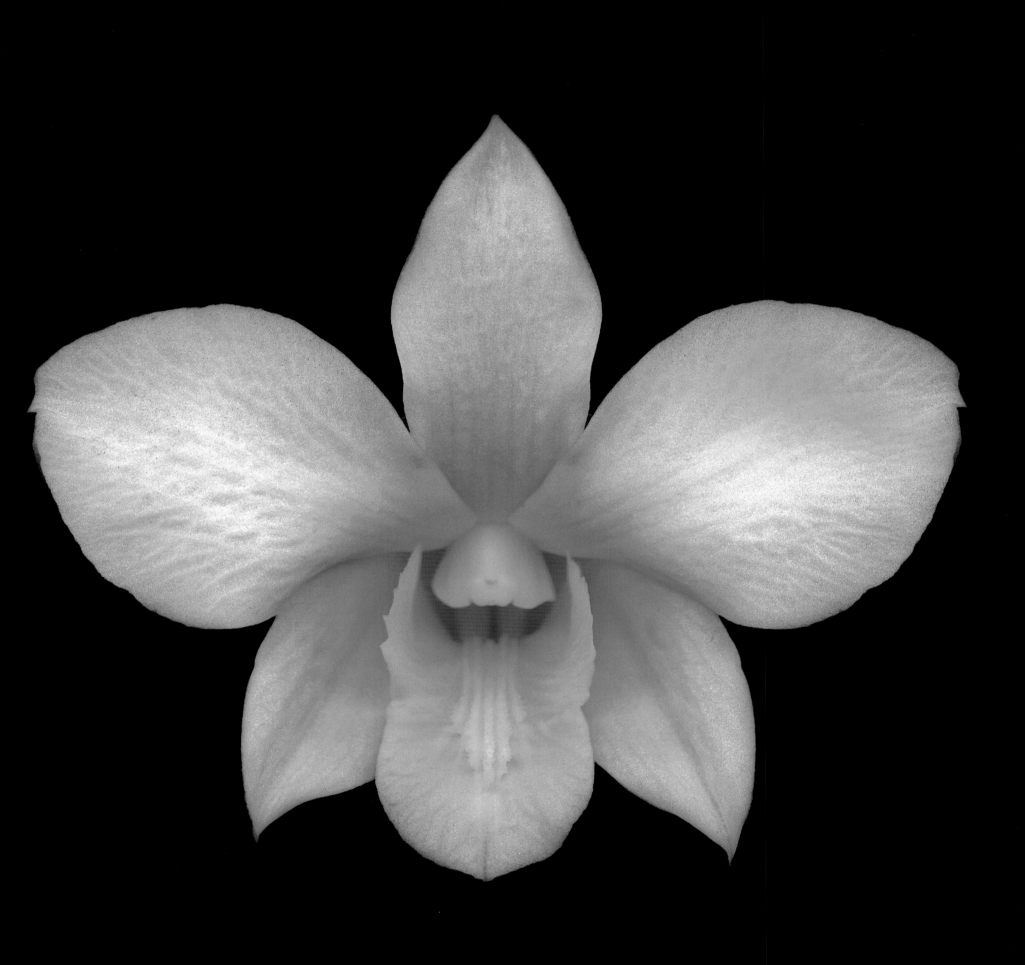

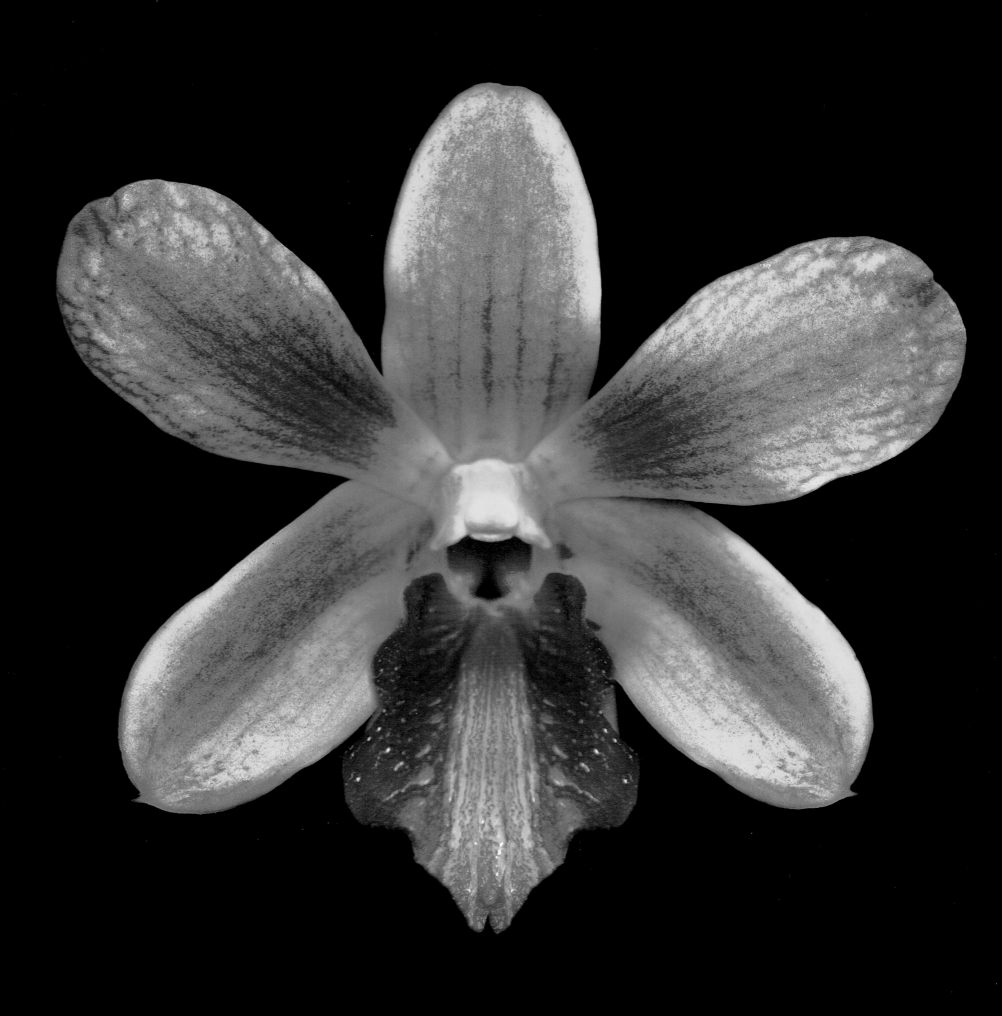

DENDROBIUM HYBRID

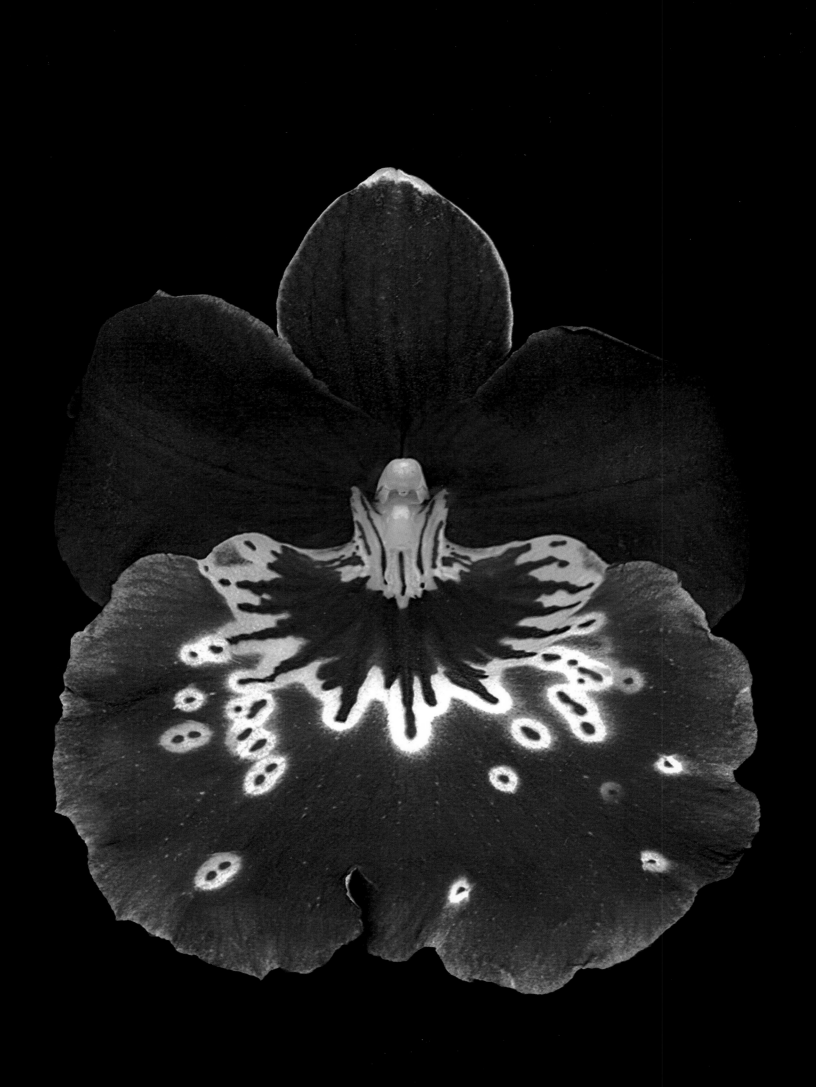

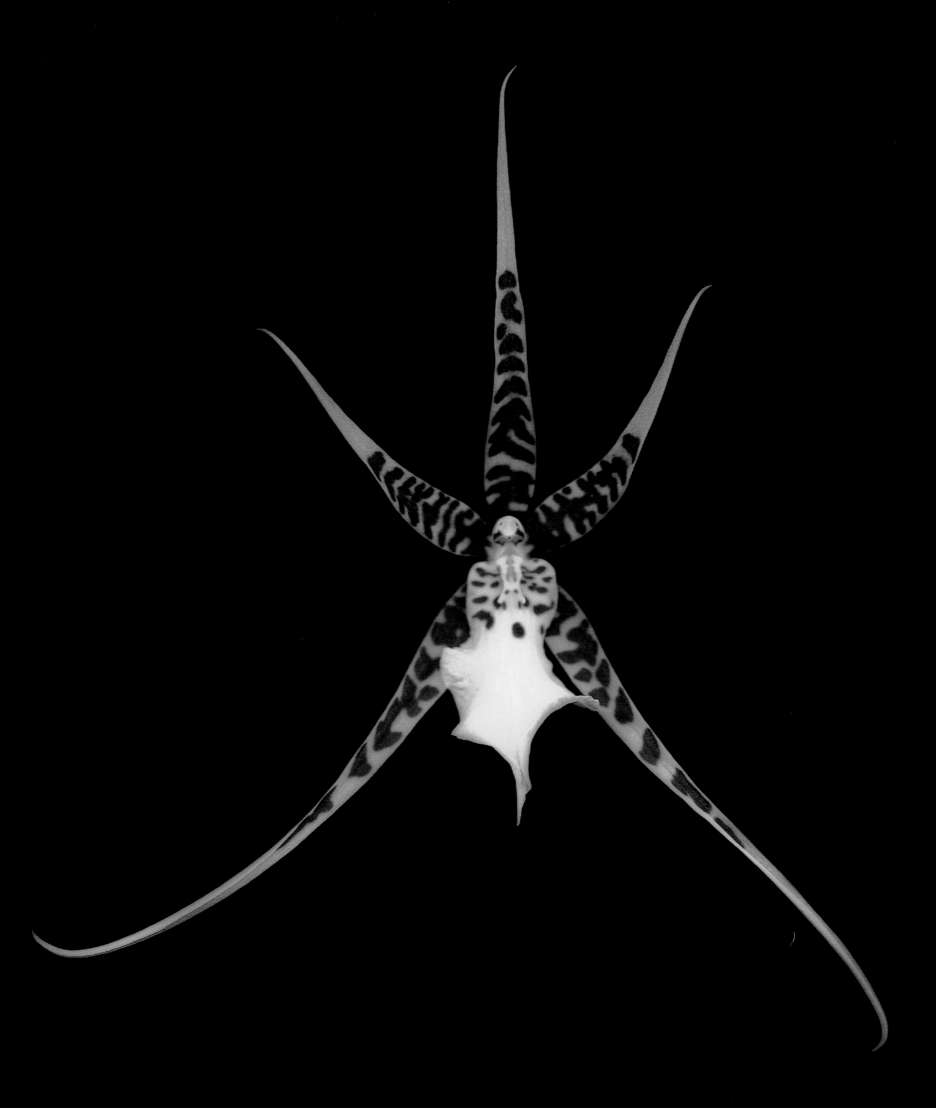

BRASSIDIUM HYBRID

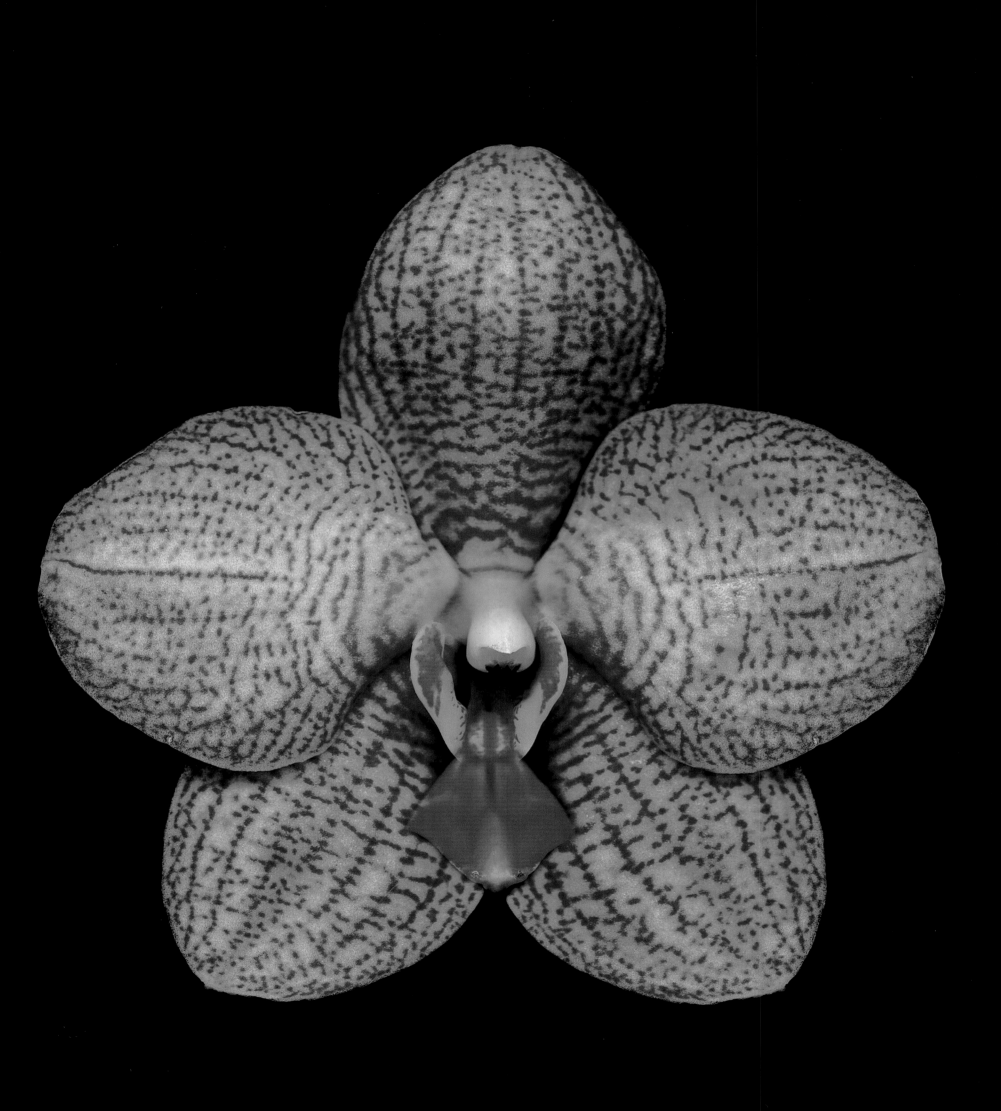

DORITAENOPSIS HYBRID

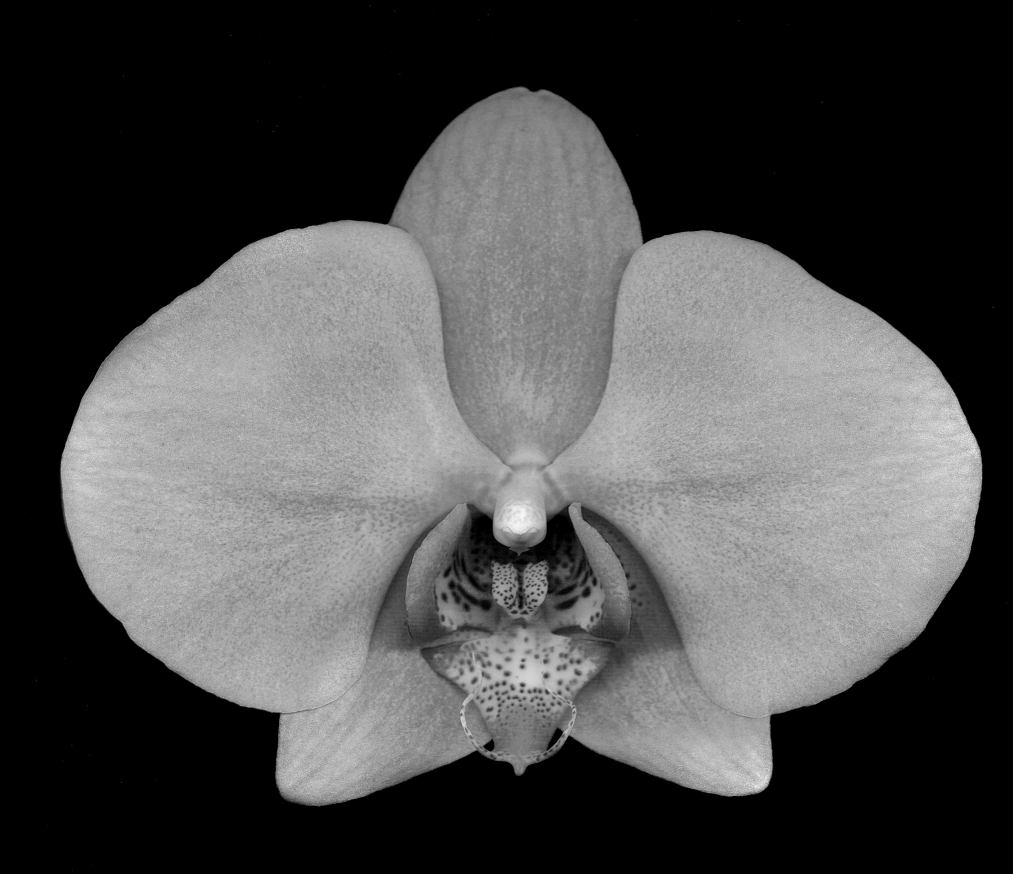

PHALAENOPSIS HYBRID

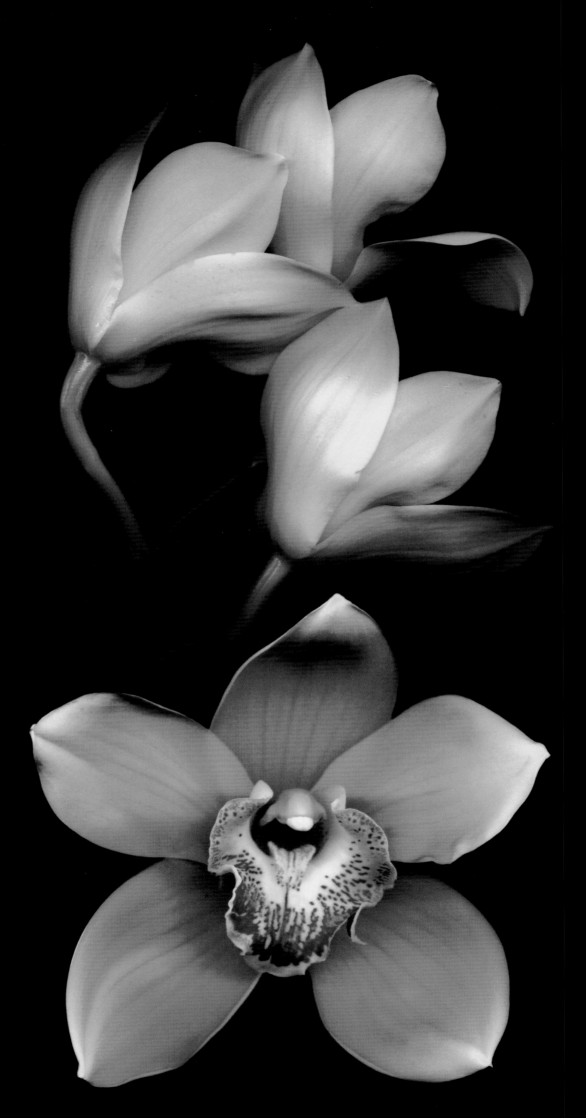

CYMBIDIUM HYBRID

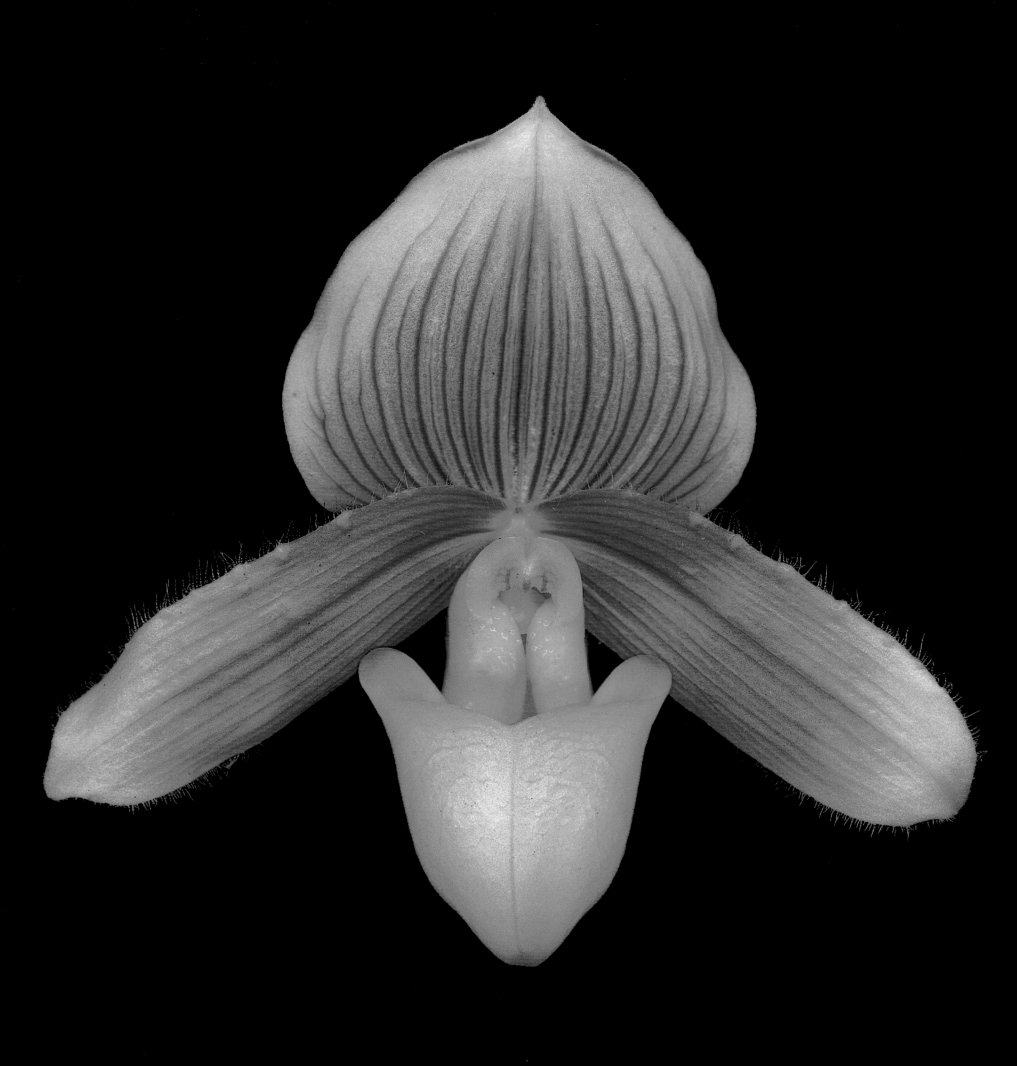

PAPHIOPEDILUM HYBRID

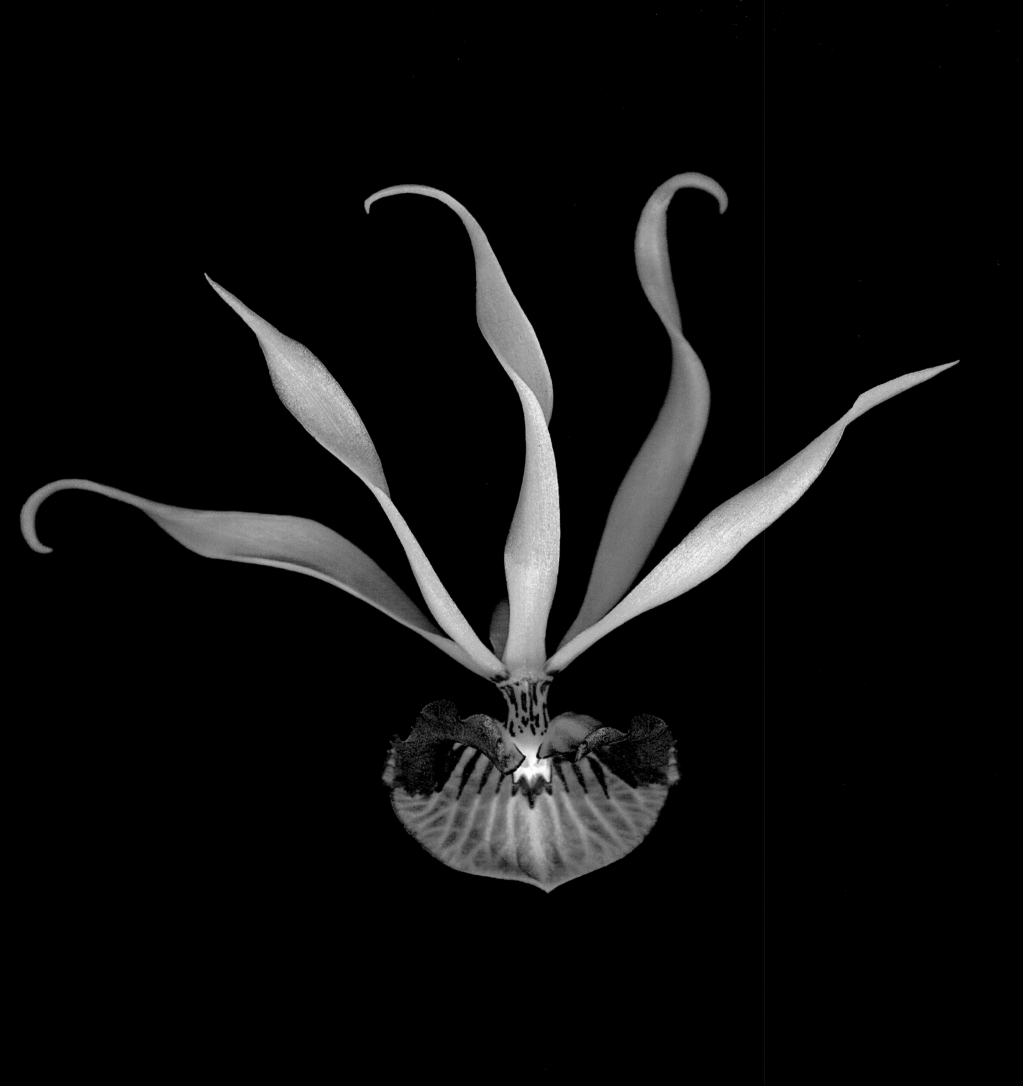

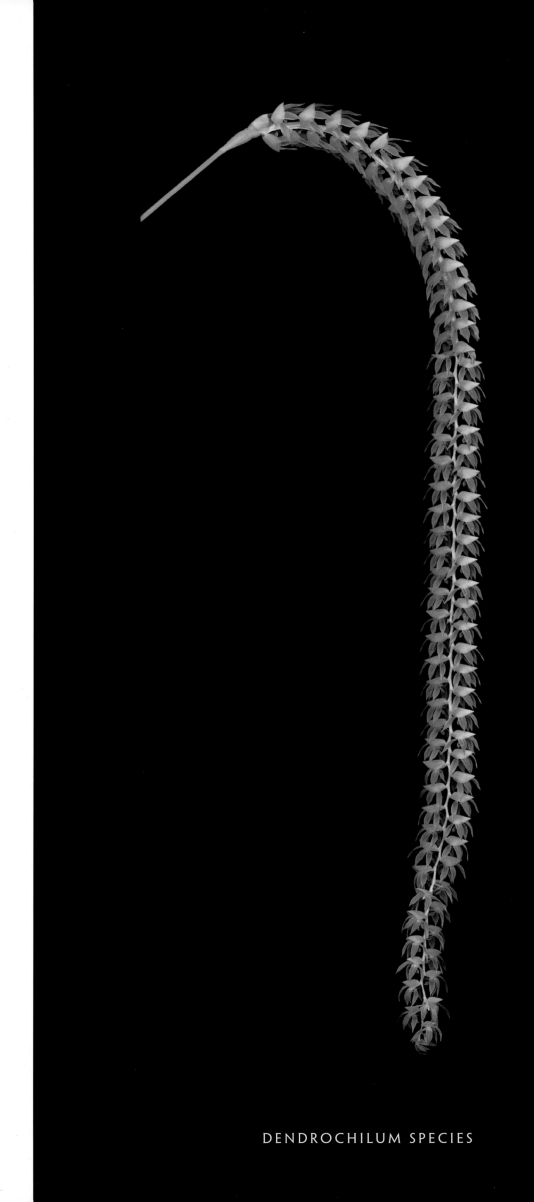

DENDROCHILUM SPECIES

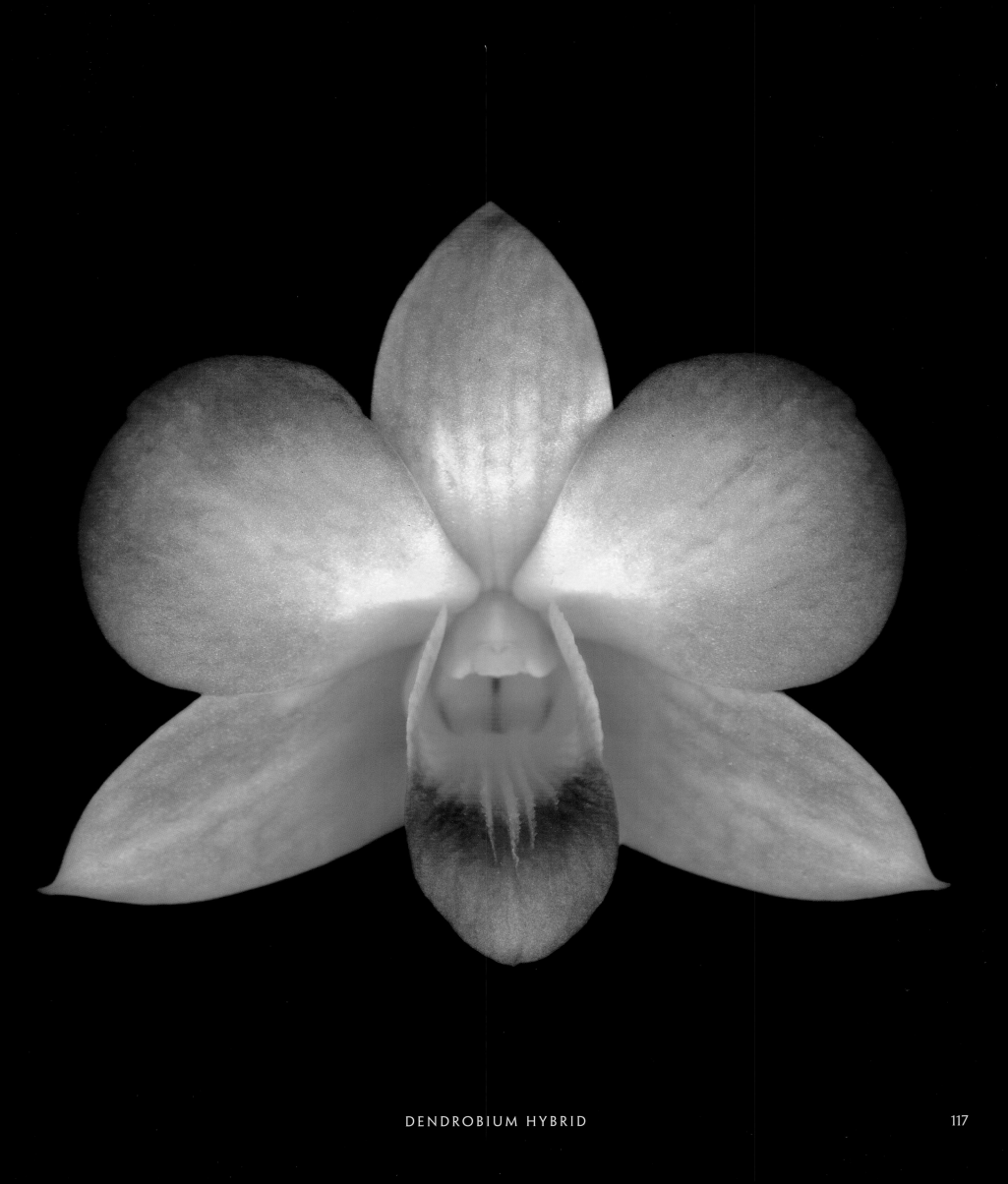

DENDROBIUM HYBRID

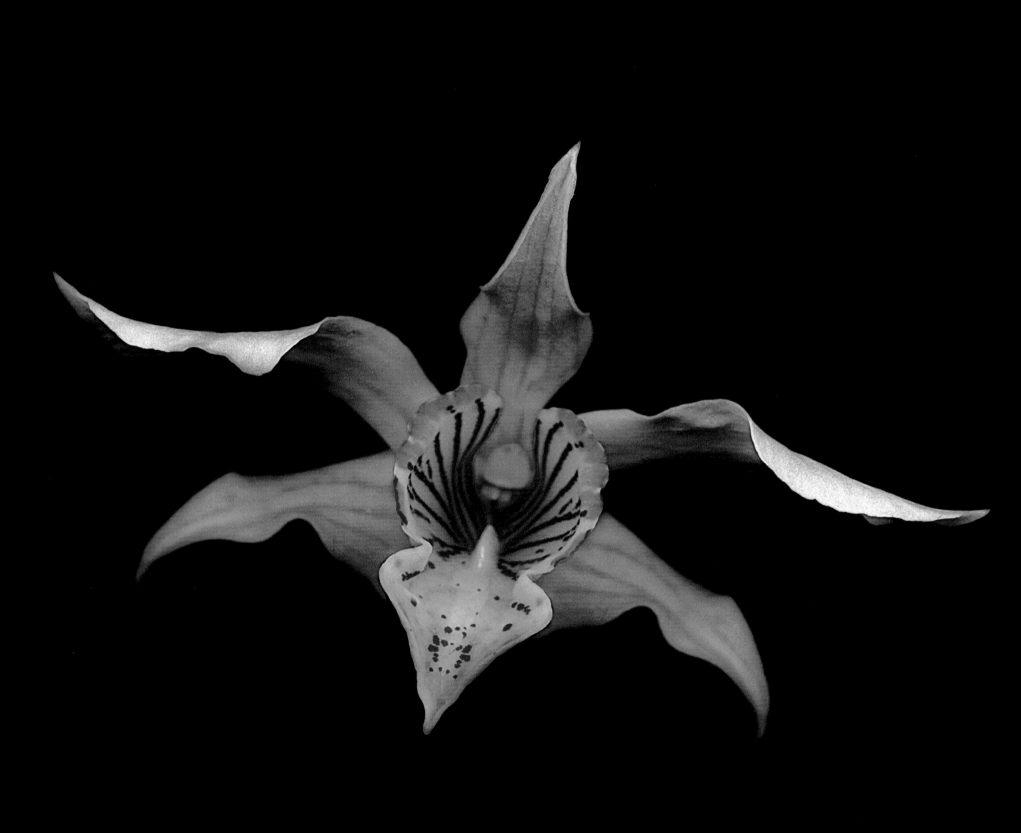

DENDROBIUM HYBRID

AFTERWORD

Harold Feinstein

WHEN I first began photographing flowers, I would hold them in my hand and frame them against the sky. In my book *One Hundred Seashells* there are some pictures of seashells that I held in my hand while wading in the surf, again using the sky as a dramatic backdrop. I used this same approach when photographing the orchids seen on the following pages, although most of the photographs in this book were made in my studio.

Prior to photographing flowers my primary work was of people, shot in black and white and often published in the old *Life* magazine. It is often with a sense of outrage that I read of the news in the world today. One place of refuge for me is to look closely at my flowers. It is here that I find a magnificent truth.

I am grateful to the medium of photography, which has been and continues to be the way for me to express my awe and experience in this life.

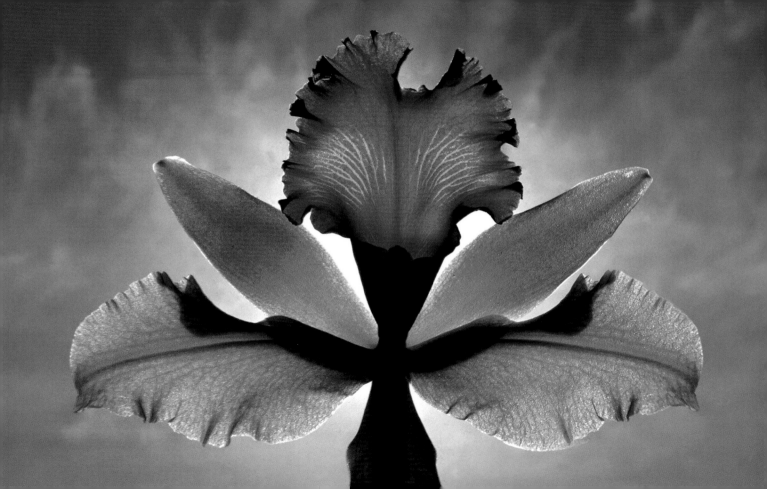

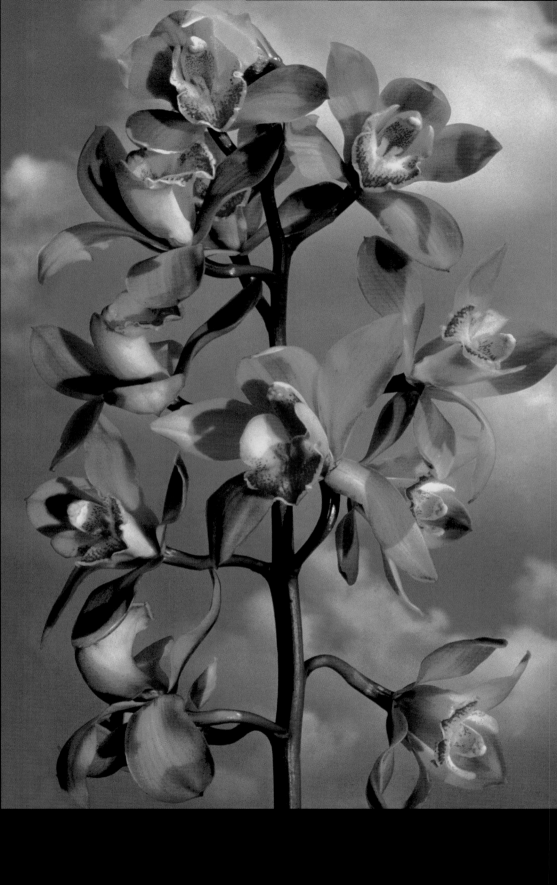

CYMBIDIUM HYBRID

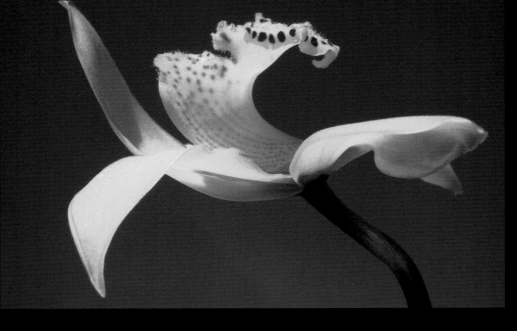

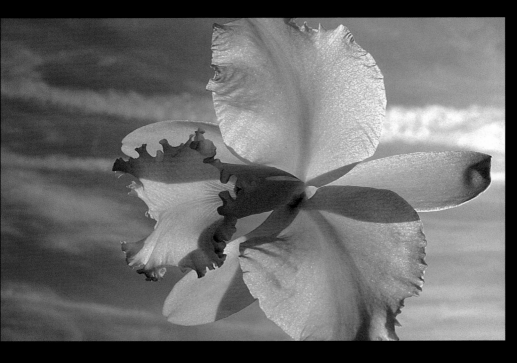

TOP: CYMBIDIUM HYBRID BOTTOM: CATTLEYA HYBRID

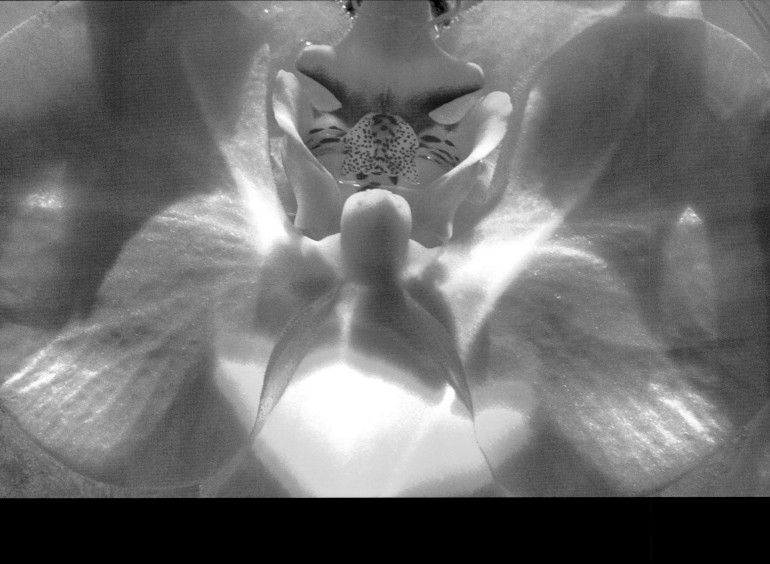

PHALAENOPSIS HYBRID

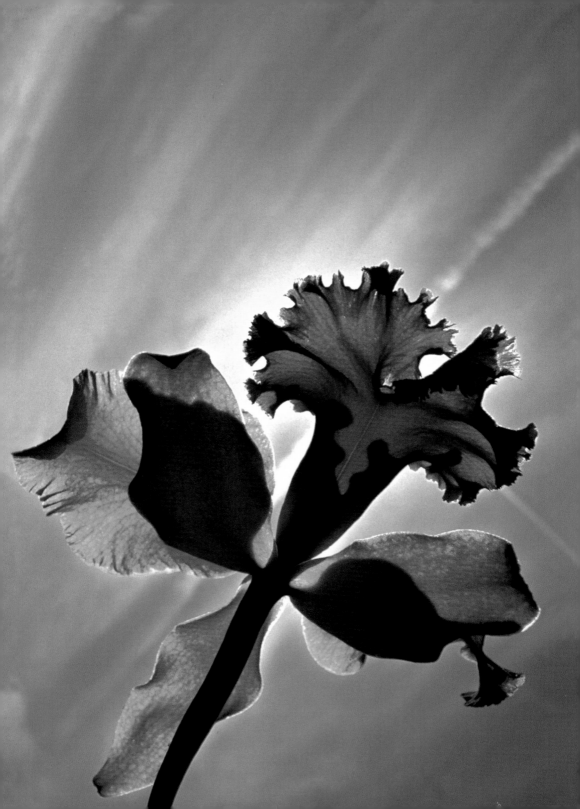

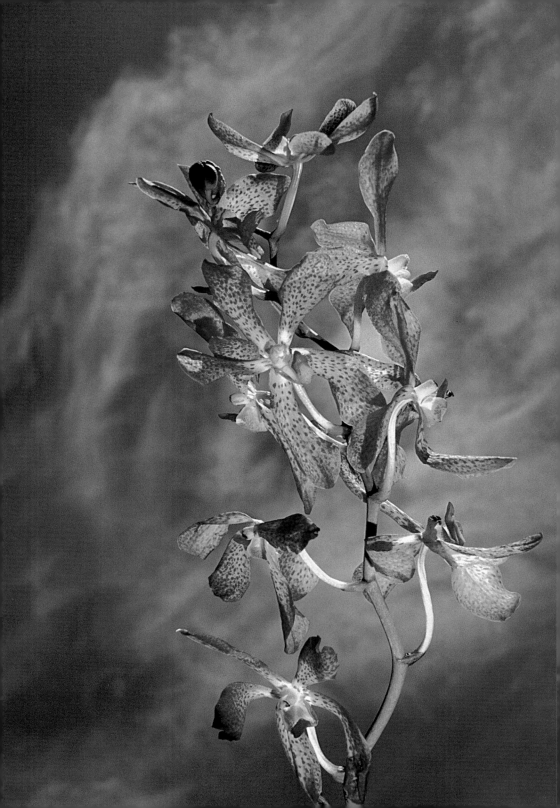

ACKNOWLEDGMENTS

I would like to thank Bob Hesse for his generous help putting me in contact with the large community of orchid growers who graciously gave me many of the flowers that appear in this book. I am certainly grateful to Lance Hidy once again for designing the layout of my photographs. I also want to thank Jill Cohen, publisher, and Michael Sand, editor, for their enthusiastic efforts and encouragement on behalf of this book. Last, I want to thank my assistant, Cherie Burton, for her indispensable help in organizing the project. — H. F.

Special thanks to Robert Winkley, a fellow American Orchid Society Judge, who has helped me with the identification of the plates. — R. H. H.

ORCHID FLOWERS PROVIDED BY

A&P Orchids, Swansea, MA
Brennan's Orchids, Mount
 Jackson, VA
DeRosa Orchids, Natick, MA
J&L Orchids, Easton, CT
Marlow Orchids, Scottsville, NY
Piping Rock Orchids, Galway, NY
Tindara Orchids, Georgetown, MA

Wickford Orchids, Wickford, RI
Ralph and Chieko Collins
Laura Eschenroeder
Brandt Moran
Gerard Nadeau
Wilford Neptune
Robert Richter
Richard Ziegler

Roger West
Marc D. Gray
Marge Tanguay
Ernie Jolin
David Walker
Steve Steiner
Mountain Orchids,
 Ludlow, VT

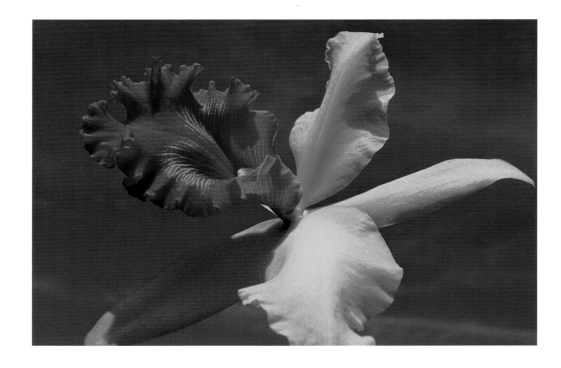

LAELIOCATTLEYA HYBRID

INDEX

AERIDOVANDA HYBRID, 25

ALICEARA (COMPLEX INTERGENERIC) HYBRID, 101

ANSELLIA SPECIES, 29

BEALLARA (COMPLEX INTERGENERIC) HYBRID, 55, 80

BRASSAVOLA SPECIES, 52

BRASSIDIUM HYBRID, 46, 65, 97, 110

BRASSOCATTLEYA HYBRID, 59

BRASSOLAELIOCATTLEYA HYBRID, 48, 79, 81

BULBOPHYLLUM SPECIES, 27, 57

CATTLEYA HYBRID, 31, 70, 73, 98, 103, 122

COLMANARA (COMPLEX INTERGENERIC) HYBRID, 61, 62

CYCNOCHES SPECIES, 23

CYMBIDIUM HYBRID, 21, 30, 40, 47, 60, 64, 68 (part), 89,
 104, 106, 113, 121, 122

DENDROBIUM HYBRID, 33, 34, 43, 45, 53, 54, 66, 67, 82,
 90, 94, 96, 102, 107, 108, 117, 118

DENDROCHILUM SPECIES, 116

DORITAENOPSIS HYBRID, 58, 111

DYKIA (SYN. ASCOCENTRUM) SPECIES, 22

ENCYCLIA SPECIES, 115

LAELIOCATTLEYA HYBRID, 120, 124, 126

MASDEVALLIA HYBRID, 86

MILTASSIA HYBRID, 39, 95

MILTONIOPSIS HYBRID, 87, 109

MOKARA (COMPLEX INTERGENERIC) HYBRID, 125

NEOFINETIA SPECIES, 74-75, 128

ODONTOGLOSSUM HYBRID, 36

ONCIDIUM HYBRID, 24, 71

PAPHIOPEDILUM HYBRID, 28, 50 (back view), 63 (back
 view), 84, 88, 93, 105, 114

PHALAENOPSIS HYBRID, 2 (frontispiece), 19, 37, 41, 49, 51,
 69, 72, 76, 78, 85, 91, 99, 112, 123

PHRAGMIPEDIUM HYBRID, 18, 83

PLECTREMINTHUS SPECIES, 38

PSYCHOPSIS (SYN. ONCIDIUM) HYBRID, 35

ROSSIOGLOSSUM (SYN. ODONTOGLOSSUM) HYBRID, 20

SCHOMBURGKIA HYBRID, 77

SOPHROLAELIOCATTLEYA HYBRID, 6

SPIRANTHES SPECIES, 11

STENOCORYNE SPECIES, 100

STENOGLOTTIS SPECIES, 32

VUYLSTEKEARA (COMPLEX INTERGENERIC) HYBRID, 44

Orchidelirium was printed and bound at Grafos, S.A. in Barcelona, Spain, on 150-gram LumiSilk paper. The text typeface is Magma, designed by Sumner Stone, and issued by the Stone Type Foundry in 2004. The titles are composed in Penumbra, designed by Lance Hidy, and issued by Adobe Systems in 1994.

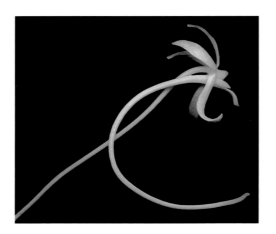

NEOFINETIA SPECIES

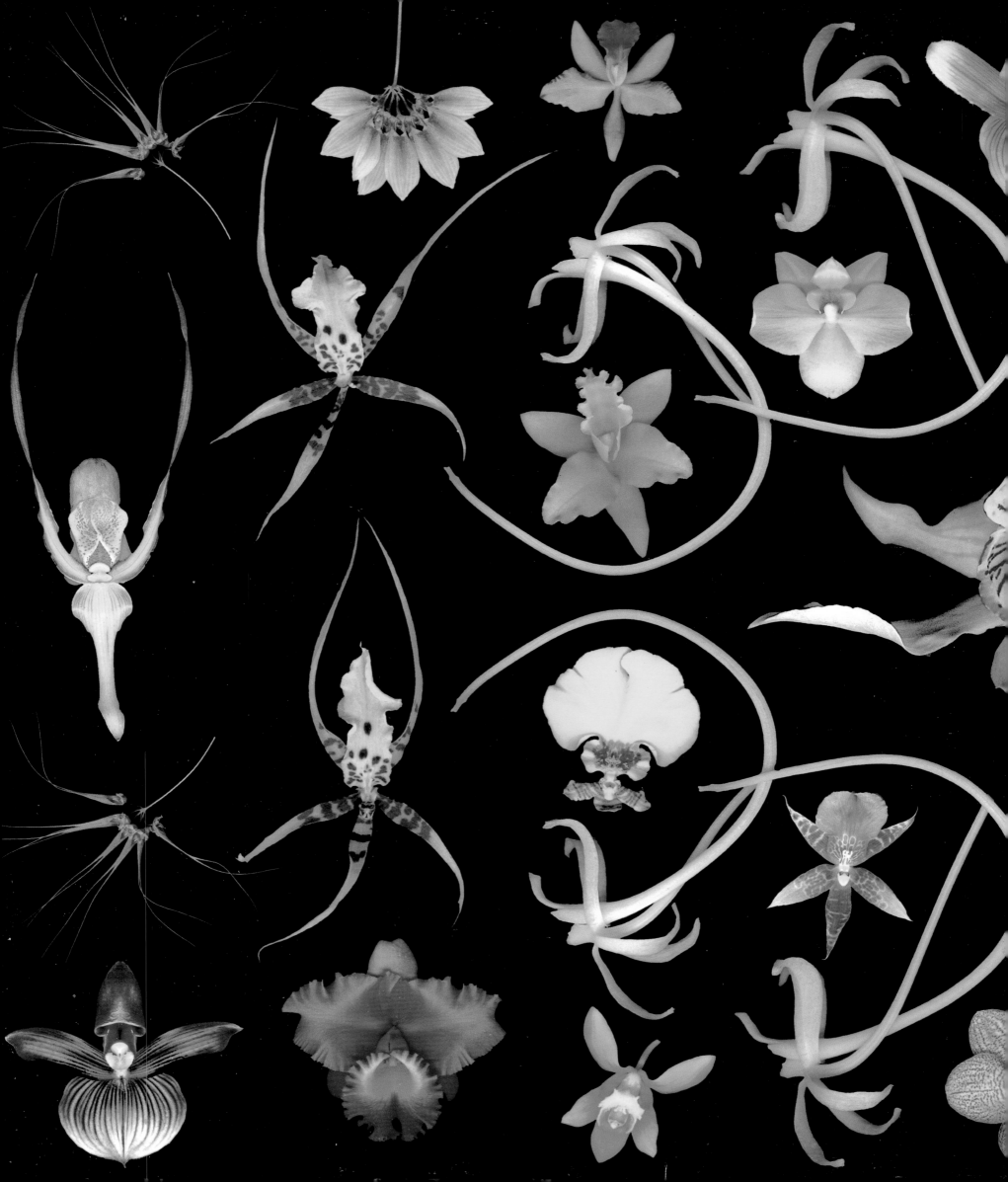